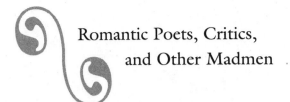

Romantic Poets, Critics,
and Other Madmen

Romantic Poets, Critics, and Other Madmen

Charles Rosen

Harvard University Press

Cambridge, Massachusetts, London, England

1998

Library of Congress Cataloging-in-Publication Data

Rosen, Charles, 1927–
 Romantic poets, critics, and other madmen / Charles Rosen.
 p. cm.
 Includes bibliographical references and index.
 ISBN 0-674-77951-7 (alk. paper)
 1. Romanticism. 2. Literature, Modern—History and criticism.
I. Title.
PN603.R66 1998
809'.9145—dc21 98-14316

Designed by Gwen Nefsky Frankfeldt

For Robert Silvers

Contents

Contents

Introduction

Words will not sit still. They change their meanings, shift from praise to blame, revise their associations. At no time did words become as slippery as at the opening of the period we sometimes call Romantic. These essays, written over a number of years, were an attempt, not to fix some of those changed meanings, but to become aware of the trajectory of the path these changes travelled. The religious revival of the time did not so much restore as transform the traditional religious patterns of the past. Madness and irrational thought took on a new prestige without shedding the horror and the distress that always accompanied them. The sense of the sublime was radically altered; genres that would have been considered inaccessible to the sublime, like private letters or moral poems for children and dance music, became major vehicles for the grand style. Even practical manuals like cookbooks could become works of art.

The traditional approach to criticism was almost unrecognizable after early German Romanticism. The different functions of criticism were no longer as clear as one had thought or hoped. Journalistic criticism ceased to be a servile pursuit: as it became a dominant mode,

it eroded the high pretentions that had been made for the grander forms.

I have always been fascinated by the ambiguity of criticism in the arts. Does it enable us to enjoy the works more? To what extent is it able to tell us about the works something relevant that we did not already know? Is it based on private experience and knowledge, or is it open to all readers, listeners and viewers? If the professional understands more than the lay amateur, what is this understanding worth? Most of these problems and pseudo-problems became important when the Jena circle of the Schlegels, Novalis, and their friends questioned the basis of objective aesthetic judgement. In spite of the efforts of some philosophers and critics like Heinrich Schenker, E. D. Hirsh, and Harold Bloom to restore prestige to objectivity, these questions have not lost their power. Most of these essays deal with the welcome variety of approaches to art. In particular, I am fascinated by the form of criticism which attempts to uncover a secret unperceived before by any other observer. I have included brief examinations of a few of these projects: the effort to reveal a secret iconography in the pictures of Caspar David Friedrich, or hidden numerical and alphabetical codes in Schumann, or concealed biographical references in Schumann and Wordsworth. Equally interesting is the criticism which claims to reveal systematic structures that are only unconciously perceived in works of art: Heinrich Schenker's *Urlinie*, or Roman Jakobson's buried syntactical patterns.

It is understandable that a critic wishes to say something original, to bring out an aspect of a work that will appear to be completely new. This desire is both inevitable and largely beneficial, but the status of a private meaning in what has always been presented as a public work has a peculiar character that needs to be taken into account. In some cases, it is pernicious, in others it is illuminating, but it is rarely simple.

In collecting these essays, I have left them without correction (except for one disastrous misprint). I do not want to read any factitious foresight into these essays, or to inject any observations on the most interesting of recent trends. It seemed more honest

to try to bring them up to date by adding a postscript when an apology or second thoughts seemed advisable, or when subsequent developments needed to be remarked. Where some of the discussion has dated, I hope that the reader will be pleased to remark a certain period flavor.

Romantic Illusions

The Definitive Text

Honoré de Balzac, George Gordon Byron, William Wordsworth

It is a convenient and pleasing Romantic myth that the true work of art springs full-blown from the unconscious mind. Revision comes from the conscious intellect or will, and this, as Wordsworth wrote, "is the very littleness of life, . . . relapses from the one interior life that lives in all things."[1] Some years ago, a novelist—Muriel Spark, I believe—was asked how she was able to write so many books in such a short space of time. She replied, "I write very fast and I never correct." This is the ideal. Few writers are so fortunate. Most revise and, as they do so, create more problems than they resolve.

One of Balzac's most interesting tales, *Le Chef d'oeuvre inconnu (The Unknown Masterpiece)*, deals imaginatively and succinctly with revision. It was a subject close to the author's heart: his books generally went

Originally written in 1987 as a review of: Honoré de Balzac, *La Comédie humaine* (published under the direction of Pierre-Georges Castex); Jerome J. McGann, ed., *Lord Byron: The Complete Poetical Works;* Stephen M. Parrish, ed., *The Cornell Wordsworth;* and Jonathan Wordsworth, Michael C. Jaye, and Robert Woof, *William Wordsworth and the Age of English Romanticism* (catalog of an exhibition at the New York Public Library).

1. *The Prelude, 1798–1799*, Stephen Parrish, ed. (Cornell University Press, 1977), p. 165.

through several versions before and after publication. However, no work of his was more completely or profoundly rewritten than *Le Chef d'oeuvre inconnu.*

The scene is laid in Paris in 1612, and the central figure is an invention of Balzac's, a demonic personality who might have stepped out of the fantastic tales of E. T. A. Hoffmann: the old Frenhofer, the greatest painter of the age (all of Balzac's important characters possess their qualities in the superlative degree, and no moderately talented artist could play a significant role in his work—even Wenceslas Steinbock in *La Cousine Bette,* when he loses his talent, becomes obsessively and spectacularly incapable and the hopelessly mediocre Pierre Grassou sees his work sold under the names of Rembrandt, Rubens, and Titian, becomes the favorite painter of the bourgeoisie, and enters the Academy). The two other painters in the tale are historical: the young Nicolas Poussin, just starting out as an artist, visits the atelier of the already established Frans Porbus, and meets Frenhofer there. For ten years Frenhofer has been working on one painting, a life-size portrait of a nude woman lying on a velvet couch—"but what are ten years," he says, "when it is a question of wrestling with Nature? We do not know how long it took Lord Pygmalion to make the only statue that walked."

Frenhofer will show no one the picture: to finish it, he says, he needs a model of absolutely perfect beauty. Poussin has such a mistress, the young and modest Gillette, who adores him. He persuades her with difficulty to pose in the nude for Frenhofer, who will in return allow him to view the unknown masterpiece. Alone in his studio with Gillette, Frenhofer compares his painting to the living form of the girl, and decides that it is finished, more beautiful than reality.

He lets Poussin and Porbus into the studio and places them before the work: they see only a

> confused mass of colors contained within a multitude of bizarre lines that make up a wall of paint. . . . Moving closer, they saw, in one corner of the canvas, a naked foot that came out of this chaos

of colors, tones, indecisive nuances, a sort of fog without form; but a delightful foot, a living foot. They stood petrified with admiration before this fragment that had escaped from an incredible, long and progressive destruction. . . . "There is a woman underneath," cried Porbus, pointing out to Poussin the finesse of the superposition of colors with which the old painter had successively charged all the parts of his figure in trying to make it perfect. . . . "There," said Porbus, touching the canvas, "ends our art on earth."

Lost in admiration of his own work, Frenhofer does not comprehend that his ten years of revision have destroyed his painting, and Poussin loses his mistress, for Gillette cannot forgive his having sacrificed her deeply felt modesty simply to see a picture.

This moral tale of the terrifying effects of revision underwent wholesale revision after its 1831 painting in a periodical, *L'Artiste*, and its reappearance with some corrections in book form the same year. Six years later, in 1837, Balzac republished it, considerably enlarged and with a different ending as part of the seventeenth volume of his *Etudes philosophiques*. In this version, definitive except for some retouching in Balzac's own copy of *La Comédie humaine*, the old painter, observing the reaction of his fellow artists, realizes the disaster, and throws the two younger painters out in a blind rage. That night he burns all his pictures and dies mysteriously.

The additions of 1837 are largely discussions of the theory of painting, in which Balzac ascribes to his seventeenth-century artists the ideas current in the 1830s: the supremacy of the colorist over the draftsman, for example. The anachronism is compounded in the reader's mind by the development of art since Balzac's day, by the suspicion that Frenhofer's superposition of colors, his multitude of bizarre lines, his chaos of tones and indecisive nuances, might be found more sympathetic today than the banal life-size nude on a velvet couch. It is more significant, however, that the isolated foot that comes out of this chaos would have had a charm already in Balzac's time precisely because it is a fragment, and Balzac's description brings out this charm magnificently:

> This foot appeared there like the torso of some Venus in Parian marble risen from the debris of a city destroyed by fire.

Perhaps the most extraordinary textual change made in 1837 is an apparently small one. Frenhofer's refusal to display his picture to anyone else is a parallel to Gillette's reluctance to pose in the nude for anyone except her lover. Before yielding he expresses his resistance with passion:

> The work I keep under lock and key is an exception in our art; it is not a canvas, it's a woman! a woman with whom I weep, I laugh, I talk and think. Do you want me to abandon ten years' happiness as one takes off a coat? To cease in a single moment being father, lover and God? This woman is not a creation, but a creature.

This is the version of 1831. In 1837 the final sentence was altered:

> This woman is not a creature, but a creation.

It is wonderful to be able to reverse the terms in this way, and the sentence still makes sense with no change of context. It is clear that for this to happen, the meaning of the words have shifted but then, as Lichtenberg once wrote, whoever decreed that a word must have a fixed meaning?

Placed so near to "creation" in both versions "creature" means not only a living being but one created, and Frenhofer's admission that he enjoyed playing God brings us to the first woman, Eve. A "creature" implies a living being, and "creation" only something made. What is imposed by the contrast is woman against portrait, the experience of life against the object. The two are fused ambiguously in both versions of this passage, but their opposition is the theme of *The Unknown Masterpiece*. Poussin loses his mistress for the sake of the portrait; Frenhofer has made his portrait the substitute for a woman, and his ten years of happiness destroy his work.

The two versions can act only as a paradox—or different paradoxes. To make sense of both, the meaning of "this woman" must shift. In "not a creation, but a creature," we have "this portrait of a woman is alive"; in "not a creature, but a creation," it changes

to "this woman is something I have made." What is disconcerting about the revision is the alteration of values. In the 1831 version, the living being takes precedence over the made object. By 1837 Balzac's hubris has increased, and the work of art is nobler than the woman. (This change has its source in Balzac's own temperament: after consoling a friend for the death of his mother, Balzac is said to have continued, "And now let us talk about something important: should I make the heroine of my new novel get married?")

The change from 1831 to 1837 is, when you come to think of it, a parallel to the story. Both Frenhofer and Poussin allow the work of art to take precedence over the living being: Eve becomes not a creature, but a thing; the work becomes a fetish. The variant of 1837 reveals a moral deterioration of the author that reflects the tale, as if Balzac were corrupted by his subject (it is significant that the earlier version is not only more humane but more directly effective, the later version more subtly insidious).

Another variant reveals the same process. Poussin endeavors to persuade Gillette to pose nude for Frenhofer, and assures that her modesty will not be violated. In the periodical version, he says:

"Il ne verra pas la femme en toi, il verra la beauté: tu es parfaite!"

He will not see the woman in you, he will see beauty:
 you are perfect.

In the first edition in book form a month later, we find:

"Il ne pourra voir que la femme en toi. Tu es si parfaite!"

He will only be able to see the woman in you. You are so perfect.

In the first version "woman" is physical, sexual, and vulnerable: the woman in Gillette will be protected from the gaze of Frenhofer. In the second, woman has become a concept, abstract and general. This suggests the way revision in Romantic art moves away from direct experience to a mediated reflection.

In the case of *The Unknown Masterpiece*, however, there is no point in judging one version superior to the other. It is clear that

a perception of the richness of meaning in these passages depends on a comparison of the different states of the text—the meanings may be implicit in each individual version, but they are more easily revealed when one version is superimposed over the other. In this sense, Frenhofer's "masterpiece" is less an allegory of the dangers of revision than an image of a critical edition with all the variant readings displayed to the reader—above all when we reflect that we would probably have preferred the magical appearance of Frenhofer's disaster to the more banal work he thought he had painted and that Porbus and Poussin all too reasonably expected to see.

Balzac's description of the picture does not correspond to the ordinary process of revision, in which the difficulties are smoothed away and the original awkwardness covered over. In the chaos of colors, tones, and decisive nuances we seem to see all of the different versions superimposed. The different variant states of *The Unknown Masterpiece* constitute a more profound and original work than any individually published text.

It is an odd and even somewhat perverse experience to read a novel or a poem in what is called a critical edition—that is, an edition which lays out all the stages that the work went through from manuscript through the successive editions, and exhibits all the variants. Our attention is constantly and abruptly halted in mid-progress to consider the change of a comma to a semicolon, the addition of a paragraph, the excision of a phrase. The reader has the illusion of sitting in the seat of the author: he can inspect and choose between alternatives, regret lost opportunities, evaluate each improvement. At every step, he is distracted from the text by another text.

This kind of edition is sometimes called a "variorum" edition, but this is—or used to be—incorrect: a "variorum" edition until recently was one that displayed all the different notes and commentaries made by the various editors of a classical text. It represented the history of the critical tradition inspired by the work.

There is no point in attacking what is by now a well-entrenched solecism (sanctioned by *The Variorum Edition of the Poems of W. B. Yeats* and *Byron's Don Juan, a Variorum Edition*), but the pedantry is useful: not only the terminology but the aspect and the function of a critical edition have changed radically over the centuries.

In the fifteenth and sixteenth centuries the notes to an old work were often printed not only at the foot of the page, but at the top and the sides as well: the text of Virgil's *Aeneid*, Petrarch's *Canzoniere*, or the Gospels, for example, was published in large type and surrounded by a commentary in small print drawn from many sources. The work took its life and significance from the circumscribing glosses: the commentary was literally the context of the literary document.

The variant readings were most often incorporated with the commentary, the purpose of which was generally to explain how the new edition was more correct than all previous ones: the editor's emendations were argued for and justified. Correcting the text of a Greek or Latin author became a major academic industry by the eighteenth century, and classical studies seemed almost to be reduced and restricted to putting out improved editions, attempts to establish a definitive text. Methods of correcting and editing were made systematic in the nineteenth century, although individual voices like A. E. Housman's were raised in protest against the thoughtlessly mechanical techniques of correction that had evolved. Variant readings and explanatory commentary were separated into two kinds of footnotes, often printed separately and with a different typeface.

The principle of the variorum edition was gradually extended from classical authors to writers in the more vulgar tongues, beginning with Shakespeare and Dante. The problems of getting an acceptable text of Shakespeare, of correcting the multitudinous faults, obvious and not so obvious, of contemporary folio and quarto printings, made it appear that the problems of editing him were similar to those met in editing Sophocles or Terence. This was soon found to be an illusion, and correcting Shakespeare became a highly individual and specialized enterprise.

Meanwhile the interplay between text and footnotes began to fade away. By the twentieth century explanatory footnotes had often ceased to be *foot*notes and were printed separately at the end of the chapter or the book. (In McKerrow's 1904–1910 edition of Thomas Nashe, often held up as the very model of a modern critical edition, variant readings are printed as footnotes, but the commentary is reserved for the final volumes.) Many publishers have insisted on the format which relegates the commentary to the end in a separate section, and have cited economy of typesetting as a justification. However, publishers are not motivated entirely by greed, in spite of appearances; the reason for separating the notes from the text is based much more on philosophical and aesthetic considerations, since publishers today have insisted on printing this way even more tenaciously, although computers have made the difference in cost negligible.

There is an obvious preference for a clean page of text, unburdened by explanation or any other supplementary matter, although it is easy to see that no text from the past can stand on its own and be enjoyed without misapprehension by a modern reader. In the new edition of Balzac, both variants and commentary are separately printed (the variants in italics) at the end of each volume; in the critical edition of Byron now coming out (edited by Jerome J. McGann), variants are printed on the page but the commentary follows at the end, and the explanatory notes of Byron himself are mixed in with the commentary of the editor, a method that certainly does violence to the intentions of the author and the way he expected his work to be presented.

A clean page of text invites us to concentrate on the work. On the other hand, it is considerably more distracting to be obliged continually to turn to the back of the book for the information necessary to comprehension. The decision to print a page with a pure text uncontaminated by notes is, in the end, the publisher's answer to an ontological question: What is a work of literature? It appears to be a well-defined aesthetic object that can survive the passage of time because it can be detached from the culture and the age that produced it, and still remain intelligible; it can be

removed as well from the successive interpretations of generations of readers. This may not be a satisfactory description of a work of literature, but we may assume that publishers believe that it will sell.

This concept of a pure, definitive text is, however, the stumbling block for many critical editions of modern works. Moreover, it betrays a lack of awareness of the change in the nature of a critical edition. To edit a classical author—Plato, Sophocles, Seneca, or whoever—is to seek to construct a single text free of the mistakes made by successive copyists. No autograph has come down to us from classical times, and our knowledge of the literature is dependent on the copies made many centuries later; we are often faced with different versions, all of them corrupt in one way or another. The role of the editor is to purge the text of the corruptions and to reduce the different versions to a single one.

The purpose of a critical edition of a modern work, on the other hand, is more often than not to multiply versions. Its reason for existing is to show us the way a novel or a poem developed from the sketches and drafts to publication, to reveal the improvement or deterioration through successive editions, and to allow us to perceive how its reception has formed our present understanding. Whereas the classical editor constructs a single, often fictive, text, the editor of Balzac or Wordsworth breaks down the single text to which we have become accustomed into a chronological series of texts, some fragmentary, and some complete. A history of the developing commentary on the work, demanded by the old sense of variorum edition, enables us to appreciate how any single version can change its significance according to the perspective of the readers.

Some works, like *The Unknown Masterpiece* of Balzac, are enriched by a critical edition, and there are still others that are not fully comprehensible without one. The first modern book of this kind is Montaigne's *Essays,* a precursor of later work in this sense as in so many others. In his copy of the second edition of 1588, already a considerable enlargement of the first, Montaigne filled the margins with new matter, sometimes lengthy developments or

even extensive observations on subjects distantly related to the text. It has now become standard to indicate the various layers of composition: at many places, the indication is necessary to follow the argument, which would otherwise be totally obscured by the interpolations. The discourse is often clarified, too, by one's knowing that a given paragraph is a comment by Montaigne written many years after the original essay. "I am myself the matter of my book," he wrote; and with a volume written over more than two decades, we need to know which of the ever-fluctuating and diverse Montaignes he is portraying: timid beginner or confident author.

"I also delight in the company of beautiful, well-bred women, *(belles et honnestes femmes)*" wrote Montaigne—but "beautiful" is added in the margin, and it is legitimate to wonder whether Montaigne became more susceptible to beauty as he got older, or simply more frank about his preferences. This kind of speculation is, in fact, the very stuff of his own thought. In 1588, he wrote, "The public interest requires betrayal and lying"; sometime later, he added "and massacre." The fact of the addition reveals what had been happening to France with the progressive acceptance of the horrors of civil war. Our knowledge that "massacre" is a marginal afterthought gives greater ironic intensity to Montaigne's comment: "Let us resign that commission to those who are more obedient, more supple."

The problem of representing these different strata in Montaigne is not a great one since he almost never excised an earlier passage. He built up his essays by a series of deposits. A few words were altered, but, for the most part, phrases, sentences, paragraphs, and whole pages were inserted as they occurred to Montaigne with very little regard for the original structure of each essay. His book was, deliberately, consciously, an image of his apparent inconsequence. The unity that we find in the *Essays* is not the result of a simple plan, and does not come from the orderly exposition of ideas; it lies in the movement of Montaigne's thought, the way he glances off one subject to another, the means he finds of indicating his meanings without making them explicit. For this reason,

decomposing his work into the various layers renders it more, not less, readable, increases its power, directness, and effect.

The editor of the new edition of Byron, Jerome J. McGann, has written persuasively about the conflicting claims of different versions,[2] but he seems to envisage the printing of more than one version almost as a measure of desperation. "For the editor of late modern works especially," he writes, "the first and crucial problem is not how to discover corruptions, but how to distinguish and finally choose between textual versions."[3] In many cases—though by no means in all or even a majority—choosing one version over all the others would mean a waste of the editor's lengthy, painstaking, and elaborate labors. It often turns the various readings into an unreadable labyrinth in which what is significant is swamped by a mass of niggling detail. The crucial problem, it seems to me, is to decide when different versions are sufficiently interesting to demand full treatment, and to find a way of presenting these in a readable fashion.

This is important, above all, for the poem in which revisions have been so considerable that it would be difficult to maintain that the first and last versions are the same work. These cases may be rare, but they do not deserve to be dressed in the staitjacket of some editorial system. McGann has recounted his problem with one such poem of Byron's, *The Giaour, a Fragment of a Turkish Tale.* This remarkable work, a romantic tale based on Byron's rescue of a girl who was to be tied in a sack and thrown into the sea at the order of the Turkish governor of Athens, is less a fragment than a series of "disjointed" fragments, as Byron himself called it in the "advertisement" (the introduction). It began as a manuscript of 344 lines, and grew to 684 lines by the time it was first published; in the seventh edition, made only six months later, it had reached 1,334 lines, after which Byron ceased to add to the fragments.

2. In *A Critique of Modern Textual Criticism* (University of Chicago, 1983), pp. 55–94. This is the most cogent of recent treatments of the problem of editing works written after 1800.

3. *A Critique of Modern Textual Criticism*, p. 55.

It is clear that a poem of 344 lines is not the same work as a poem of 1,334 lines, even if (as is not the case) all the words of the manuscript reappear intact in the seventh edition. Moreover, McGann informs us that the punctuation is radically different in the first and seventh editions, the first being punctuated rhetorically—that is, following the vocal pauses made by a speaker, and the seventh more strictly according to the syntax; the first edition is therefore closer to the way Byron himself punctuated, and reveals his sense of the rhyme, while the seventh conforms to the way he felt his writing should be respectably presented to the general public. A publication that represents *The Giaour* only by the seventh edition while allowing the reader to excavate the other versions from the tiny print at the bottom of the page and in the back of the book, does not live up to the claim of its title, *The Complete Poetical Works*.

A printing on facing pages of the first and seventh editions, along with simple notes on the difference between the original manuscript and the first printing and an indication of the various expansions that appear in the intermediate editions between one and seven would have made it possible not only to reconstitute the various versions but to read them with pleasure. McGann did envisage a printing on facing pages, but largely for the purpose of representing the different systems of punctuation; he would have given with the first edition the added passages as they appeared in the manuscripts that Byron sent to the press, without the editorial punctuation: he claims, somewhat ruefully it seems to me, that "the exigencies of the whole edition obviated this possibility."[4] It is not clear why.

Only a few poems of Byron ask for such special treatment, and since the publisher is demanding almost sixty-four dollars for the paperback and one hundred twenty-five for the hardback volume, the reader interested in Byron could be granted more considera-

4. *A Critique of Modern Textual Criticism*, pp. 106–107.

tion. As things stand, it is easier to become acquainted with many aspects of the earlier versions from the edition published by Murray in 1900 and edited by E. H. Coleridge. At least, there the variants are printed as verse and not as a prose jumble.

We find ourselves here facing two bibliographical fetishes. The first is the question of "copy text" (i.e., the text that is taken as the basic one to be edited and published), a subject upon which bibliographers have spilt more ink than on any other—for many of them, indeed, choosing a copy text is their reason for existing. The truth is that for most books, the vast majority, in fact, the choice of copy text does not make much difference (after the first printing, the novels of Flaubert and the poems of T. S. Eliot, for example, underwent no revision). For a small number the conflicting claims of different copy texts are so strong that all should be represented: whether by variant readings or by the complete printing of all versions. Shakespeare's *King Lear* and *Hamlet* and the poetical works of Pierre de Ronsard are among the most famous examples that contain such problems, and we are gradually becoming aware that the first half of the nineteenth century presents us with several others.

The other fetish is the belief that the author's final version has the greatest authority and is therefore privileged. Here aesthetics has become oddly confused with law, and critical evaluation becomes an affirmation of property rights. An editor's judgment seems often to be supplanted by the traditional rules of copyright, and an author who has been dead for more than a century is still allowed to decide which version of his work we shall be permitted to read. In most cases, this fetish does no harm, as authors are often no worse than any one else at correcting their works. There are, however, cases in which successive versions do not produce greater polish or enrichment, but tend to weaken and even to betray the original conception. That so many examples of this progressive deterioration are found in the early nineteenth century suggests that we are not dealing with the psychological difficulties of individual authors but with a problem of style. In recent years,

the extension of the study of revisions and variants to this period has deepened our apprehension of Romantic art.

～➤➤

Romantic artists die young, or else lose their genius and sink into insanity, drug addiction, or respectability. This is a principle of Romantic ideology, not a fact of life, and there are many exceptions; nevertheless it is astonishing how many writers, artists, and composers of the first half of the nineteenth century conformed faithfully to the model. Dying young, of course, is not the prerogative only of Romantic artists; the lives of du Bellay, Pascal, Marlowe, and Mozart were cut sadly short like those of Schubert, Géricault, Novalis, Kleist, Keats, Shelley, and Byron. Moreover, renunciation of a brilliant career was not unknown before 1800; the most interesting examples are those of Congreve, the finest playwright of his generation, who retired to become a gentleman, and Mariotto Albertinelli, the contemporary of Raphael, who after painting a masterpiece like the *Visitation*, now in the Uffizi, retired to become a cook.

What is unprecedented about the Romantic movement is the number of important figures who follow a few spectacular years with several decades of pedestrian work lit only by intermittent flashes of earlier genius. These include the major writers of Germany, France, and England who began to work in the very last years of the eighteenth century: Friedrich Hölderlin, Friedrich Schlegel, François René de Chateaubriand, Étienne Pivert de Sénancour, Samuel Taylor Coleridge, and William Wordsworth. A little later, the generation of composers usually called Romantic, born around 1810, has a similar history: Chopin died at thirty-nine, Liszt completed almost all his major works by the time he was forty, Schumann by the age of thirty-one, Mendelssohn before he was twenty.

The most important achievements of Wordsworth, Coleridge, Schlegel, and Sénancour were completed between 1797 and 1807; in 1805 Hölderlin was overwhelmed by schizophrenia, and spent

the next thirty-eight years passively writing unremarkable verse, after a decade of work so powerful and innovative that it was fully appreciated only a century later. These years between 1797 and 1805 were filled with the most daring experiments in literature. They were a time of despair after the failure of the French Revolution and of half-ironic, half-serious hope for a new spiritual rebirth, a transformation of the world through art. Sénancour produced the *Reveries on the Primitive Nature of Man* and *Obermann.* The latter inspired Franz Liszt and Matthew Arnold, and was called "the Bible of Romanticism" by Sainte-Beuve. In 1798, Schlegel founded the *Athenäum,* a literary review, with his brother August Wilhelm, and published there the eccentric, richly paradoxical *Fragments* which constituted a manifesto of German Romanticism and laid a foundation for most of the basic ideas of modernism—its experimental, progressive nature, the attack on established classical forms, a literature of visionary imagination alongside the portrayal of even the most repellent aspects of modern life. (Schlegel suppressed these fragments, his most remarkable achievement, when he later collected his works.) These were also the years of the *Lyrical Ballads* of Coleridge and Wordsworth, of "Kubla Khan," of *The Prelude,* and of almost everything else that we still read today of their poetry. Even the magnificent first book of Wordsworth's *The Excursion* was drafted at this time.

It was understandably impossible to sustain the creative energy of these brief years. To a large extent this was a literature of opposition. Above all, it was drawn directly from memories of adolescence, and as these memories receded into the past their evocation became more and more artificial, or else the writer found himself with a fully developed manner and no content. After 1805 Wordsworth drew with increasing difficulty upon the feelings that had provided the material for his finest work, and turned to producing a long series of sonnets in favor of capital punishment. The impoverishment was as evident to contemporaries as to posterity.

Chateaubriand alone of these writers was able to continue to produce work in later years comparable to his first masterpieces. His case is exemplary: what he did was to continue to publish and

develop his earliest work. He returned from America aged twenty-four carrying an enormous manuscript (he claimed improbably that it later saved his life during the wars against the young revolutionary government of France by stopping a bullet). He extracted one book after another from this, starting with the *Essay on Revolutions, The Genius of Christianity,* and *The Voyage to America.* The successive revisions weakened what we have been able to learn of the original: in *The Natchez,* a grand epic of American Indians, the influence of travel literature and the Marquis de Sade was sadly watered down by injections of Milton and classical reminiscences. The late autobiographical work, however, retains much of his youthful power: considerable portions had been written much earlier, and the title, *Memoirs from Beyond the Tomb,* is revealing—Chateaubriand wrote as if already dead and he had less need to compromise.

Revision always means compromise, but rarely has a style been created in which it was so difficult to preserve the original inspiration. Goethe thought that Romantic art was a disease; in a sense he was right—healthy attempts at correction most often ended up by destroying the essential character of the first drafts, replacing the initial fever with something tame and bland. This is evidenced not only in larger issues, in the attempts of Sénancour, Chateaubriand, Coleridge, and Wordsworth to blur the evidence of their earlier political and religious sympathies, but in the smallest details of diction. The opening lines of Wordsworth's "Home at Grasmere," drafted most probably in 1800, originally read:

> Once on the brow of yonder Hill I stopped
> While I was yet a School-boy (of what age
> I cannot well remember, . . .)

By 1814 this had become:

> Once to the verge of yon steep barrier came
> A roving School-boy, What the Adventurer's age
> Hath now escaped his memory; . . .

The manner has become archaic, the vocabulary trite ("roving

School-boy"), and the change from first person to third has reduced the immediacy of expression and gives a stilted air to the passage.

Sometimes the change is apparently minimal but disastrous. Lines 24 to 30 originally read:

> . . . Who could look
> And not feel motions there? I thought of clouds
> That sail on winds; of breezes that delight
> To play on water, or in endless chase
> Pursue each other through the liquid depths
> Of grass or corn, over and through and through,
> In billow after billow evermore.

Wordsworth changed "look" to "gaze," and "liquid depths" to "yielding plain"; he added an enjambment to the last verse by writing:

> In billow after billow, evermore
> Disporting.

Perhaps he was disturbed by the insistence on "liquid depths" in what followed, but "yielding plain" is second-rate Pope, the triteness reinforced by "disporting." Wordsworth himself recognized that his revisions generally made things worse, but he could not prevent himself from trying. What we have here is an attempt to disguise and distance the original thought.

The project of *The Cornell Wordsworth,* already much advanced, is to publish all the early manuscripts; "diplomatic" transcriptions, which show typographically all the layers of revision, are provided, along with photographs of the most important manuscripts. The demands of the lover of poetry who wants to read an uninterrupted text are amply fulfilled, since "reading texts" of the most interesting poems or passages are given, often in different versions on facing pages. (These reading texts present the manuscript versions as the poet would have read them aloud to friends, with none of the obtrusive indications of correction and revision.) These volumes are expensive, even though the project must be heavily subsidized; but I presume that the reading texts, which often make

up only a quarter of the total pages of each book, will eventually be collected in one volume, making Wordsworth easily available in his freshest and most immediate form.

A revival of interest in Wordsworth has been stimulated and, indeed, created by the publication of these early versions, starting with de Sélincourt's printing of the 1805 version of *The Prelude* in 1926. The complacent, serene, and even stodgy Wordsworth often presented by the work published during his lifetime has given way to a more tormented writer. (It is true that the more disquieting Wordsworth could have been construed from what was already before us, but the discovery was facilitated by the new material.)

The most striking aspect of the early versions is their greater concentration. The two-book *Prelude* of 1798–1799 contains all the "spots of time," those intense experiences of childhood and early adolescence which return as memories to sustain and fortify us later; they are not dramatic events, but ordinary sights invested by the imagination with a visionary power. The thirteen-book *Prelude* of 1805 does not present all this material in the opening books, but diffuses it as well through books V, VIII, and XI. The two-book *Prelude,* discovered after the final version, makes the odd impression not of a preliminary sketch, but of a ruthless abridgment, a stripped-down selection with a fierce intensity.

This newly found intensity, which has been given back to Wordsworth by recent studies, is confirmed and even consecrated by the exhibition "William Wordsworth and the Age of English Romanticism," now at the New York Public Library at Forty-second Street until January 2 [1988], which presents an astonishingly complete picture of the period through pictures, prints, books, and manuscripts. The display of manuscripts is generous: alongside the most important of Wordsworth's drafts, there are Coleridge's "Kubla Khan," several sheets of Shelley and Keats, and Blake's copy of Wordsworth's *Poems* opened at the flyleaf, where Blake expresses his stern disapproval of some aspects of the work. Documents and books trace the effect of the revolutionary events in politics and the changing movement of taste: the agitation over the slave trade, the American and French revolutions, the quarrels

over the picturesque, the fashionable interest in mountains. Paint-ing is represented with a richness that one could hardly have hoped for. The full range of Constable's genius is on display. Recent stud-ies of Constable have paralleled the reevaluation of Wordsworth, and have recognized a similar violence and passion in the artist.

Best of all, the pictures do not simply illustrate the manuscripts, or the poetry displayed act merely as captions to the art: they inter-act to reveal the ferment and the energy of the period. Besides Constable, we find J. M. W. Turner, John Sell Cotman, Samuel Palmer, and Thomas Girtin at their finest. There is a chance to see rarely displayed watercolors like Cotman's picture of industrial desolation, *Bedlam Furnace,* and Girtin's supreme masterpiece, *The White House at Chelsea.* The new vision of Wordsworth that inspired the show allows us to appreciate the full power and eccen-tricity of these and other works, and restores their intensity.

The excellent catalog gives the best popular account of the political significance of Wordsworth's style and his break with the eighteenth century. The only fault is a certain provinciality: the influence of German poetry and thought on Wordsworth and oth-ers goes unmentioned, and the importance of the standard trip to Italy in the liberation of many of the English painters (John Robert Cozens, Turner, Richard Wilson, etc.) from the constraints of local tradition is not recognized. The novelty of English Romantic art was not specifically English. Nevertheless, this exhibition and cat-alog give the best synoptic view of recent studies of the period. Wordsworth is presented throughout almost entirely by the early drafts of his work, and the fruitfulness of these studies is well estab-lished.

There has been an inevitable modish reaction to the new ten-dency in criticism of Wordsworth, and a few critics feel that the preference for the early versions has gone too far. One such is David Bromwich, who attacked the 1799 *Prelude* and claimed that the text of *The Borderers* of 1842 is superior to the manuscript of 1797–1799 and has a greater dramatic intensity.[5] It is difficult to

5. *TLS* review of *The Borderers* (September 9, 1983).

see how anyone of modern sensibility could prefer a version of a tragedy in which the hero's name has been changed from Mortimer to Marmaduke. Some of the alterations, of course, may be defended. In the crucial scene, where the villain (Rivers, later called Oswald) recounts his emancipation from the ordinary rules of conduct, the simplicity of one passage has been altered for greater smoothness (IV, ii, 141–145):

> When from these forms I turned to contemplate
> The opinions and uses of the world,
> I seemed a being who had passed alone
> Beyond the visible barriers of the world
> And travelled into things to come.

This became

> When from these forms I turned to contemplate
> The World's opinions and her usages,
> I seemed a Being who had passed alone
> Into a region of futurity,
> Whose natural element was freedom.

Perhaps the repetition of "world" in the original was felt to be awkward, and the new last line adds greater clarity to the moral exposition. There is a regrettable loss of power, however, and the revision of the extraordinary verses that follow is indefensible. They present an important aspect of contemporary political thought, one which Wordsworth may never have fully accepted, but by which he had been tempted:

> Is not shame, I said,
> A mean acknowledgment of a tribunal
> Blind in its essence, a most base surrender
> Of our knowledge to the world's ignorance?
> I had been nourished by the sickly food
> Of popular applause. I now perceived
> That we are praised by men because they see in us
> The image of themselves; that a great mind
> Outruns its age and is pursued with obliquy

Because its movements are not understood.
I felt that to be truly the world's friend
One must become the object of its hate.

The first four lines were cut, and the succeeding ones watered down, made more diffuse:

I had been nourished by the sickly food
Of popular applause. I now perceived
That we are praised, only as men in us
Do recognise some image of themselves,
An abject counterpart of what they are,
Or the empty thing that they would wish to be.
I felt that merit has no surer test
Than obloquy; that, if we wish to serve
The world in substance, not deceive by show,
We must become obnoxious to its hate,
Or fear disguised in simulated scorn.

In the fourth line, "do" is patently introduced only to fill out the rhyme. "Obnoxious to its hate" is an absurd tautology (even worse than "not deceive by show"), and the last verse adds an unwanted precision which weakens the force of the thought. Still feebler is the way "to be truly the world's friend" is pedantically spelled out as "to serve / The world in substance, not deceive by show." The contempt for general human dignity and for popular democracy inherent in much revolutionary thinking is drained of most of its expressive force.

The new critical position on Wordsworth may derive directly from a reexamination of the manuscripts, but it must be acknowledged that presenting an author largely by those aspects of his work that he never wished to be seen by the public is a peculiar undertaking, and seems an immoral one to many. In 1835 Balzac canceled the serial publication of *Le Lys dans la vallée,* refusing to send the next installment, and sued the publisher. What outraged him was the attempt of the publisher to make some extra profit by selling an early draft of one installment to the distant *Review of*

Saint Petersburg, hoping that the author would not get wind of it.

Balzac's agreement with his publisher required the initial setting of his work in a typeface which would not be used for the publication and from which only one proof was to be made; on this the author was to enter all the corrections, and it represented a second manuscript which had then to be reset in a different typeface. It was this first proof that was sent to St. Petersburg, and was printed there, including at one point, with comic effect, Balzac's directions to himself, "CONTRAST" in capital letters, intended to remind him to insert a letter from the heroine. This proof was rather like an initial typescript, and Balzac's rewriting increased the difficulty for the typographers who found his handwriting a chore to read. ("I've done my hour of Balzac," he once heard a typesetter shout; "Who's next?")

It is easy to imagine Balzac's justifiable anger when this half-completed version appeared in print—but we must not hastily deduce that he was ashamed of it. He had this first proof bound luxuriously in folio by an important binder; he had the other successive sets of proofs bound as well and presented to his friends. Balzac was proud of the way he built up his novels in a series of rewritings, enrichments, expansions, and retouches. He would have considered the present study of these states not so much flattering as deserved. The biography of a book would have seemed as natural to him as the biography of an author—equally vital, equally organic.

After the original publication in book form, Balzac altered the scene of the death of his heroine and struck out a long passage in which she bitterly reproaches the much younger hero for having too much respected her, for not having seduced her. "If you had been less submissive," she cries, "I should live, I should be able to care for the happiness of my children, to get them married, to guide them in their lives. Why did you not take me by surprise at night?" These tactless phrases, and others like them, were removed by the author on the advice of his mistress, Mme. Hanska, and of a recently deceased mistress, Mme. de Berny, as well. He wrote ambiguously about the decision:

As my pen crossed out [these sentences], I did not regret a single one, never heart of man was more strongly moved, I seemed to see before me that great and sublime woman [Mme. de Berny], that angel of friendship, smiling as she smiled when I employed that rare power which consists of cutting off a limb and feeling neither pain nor regret in correcting and vanquishing oneself.

He then added about his heroine these words for himself: *"Oui, il faut ne laisser que soupçonner les regrets"* (We must allow only a suspicion of regret).

Many writers have experienced the necessity of eliminating the disastrous improvements of editors, of writing *stet* throughout their previously corrected typescripts, of restoring the vulgarity and the solecisms that rendered their thought with greater energy. Here it is the author himself who has damped the vulgar explicitness of his original. I do not think that the editors of the new Pléiade text were necessarily wrong in choosing the less powerful final version for the basic text and relegating the first published form to small print in the back of the book, particularly in light of all the changes in format that Balzac made in order to integrate this novel into *La Comédie humaine,* including the disappearance of the division into chapters. What is disquieting, however, is that the decision was made more or less automatically, not because the editors considered the final text as the most satisfactory.

Editors and biographers dislike the injection of what they call subjective elements into the choice of "copy text." It is difficult to see whether anything coherent is signified by this prejudice. A taste in these matters is anything but arbitrary: a decision to choose the 1805 or 1850 version of *The Prelude* is more like a reasoned decision to invest in a certain kind of stock than like a preference for raspberry over apricot jam. Subjective choice of copy text seems to imply the use of critical intelligence: objective choice is the kind that can be exercised without disaster by an idiot. It goes without saying that, in bibliography as in any other field of human endeavor, no one has ever invented a system that will preserve us from foolishness.

"Dramatic irony," was defined by Friedrich Schlegel in his essay *On Incomprehensibility*, as "when an author has written three acts, then turns unexpectedly into another man and now must write the last two acts." Romantic art presents us with numerous examples of such "dramatic irony," less often in works for the theater, where tradition tends to impose strict limits, than in novels and poems and in the more innovative musical forms. Paradoxically—or not so paradoxically, after all—the closer a work is tied to the artist's life, the less he seems to be able to exercise his critical sense, above all when he returns to the work after a lapse of time. Schumann's second editions of some of his finest conceptions like the *Davidsbündlertänze,* when he reprinted them more than a dozen years after they were completed, show a consistent attempt to remove some of their most original features. The most regrettable changes show how far he had distanced himself from the young composer he once had been—he added a large number of indications of repetition, so that many of the eight-bar phrases that appeared fleetingly and then quickly disappeared are to be given a new, heavy emphasis.

The Romantic belief in the importance of the unconscious will in artistic creation begins to appear more sensible and reasonable than we might be willing to acknowledge. Many an author has had the experience of creating a work that, as it grew, seemed to develop a logic and even a kind of will power of its own: the author carries out a plan of which he is only half aware. Bernard Shaw once remarked that he began his plays with no idea how they would go on, that the characters seemed to go their own way as he continued to write. The work at a certain point develops its own intention for which the author is only an agent. Even language had, for the Romantic artist, a momentum and an energy independent of the will of the artist. Novalis claimed:

> It is the same with language as it is with mathematical formulae— they constitute a world in themselves—their play is self-sufficient, they express nothing but their own marvelous nature, and this is the very reason why they are so expressive, why they are the mirror to the strange play of relationships among things.[6]

Some revisions betray the work's intention. Often these revisions are imposed on the artist from outside. Between the quarto and folio versions of Shakespeare's *Othello,* a law prohibited the use of profanity on the English stage: it would not be unreasonable to choose the folio as copy text and to restore the oaths that had then been banned. The second version of Mozart's *Don Giovanni* is dramatically weaker than the original one for Prague, in spite of the beauty of the new arias added: these were forced on Mozart by the demands and limitations of the singers.

With Romantic artists, we reach a generation often disconcerted by the implications or intentions of their own works. When this happens, the revisions become a betrayal of the work when they are not a form of tinkering. We might say that the writer has ceased being an author and has turned into an interfering editor of his own work. With a number of works—"The Rime of the Ancyent Marinere," "The Ruined Cottage," Hölderlin's "Patmos," Liszt's *Petrarch Sonnets*—the editor is forced to consider which revisions are developments of the intention, and at what point the changes begin to betray rather than to enrich.

This no doubt opens the door to a certain kind of irresponsible editing, a descent back into the Dark Ages of publishing when an editor altered and repunctuated as he pleased and made up eclectic texts of all the little bits of different versions that he liked best. I do not believe this is probable. I should be happy, however, if more editors would acknowledge the conflicting claims of multiple versions, and realize that the establishment of a definitive text is, only too often, an imposture.

Postscript, 1998

This review would have been better balanced if it had taken consideration of the important and influential views of Jerome J. McGann, who observed that "the essential character of a work of art is not determined *sui generis* but is, rather, the result of a pro-

6. Quoted from *German Aesthetic and Literary Criticism* ("Monologue," p. 93), K. Wheeler, ed. (Cambridge University Press, 1984) and slightly altered.

cess involving the actions and interactions of a specific and socially integrated group of people" (*The Beauty of Inflections* [Oxford, 1988], p. 117). It is sometimes claimed, for example, that editing the manuscript versions of poems by John Clare betrays the author's intentions, as he expected the publisher to correct his grammar and his spelling. The "corrected" form is as intentional as the handwritten original, and it better represents the social function of the poems.

My plea is not that we return to the original against the artist's intentions, but that a good edition—particularly the expensive critical edition paid for by taxpayers' subsidy—should adequately represent the different possibilities for the pleasure of the average reader. McGann's view, however, conceals a paradox. For him, the final published version is a social project; for an author like W. H. Auden, however, the final version was a personal and individual property. In a tribute to Auden by many of his friends (*New York Review of Books*, December 12, 1974), I remarked:

> no poem could ever become completely public for him. He refused to admit the public nature of publication. His poems always remained his private property, he felt, to withdraw as he pleased, to alter, to suppress. No one has ever taken so ethical a view of copyright as Auden.
>
> I once told him about going up to speak to Marianne Moore (whom I had never met) after she had given a reading of some of her poems, to tell her that I regretted a poem she had left out of her collected poems: it had a beautiful comparison of the swan to the mathematician's sign "greater-than" bearing its point upon the lake, and it ended with, "An arrow turned inward has no chance of peace" (a line I am no longer certain I care for so much). "I am glad you liked that poem," said Miss Moore, "I liked it too, but James Laughlin didn't, so I left it out." When I told this to Auden, I had forgotten that he was sensitive about the revisions and suppressions he had performed on his own work. He was very indignant at my story, and curiously, most indignant at Miss Moore's reaction, which he must have felt had compromised her fellow poets.
>
> When I said that there were writers and composers, like Schu-

mann, whose revisions fell below the standard of their original inspiration, he replied that quality had nothing to do with it: the work belonged even after publication to the author. He felt I had gone beyond what was permissible in playing Schumann's original versions. A suppressed version had no right to exist: to read it was almost to pry into the author's life, to force into light that which he had chosen to hide. Public and private were absolutely separate for Auden, but each could be transformed into the other by an act of will, which was always a moral decision.

I insert these observations to show that the question of choice of text is often obscured rather than illuminated by moral and ideological bias. The primary goal of an edition should, I think, be the pleasure of the reader. This is often influenced by changing fashions, and different readers have different pleasures. Nevertheless, a reader who wants to read Clare's less polished original or Byron's initial inspiration should not have to winkle it out of footnotes or endnotes in small print. (It is only honest to point out that it is generally the parsimony of publishers and not the dogmatism of editors that prevents a printed presentation that would give greater pleasure to more readers.)

The subject of which version of a classic text to print, however, seems to be a very touchy one, and this review provoked an irascible letter from Hugh Amory, one of the editors of the Wesleyan Edition of Henry Fielding, who oddly claimed that "Mr. Rosen's problem is that he wants definitive editions that print *only* original intentions." I quote a few passages of my reply to this controversy only to avoid any similar misapprehension:

At no point did I plead for "definitive editions that print *only* original intentions." On the contrary, what I wrote was that "for a small number [of works] the conflicting claims of different copy texts are so strong that all should be represented." . . . It is clear from the review that I thought this multiplication of versions a good thing. I did deplore the parsimonious habit of printing the more interesting versions as variant readings in small type at the back of the book, with the verse run together as prose. What I called an "imposture" for a critical edition was precisely the impression given

of a single, clean, definitive text in large type. Amory seems to have taken umbrage as if I had been calling his colleagues frauds and imposters. They do not need his defense, and I should be surprised if many of them welcome it.

I was interested in observing that, of a minority of works for which the most interesting version is the earliest one, a surprising number are to be found in the early nineteenth century. An editor of these texts who prints only what the author at the end of his life wished the public to see does both public and author a disservice.

Why does Amory think I represent myself "romantically . . . as a lone creative voice in a world of mechanicians" when I was celebrating the recent scholarship that has made so much new material available and, as I said, has transformed our view of Romantic style? His misinterpretation of my review is the kind that gives rise to cheap jibes about bibliographers being able to do anything with a text except read it. I should have welcomed a letter simply pointing out that the critical independence I expect from editors is more widespread than my review may have implied, and could have added the recent editions of Dickens and Hölderlin as examples.

Nevertheless, Amory is comically wrong when he claims that it is standard practice nowadays to print what the editor considers the most interesting version rather than simply the final one, and it is still less frequent to represent all significant versions adequately even in critical editions for which the publisher charges an unreasonably high price. Neither of the two critical editions of Baudelaire, for example, prints the first version of *Les Fleurs du mal,* although the order of the poems is very different from that of later editions (the first edition mixes the pictures of lower middle-class life with the more highfalutin poems instead of relegating them to a separate section): you can dig the order out of the variants, but you cannot read the poems in that order with any pleasure. The dead hand of "final intentions" still weighs upon editorial practice.

The Intense Inane: Religious Revival in English, French, and German Romanticism

M. K. Abrams, William Empson

For the young who lived through it, the French Revolution remained a vision of a lost paradise. Chateaubriand was twenty-one in 1789, an impoverished aristocrat forced into the hosiery trade by his debts (when he wrote his memoirs, he omitted this shameful descent into commerce); he never forgot the exhilaration of that dawn when it was "bliss . . . to be alive, / But to be young was very heaven." More than thirty years later, he wrote about the beginning of the revolution in Paris:

> Moments of crisis produce in men a heightening of life. In a society dissolving and reconstructing itself, the struggle of two spirits, the collision of past and future, the mixture of old and new ways of life, make up an unstable compound that leaves no place for boredom. Liberated passions and dispositions reveal themselves with an energy they do not have in a well-ordered polity. The infraction of laws, the freedom from duty, from custom and from propriety, even the perils increase the excitement of the disorder. The human race on holiday takes a walk in the

Originally written in 1973 as a review of M. H. Abrams, *Natural Supernaturalism: Tradition and Revolution in Romantic Literature* and William Empson and David Pirie, eds., *Coleridge's Verse: A Selection*.

streets, delivered from its preceptors, restored for a moment to the state of nature, and realizing again the necessity of social restraint only when under the yoke of the new tyrants engendered by license. . . .

I could not paint the society of 1789 and 1790 better than by comparing it to the architecture of the time of Louis XII and Francis I, when the Greek orders began to mingle with the gothic style, or rather by equating it with the collection of ruins and tombs of every century, piled up pell-mell after the Terror in the Cloister of the Augustinian Minors: but the fragments of which I speak were living and varied endlessly. . . .

. . . duels and love affairs, friendships born in prison and the fraternity of politics, mysterious rendezvous among the ruins under a serene sky amidst the peace and poetry of nature, walks apart, silent, solitary, mingled with eternal vows and indefinably tender sentiments, against the muffled din of a world that was vanishing away, against the distant noise of a crumbling society, whose collapse threatened these felicities overshadowed by the events.

In these words there sounds an enduring nostalgia. It is the tone we hear today in the voices of many who were present at the riots of May, 1968, in Paris. They claim the same sense of excitement, of genuine fraternity between strangers in the streets ("here and there a face / Or person singled out among the rest, / Yet still a stranger and belov'd as such"), of enhanced vitality, of energy as eternal delight. The myth of the revolution will die hard. In 1968 the state of nature lasted only a few weeks: in 1789–1790 the redoubled intensity of life burned far more than a year. The betrayal of the revolution was a traumatic blow to the generation that had lived through it and was young enough to hope. These hopes had spread throughout Europe: for the century that followed, the brief glimpse of the possibility of happiness "in the very world, which is the world of all of us," the brief appearance of what Hazlitt called "romantic generosity" dominated politics and art.

In this state of nature that appears unexpectedly at the moment of total corruption and final dissolution, there is a strange innocence, an innocence regained. The human race on holiday has no premonition of the terror that will follow license: for a brief moment, men and women have found once more the grace and

naiveté of the savage, of Adam before the Fall. The messianic program of the early Romantics,[1] a program in which politics and art cannot be separated or even distinguished, was to recapture and make permanent that state of nature which had proved to be so transitory.

After the failure, the betrayal even, of the political and social dream of 1789, the Romantic program presented itself in increasingly religious terms, with the Nazarene painters' revival of medieval imagery, the ecstatic cannibalism of Novalis's vision of Christ's sacrifice, the vocabulary of mysticism that reappears in the poetry of Wordsworth and Coleridge, and the fiercely irrationalist religious and political philosophy of Joseph DeMaistre. It would be a mistake to characterize the religious "revival" of the early nineteenth century as specifically antirevolutionary; the revival had already taken place within the heart of the revolutionary movement, when, under Robespierre, one could be imprisoned for speaking disrespectfully of the deity.

The revolution, in short, had already betrayed itself in reinstating God. The religious language of the early Romantic writers, however, has a curious and ambiguous significance. Two recent and important books touch on this problem: William Empson's selection of Coleridge's verse, in which perhaps the greatest of our critics attempts to rescue Coleridge from priestcraft, and M. H. Abrams's *Natural Supernaturalism,* published in 1971, which deals with the survival and transformation of religious patterns of thought in the Romantic period.

M. H. Abrams, whose *Mirror and the Lamp* is one of the most influential books on the early nineteenth century, is a master of

1. By "early Romantic" I mean simply the men who did most of their important work between 1795 and 1815: e.g., Blake, Wordsworth, and Coleridge in England; in Germany the poet Hölderlin, the philosopher Fichte, the critic and philologist Friedrich Schlegel, the poet and philosopher Novalis, the novelists Ludwig Tieck and E. T. A. Hoffmann (the last a half generation later than the others); and, in France, Chateaubriand and Sénancour, author of that bible of French Romanticism, *Obermann* (1804), and the novelist Benjamin Constant. Beyond the fact that certain statements can be made about all of them, I have not found it necessary to assume here that they formed a movement or created a style, nor shall I try to clarify the relations among them.

the themes of Romanticism. It is doubtful if anyone has surpassed, or that many have equaled, the range and depth of his reading. His point of departure in *Natural Supernaturalism* is Words-worth's scheme for the great unfinished poem called *The Recluse,* a poem which was to crown the poet's work and to which the rest of his verse was to stand as chapels to the main body of a cathedral.

From the "Prospectus" Wordsworth wrote for *The Recluse,* Abrams isolates the concept of the spiritual resurrection of mankind by the marriage of nature to the mind of man. For Wordsworth, mind or spirit here has become largely secular: God appears—if at all—only as *within* man's mind, and Abrams recalls a rich seventeenth-century tradition that resists any attempt to place God outside ourselves (the writings of Gerard Winstanley, the leader of a Digger community in Cromwell's time, are par-ticularly striking in their apparent similarity to Blake and Words-worth). The wedding of man and nature is seen by Abrams as achieving its full meaning as a manifestation of the millennium, a vision of the apocalypse secularized into revolution, but he char-acterizes this union with nature as a consolation and a substitute for the shattered revolutionary dream.

From here, Abrams is concerned chiefly with Romantic meta-phors of alienation—of man from nature, of man from himself. The marriage of nature to the mind of man is a metaphor for the overcoming of this inner and outer division. The most persistent metaphor Abrams finds is that of the "circuitous journey," the vision of a regained paradise, a return through alienation to an original state of "organic" unity, now made transcendent by incor-porating and resolving the contradictory forces of the journey itself. The circle is therefore generally a spiral, a return to the same point on a higher level. As the mature mind, in Wordsworth, returns to the child's unconscious acceptance of the world, now transformed by experience, so Hegel's spirit in reaching absolute consciousness attains the static condition, the complete repose of pure, undifferentiated, unalienated being. The juxtaposition of Hegel's *Phenomenology of Mind* with Wordsworth's *Prelude* is per-haps the most brilliant detail of Abrams's book.

The image of the circuitous journey is, indeed, pervasive and persistent. Abrams does not discuss Romantic natural science, but the metaphor has its power there as well. J. W. Ritter, a young scientist who discovered ultraviolet rays and belonged to the Jena circle of the Schlegels and Novalis, delivered a talk to the Munich Academy of Science in 1809 entitled "Physics as Art." He presented the original state of the earth as totally organic, and the present division into organic and inorganic matter as a late and degenerate condition. The earth has died, and the mineral veins of the earth are picturesquely the fossil remains of its former living skeleton. The task of physics is twofold: historical (the reconstruction of the decline into the present state) and apocalyptic (the retransformation of all matter into living organic form). Ritter was curiously enough both a serious scientist who did important work in galvanism and a brilliant, poetic, and erratic writer.

If anything, the image is too pervasive. It cannot be said to define Romantic thought if it characterizes so much else, including *Candide,* that masterpiece of the Enlightenment which is said to represent everything that Romanticism opposed. Like Wordsworth's *Prelude* and Goethe's *Wilhelm Meister, Candide* is a *Bildungsroman,* a novel of intellectual development and progress toward maturity, and the garden that Candide cultivates at the end is as much the earthly paradise—the Garden of Eden found again and transformed by experience—as any of Abrams's examples. It is also a "return": Constantinople is not Westphalia, but then Wordsworth's Grasmere is not Cockermouth; nevertheless, the little society of Thunder-ten-Tronckh is reconstituted. Doctor Pangloss philosophizes as before, and Candide is reunited with Cunégonde, grown ugly and ill-tempered but able to cook splendid pastry.

Are the patterns of Romantic thought, as Abrams believes, theological or even religious? These terms can be used loosely. Some years ago Carl Becker's *Heavenly City of the Eighteenth-Century Philosophers* found these same apocalyptic patterns in Voltaire and Helvétius. The influence of eschatology on Marx and of Old Testament morality on Freud are an essential part of the middle-brow

vulgarization of these authors. We should be accustomed by now to posthumous attempts to convert the heathen. Nevertheless, if these patterns are to be found wherever one looks (as Abrams finds them from Saint Augustine to Proust), it may be that they are forms deeper or more general than theology, which has used them—as have poetry and science—as part of a repertory of expression.

Abrams, however, has precedent for his view from the Romantics themselves. Wordsworth, for example, spoke easily of "such religious feelings as cannot but exist in the minds of those who affect atheism." This generous view of the meaning of "religious" is found often enough today, if only because the more precise and rigorous sense has come to seem unbearable to so many. But the significance of the early Romantics' use of religion can only be assessed if we measure it against each poet's relation to religion and morality proper—organized, established, or at least traditional.

The extent of the problem may be indicated by the following lines from Benjamin Constant's diary of 1804, when he was in Weimar with Mme. de Stael:

> Goethe: Difficulty of all conversation with him. What a pity that he has been caught up in the mystic philosophy of Germany. He confessed to me that the basis of this philosophy was Spinozism. Great idea that the mystic followers of Schelling have of Spinoza, but why try to bring in religious ideas and what is worse, Catholicism? They say that Catholicism is more poetical. "I would rather have Catholicism do evil," says Goethe, "than be prevented from using it to make my plays more interesting."

Goethe has still the grand cynicism of the eighteenth century; a few months later Constant notes about August Wilhelm Schlegel:

> . . . strange system of Schlegel who regrets a religion in which he does not believe, and who believes that one can remake a religion once it has fallen.

As for Friedrich Schlegel, he wrote, "To have religion is to live

poetically": the violent dislocation of the concepts of both religion and poetry is evident. Coleridge considered himself deeply religious, and called Wordsworth "at least a semi-atheist," whatever that may mean; but the dirtiest word in Coleridge's vocabulary was "priest," and he included in that category all Protestant (as well as Catholic) ministers who assumed the role of religious *authority.*

Most of the early Romantics came from conservative, Protestant, Pietistic families, from which they derived much of their language and imagery and their views of the world. Their magnification of the purely inward, personal elements in Pietism was turned not only against the "atheistic" Enlightenment—they were all deeply influenced by Hume and Voltaire—but against their own background as well. Their early reading in seventeenth-century mystics like Jakob Boehme provided them with ammunition in this battle on two fronts. The mystical philosophy of the seventeenth century had often been conceived as an attack on organized religion and even as part of a program of social and economic reform. (For example, Winstanley's refusal to accept any Christ outside the inward Christ that was in each man's heart was inextricably bound up with his revolutionary movement to seize the common land of England and turn it over to the poor.) Abrams is right to maintain that the Romantic poets' need of a theological vocabulary was independent of their religious creed or lack of one, but the meaning of that vocabulary cannot be understood except through its relation to organized religion and society.

Empson, on the other hand, is very much concerned with Coleridge's social and religious thought, above all with the changes that his religious creed underwent during his lifetime. Empson is a large-spirited critic, and it pains him to see his poet gradually succumb to the horrors of orthodoxy. To restore Coleridge to himself, Empson and his co-editor, David Pirie, have rewritten the *Ancient Mariner.* Except at one place, they have not actually changed any of Coleridge's words, but they have produced a text

that does not look precisely like any of the different versions that Coleridge published. In a way, this serves Coleridge right: he had himself proposed a selection of the great English poets rewritten by himself as a great improvement over the originals; and when he was asked to translate Goethe's *Faust*, he considered whether he should remodel it, adding that it would be even "more easy to compose the whole anew."

Empson and Pirie have divided the changes that Coleridge made to his poem of 1798 into two parts: those that merely refine and clarify the original conception, and those that seriously alter it, and even conceal it behind a smoke screen of Christian allegory. In other words, for Empson, Coleridge afterward "ratted on the poem" and tried to pretend that it was about something else, just as he spent the later part of his life insisting that he had never been a "Jacobin" revolutionary. There are, indeed, serious cuts in the 1800 version of the poem, and the marginal glosses of 1817 give an interpretation based on sin and redemption through suffering that is gravely at odds with the text of 1798. Empson believes that redemption by torture is wicked, and that for God to redeem the human race by torturing His son is even more shockingly wicked; the Coleridge of 1798 and even later was enthusiastically and courageously of the same opinion and risked his career and his livelihood for this belief.

Empson and Pirie's treatment of the text may be high-handed, but any edition with variant readings invites every reader to form just such a text for himself. In their great edition of the *Prelude*, de Sélincourt and Darbishire called upon the reader to form his "ideal text" from the material they provided. However, it is not, strictly speaking, the "ideal" text that Empson and Pirie seek, but the one truest to the original idea of the poem.

Their search implies an idealistic (and Romantic) view of literature in which none of the various stages of the text is the poem itself, but only approaches to it. This is indeed the only coherent view that permits genuinely interpretative criticism. (Only a sacred text cannot be otherwise than it is, and when the form has become totally rigid, the meaning becomes unattainable—i.e. untranslat-

able and unparaphrasable—and the possibility of interpretation is either zero [the text is a magic formula] or multiplies uncontrollably.) The poem is the idea (Coleridge would have put a capital I) which the text seeks to realize, and which the text may therefore betray and falsify as well as reveal.

This idea of the poem is placed by Empson squarely in the poet's mind, and he equates it with the poet's intention, which is partially misleading. Coleridge knew better when he put the capital I: the poet's intention is itself only an approach to the idea.[2] Empson has (in an earlier essay[3] on the *Ancient Mariner*) exploded his own position with an irresistible joke about "four times fifty living men . . . , They dropped down one by one," when he wrote, "I do not believe that there were two hundred of them; Coleridge or the Mariner invents this number to heighten the drama of their all dying at once." As usual Empson is right, four times fifty is clearly an exaggeration, and it is impossible and irrelevant to decide whether the author or the poem is inflating the figure.

Empson treats Coleridge's betrayal of his poetry with generosity and sympathy, and he is wonderfully free of the pious moral airs expressed by recent critics faced with Coleridge's weaknesses. Opium, cowardice, plagiarism, and procrastination make a formidable array, but they seem to have touched Coleridge's nobility of spirit very little in the end. For Empson, indeed, the theme of the *Ancient Mariner* is the very reason that Coleridge betrayed the poem and tried to convince his readers and himself that it was about something else. The theme is a sense of guilt and revulsion from life greater than any possible motivation. The disparity between the shooting of the albatross and the subsequent horrors

2. The poet's understanding of his inspiration is not privileged: this is perhaps the oldest critical tradition we have, going back to Plato. For Plato, the poet was the last man to be able to explain his own work. This paradox was already understood then as a hard nut to crack, but essential to literature. But Empson is right to claim what we can reconstruct of the poet's intention as evidence for the meaning of his work. For all Empson's sniping at the Intentional Fallacy (which means largely that the main evidence for the meaning of a poem is the text, whatever the poet may have had in mind), he has a conception of intention grand enough to accommodate any theory of interpretation.

3. *The Critical Quarterly*, 1964.

visited upon the Mariner and the crew is the most terrifying aspect of the poem.

When the Mariner is able for a moment to conquer his disgust for the slimy creatures of the deep and to bless them, it is not true that "at once the terrible spell snaps," as Abrams writes in the wake of the majority of critics. The relief is only temporary when the albatross hung round his neck slides off into the sea and the Mariner is able to pray. Greater penance is still to be exacted from the Mariner, as Empson points out, and even more terrible horrors are to appear. There is never, in fact, any final release: the Mariner is condemned to tell his story obsessively over and over again without obtaining absolution. The poem affirms ambiguously the love that should unite all creatures of the universe and the irrational terror of being unable to sustain and meet that love. Almost as much as anything else, the *Ancient Mariner* warns us of the awesome consequences of religious guilt, and it is in this sense a deeply antireligious poem.

The religious imagery and language of the *Ancient Mariner* are, of course, essential and even obsessive. But Abrams stands things on their heads when he writes:

> The *Ancient Mariner* is neither an allegorical fable nor a symbolist poem. The persistent religious and moral allusions, however, both in the text and in the glosses which Coleridge added to assist the bewildered readers of the first unpublished version, invite us to take the Mariner's experience as an instance of the Christian plot of moral error, the discipline of suffering, and a consequent change of heart.

The Christian plot is not an inward meaning, it is the outer shell. The poem uses religious semi-Christian, semi-pagan narrative patterns openly, and invites us to read into them feelings of a different order. As Coleridge himself wrote about the poem, he treated the supernatural characters "so as to transfer from our inward nature a human interest and a semblance of truth sufficient to procure for these shadows of imagination that willing suspension of disbelief for the moment which constitutes poetic faith."[4] It is to

Coleridge's conception of "our inward nature" that the reader's attention is drawn, and to this end the religious images are drained of their specifically religious content and filled with something new.

⁓⁀⁀

This is the process of secularization with which Abrams's book deals, and he is deeply aware of its presence without, however, being able to elucidate its action. That is because he appears to claim for his theological forms and images a fundamental and inalterable meaning—a significance which remains constant even when they are reformulated in radically different contexts. What the Romantics discovered, however, was the possibility of stripping forms of their original significance and of giving them a new sense almost diametrically opposed to the original (as Tieck, for example, begins a play with the epilogue).

What they looked for was the tension between the new meaning and the inevitable residue of the old. This was the tension that enabled the Romantics to carry out their program of reconceiving art and literature as a dynamic and endless process that was to reach a static and resolved form only at the point of infinity. For "point of infinity" read "God," and for "God"—as far as that word was given a specific meaning by the Romantics—read nothing more than the immediate use that each writer might have at the moment for Him: the resolution of the dynamic process of life, the realm of the unconscious and the unknowable, humanity realizing itself as absolute Mind, and so forth. In this way, Hegel can be an atheist who talks freely about God and identifies Christ not with Jesus but with Napoleon-Hegel. This free use of language enables Wordsworth to change his religious beliefs over the years without finding the need to alter their expression except in minor details.

The fundamental importance of Spinoza for this period provides an example of these shifts of meaning. For most of the eighteenth century Spinoza was simply an atheist. If you were accused of athe-

4. *Biographica Literaria*, Chapter XIV.

ism yourself (as Pierre Bayle and Voltaire were), you could always set up a splendid smoke screen with a violent attack on Spinoza. The break came in 1785 when the German philosopher Jacobi disclosed the great critic Lessing's secret Spinozism. By the last decade of the century, Spinoza had completely changed from an atheist to a "God-intoxicated" philosopher, and it is a question who had been converted, Spinoza or God. To some extent, the religious revival was only a further secularization.

Abrams, nevertheless, views the Romantic movement as a rescue operation, an attempt to salvage the debris of religion torn apart by science and the Enlightenment, to conserve the lost values of religion while giving them an acceptably secular form. "Much of what distinguishes writers I call 'Romantic' derives from the fact that they undertook, whatever their religious creed or lack of creed, to save traditional concepts, schemes and values which had been based on the relation of the Creator to his creature and creation,[5] but to reformulate them within the prevailing two-term system of subject and object, ego and non-ego, the human mind or consciousness and its transactions with nature." But if writers from Goethe to Proust used theological values to save them, what are we to make of the beautiful quotation from Proudhon that Abrams cites?

[I am] forced to proceed as a materialist, that is to say, by observation and experience, and to conclude in the language of a believer, because there exists no other; not knowing whether my formulas, theological despite myself, ought to be taken as literal or figurative. . . .

(The theological formulas have here been reduced to the status of nouns and verbs, and the process by which they were so neutralized is one of the most revolutionary in the history of style.)

The Romantics inclined often enough to Abrams's view of their work, but what they performed was more often than not a whole-

5. One of the dogmas of Christianity that Wordsworth disliked most of all was that God created the universe. At least, he felt that one shouldn't talk about it, probably because it was the only thing about God that Voltaire believed.

sale act of seizure and destruction. Blake's little child contrasts the warm ale-house with the cold church, and says:

> But if at the church they would give us some ale
> And a pleasant fire our souls to regale, . . .

The word "soul" has been almost totally expropriated in order to affirm its absolute identity with the body: yet the meaning of "soul" depended traditionally upon a radical opposition with the body. Blake is not conserving a traditional theological concept but destroying one that his hated many-headed monster, Voltaire-Newton-Gibbon, had been powerless to touch. It cannot be said that Novalis, Hölderlin, and Wordsworth (at least before 1807) were less radical than Blake.

The belief that an earlier concept can remain essentially unchanged in a later reformulation of it is the original sin of the history of ideas. It is especially unfortunate as an approach to the early Romantics, who were the first to insist so fully upon the inseparability of thought and expression. (Language and thought, said Friedrich Schlegel, must in theory be distinguished, but in practice we can only do so when one of them malfunctions.)

Abrams *expounds* ideas in Romantic poetry that lose all vitality when reduced to plain prose that cats and dogs can read. He outlines the concepts of alienation and reconciliation with nature as they were derived from a long theological tradition by Wordsworth and Coleridge, which he believes still useful today, and adds: "These ideas are shared in our time by theologians, philosophers, economists, sociologists, psychologists, writers, critics and readers of *Life* magazine and the *Readers Digest*. . . ." What a crew! Abrams's tone is ironic, but the irony is sadly aimed at the rejection of ideas so universally admired instead of at the reduction of Wordsworth, and us, to so common a denominator.

However vulgar the romantic notion of alienation could become, it was not that of the popular twentieth-century evangelist —and I do not mean to imply that Abrams does not know this, but only that his thesis of Saint Augustine, Wordsworth, and the bereft readers of *Life* reaching out to each other over the ages

will not permit him to express it. Alienation played a large role in Romantic thought and it is finally expanded so far as to destroy itself. From Rousseau the early Romantics inherited the idea that self-consciousness is a disease, an alienation of oneself from oneself, a loss of unity. This view of self-reflection was most powerfully delineated in 1794 by Fichte, who influenced all the German and (through Coleridge) the English writers of the turn of the century. As Abrams points out, they regarded "philosophical reflection, the very act of taking thought, . . . as in itself, in Schelling's words, 'a spiritual sickness.' "

This division of the self is, indeed, a fall from grace; the act of reflection is the knowledge of good and evil. But Abrams does not carry it far enough. For Fichte, the ego (the self) does not *exist* except as the act of self-alienation, and comes into being only at the moment of the act. I can be myself only in so far as I am aware of myself as something distinct from the totally subjective, only as my own mind takes a part of itself as an object; otherwise there is no "I." The Fall from grace continuously re-enacted at every moment is the condition of life. Alienation, for Fichte and for Coleridge, is synonymous with existence.

When the concept of alienation is expanded illimitably—is made *absolute*, to use the Romantic term, then the status of the impulse to heal the division, to integrate the ego with itself and with Nature, is threatened. If alienation can be seen as existence itself —the continuous effort to be what one is, to affirm the "I" as distinct from everything else, integration becomes death. In E. T. A. Hoffmann's *Princess Brambilla*,[6] there is a ministerial council meeting at which the treasury of wit is to be replenished for a time of need. The king makes his contribution: "The moment in which a man dies is the first in which his true ego arises," and he drops dead at once.

This is the ambiguity at the heart of the "circuitous journey";

6. See the comment on this passage by Paul de Man, "The Rhetoric of Temporality," in *Interpretation, Theory and Practice*, Charles S. Singleton, ed. (Johns Hopkins University Press, 1969).

the lost paradise regained is death. Abrams interprets the end of Hölderlin's *Hyperion* as a renewal of joy and life. When the hero gives himself up to Nature after his defeat, his rejection by his father, and the death of his love, that is indeed how Hyperion himself appears to present it. Yet his reconciliation with nature and his new-found joy have a secret and bitter despair:

> And yet once more I looked into the cold night of men and shud-dered, and wept for joy that I was so blessed, and I spoke words, it seemed to me, but they were like the rushing sound of a fire that flares up and leaves ashes behind.

As Geoffrey Hartman has recently written about a similar identi-fication of the self with Nature by Coleridge: "Nothing is lost by this sublimation except all."[7] Abrams recognizes in *Hyperion* the inevitable return of alienation after this "renewal," but in trying to impose on it his theological doctrine of redemption and res-urrection,[8] he does not see that the resurrection itself is a new form of death.

Abrams also omits as irrelevant all mention of the explicitly ironic Romantics like Byron and E. T. A. Hoffmann; but their comic sense is not an aberration from the Romantic tradition but an illumination of patterns implicit in Hölderlin and Wordsworth. Hoffmann's ebullient and fatuous young cat Murr shows how "alienation" can be made to signify almost anything one wants. When he meets his long-lost mother ("come to my paws," she cries) he goes to get her a herring-head he has hidden after dinner. On the way back he gets hungry, but relates this pedantically in the language of Romantic idealistic philosophy: "My ego was alienated from my ego in a strange way so as to remain still my ego and I ate the herring-head."

7. "Reflections on the Evening Star," in *New Perspectives on Coleridge and Wordsworth*, Geoffrey Hartman, ed. (Columbia University Press, 1972).

8. Readers are warned by Hölderlin in a preface that if they reads the book for the doctrine they will not understand it.

Alienation is here the instinct for life. In the ironic movement necessary to Romantic art—to Wordsworth as to Byron, to Novalis as to Hoffmann—the "suspension of disbelief" is never a completed act of integration. We accept the supernatural without believing it, we allow what is strange to keep its alien identity, "a stranger and belov'd as such." It is not unity and reintegration, not the return to the lost paradise that is sought, but division and estrangement. In fact the early Romantics conceived the act of poetry as essentially a technique of alienation: for Novalis, it is the power of making the familiar distant and strange; for Coleridge, the "power of giving the interest of novelty by the modifying colors of the imagination."

The uncontrolled expansion of concepts until they referred potentially to everything and therefore to nothing so that their powers of association were completely liberated and magnified was a process repeated until it could seem like a vulgar and maddening trick. "Irony is the form of paradox. Paradox is everything that is both good and great" (Friedrich Schlegel), "Thinking is speaking. Speaking and doing or making are only modifications of one and the same operation" (Novalis), "Truth is Beauty, Beauty Truth" (Keats)—examples are numberless. This technique of expansion contributed to the instability of meaning that made Byron compare the philosophy of August Wilhelm Schlegel to a rosy and agreeable mist cast over everything. But it is a trick based upon a profound comprehension of speech, a realization that there is no possibility of authentic and direct communication without some looseness, some play in the mechanism of language.

This new freedom in the use of meaning is the revolutionary achievement of the early Romantic generation, the men who turned twenty at the time of the French Revolution. "The situation is overripe and stinking and needs to be shaken up," the great linguist and philologist Wilhelm von Humboldt wrote about the contemporary state of poetry, and he tentatively praised the efforts of the Schlegels and Novalis to revolutionize art. "I do not like what they are doing . . . but they are the only hope we have." For Hazlitt, the poetry of Wordsworth and Coleridge was the literary

analogue to the French Revolution,[9] and he remarked in an amusing image that the infrequency of personification in the poetry of the new school compared with that of Pope and Johnson was a reluctance to bestow the undemocratic dignity of a capital letter.

The newly released power of association created by the whole or partial destruction of the central meaning of words made possible the nonsense verse of *Kubla Khan* and the late poems of Novalis. Empson convincingly says that *Kubla Khan* is about the role of the artist as conqueror, as spokesman for the unconscious desires of his society. But Empson oddly refuses to see the importance of presenting this theme as if it were a vision, as a kind of involuntary nonsense. Coleridge was not, as Empson claims, pretending that he did not know what the poem was about when he added his introductory explanation of the interrupted attempt to write down his dream. *Kubla Khan* is the great Romantic example of the fragment, the created ruin, and the "person on business from Porlock" who broke into Coleridge's inspiration is an essential part of the work. Coleridge's achievement is like a realization of Novalis's contemporary program for writing poems and stories "without sense or logic, but only with associations like dreams or music."

What then was the use of religious frames of thought to men who could be atheists or, like Coleridge when he wrote his great poems, so little a Christian that he refused to accept even Unitarian doctrine? Why did they persist in using religious terms which they often rendered so vague as to accommodate any meaning? A letter of 1803 by Wilhelm von Humboldt may suggest an answer. He wrote about the interrelationship, the "belonging-together" of all intellectual beings, not in a single totality but in

> a unity in which all concept of number, all opposition of unity and multiplicity disappears. To call this unity God would be absurd, I find, as it throws it outside of the self for no good reason.

9. Hazlitt saw this aspect of the poem more clearly than Empson when he said that he could repeat certain lines of *Kubla Khan* forever with delight without knowing what they meant.

This unity which itself swallows up the concept of unity is an explicit image of infinity. Humboldt settles for calling this infinity "Humanity" instead of "God" after rejecting "Universe," "World," and "World-Soul." (It is extraordinary how he could try out different words as if they were hats.) Most of the Romantics called it "God" without hesitation. The fund of religious imagery and concepts provided a copious (and, at worst, a cheap) source of "innumerable analogies and types of infinity."

This is Wordsworth's phrase for the fundamental virtue of Romantic style; in another place, where he explains the significance of his images, he calls them the "types and symbols of eternity." It is for his generation the basic figure of speech, or, better, figure of thought, since the old rules of rhetoric had been dissolved in a more generalized and fluid concept of language. *Type* and *symbol* (or *analogy*) are not synonymous for Wordsworth: although *type* had still the old meaning of "emblem" or "symbol," it already meant example or model.[10] Images like

> The immeasurable height
> Of woods decaying, never to be decay'd,
> The stationary blasts of waterfalls

are both examples (metonymies) of eternity and metaphors for the secret invariance at the heart of constant mutability. They are therefore examples of what they themselves signify by analogy, embodying that contradiction that Coleridge saw as essential to every symbol, which "partakes of the reality which it renders intelligible . . . abides itself as a living part in that unity of which it is the representative." Such types and symbols of eternity are like the

> . . . Yew tree, pride of Lorton Vale,
> Which to this day stands single, in the midst
> Of its own darkness

10. In spite of the OED, which dates this use much later, English-French glossaries give the meaning "example" as early as 1815. Wordsworth generally uses "type" as an element in a pair ("types and symbols," "type or emblem"), and it is kinder to him to believe it is not always a tautology.

These types of infinity are images of freedom. The early Romantic's battle against atheism was essentially against the new authoritarian, religious tyranny of mechanistic thought. The Infinite was a medium in which the imagination could allow for the free expansion of associations, dreams, music—all that the calculating mind held senseless. Yet the early Romantic Infinite is illuminated by the light of common day. As the French émigré Étienne de Sénancour wrote in 1804:[11]

> Love is condemned as a completely sensual affection, having no other principle than an appetite that is called gross. But I see nothing in our more complicated desires of which the true end is not one of the primary physical needs: sentiment is only their indirect expression: Intellectual Man was never anything else than a phantom. Our needs awaken in us the perception of their positive object, *as well as the innumerable perceptions which are analogous to them.* The direct means would not fill life by themselves, but these accessory impulses occupy it fully, *because they have no limits.*

The metaphorical activity (the "analogous perceptions") is life itself and cannot be limited or fully determined: the medium of its action is God, to employ the Romantic significance of this much used word. It is in this medium that the individual ego which is only an abstraction rejoins the unconscious and the involuntary that the poets realized they had to master. To this end they abandoned a specific and limited kind of control over meaning to look for a more efficient way of commanding the marginal phenomena of significance that the eighteenth century had appeared to renounce.

That God is the unconscious of humanity is explicit in Wordsworth (although we must be careful not to read back into him Freudian or Jungian meanings). In some lines, unpublished until 1925, he dismisses both passive and active forms of consciousness:[12]

Such consciousnesses seemed but accidents
Relapses from the one interior life

11. *Obermann,* eighth year, Letter LXIII.
12. *The Prelude,* Ernest de Sélincourt and Helen Darbishire, eds. (Oxford University Press, second ed., 1959), p. 535.

> In which all beings live with god, themselves
> Are god, existing in the mighty whole
> As indistinguishable as the cloudless east
> Is from the cloudless west, when all
> The hemisphere is one cerulean blue.

Wordsworth never printed these daring lines written when he was producing his finest poetry: perhaps he would not have subscribed to them some years later. In these lines, the ego is dissolved in the interior life, which is in no sense an individual unconscious: it is the interior life of all beings, and God is here an image of fraternity as well as liberty.

These images of infinity had therefore a political significance as well. When the ideals of the revolution were corrupted, the political vocabulary became corrupt too: to use it without irony was to support betrayal on every front. The vocabulary of mysticism and religion offered refuge, but only briefly. The old traditional meanings soon returned. By 1810 most of the early Romantic writers had abandoned their mixture of free-thinking and mysticism and moved toward orthodoxy.

This is, no doubt, a coarse view of a history that needs more caution, greater reserve: it is offered as a corrective to a portrayal of the early Romantics as hopeful and optimistic. Their poetry is the greatest poetry of despair that survives today, the greatest because entirely untouched by resignation. The messianic revolutionary ideals are kept alive in the hyperbolic language of mysticism because they had been proven hopeless to a generation that refused to accept their final defeat. Not until the 1830s did one find the poignant and melancholy resignation of Tennyson or the magnificent and fatuous optimism of Hugo. The writing of the early Romantics could be sustained for only a brief time; they died young like Novalis, lost courage like Coleridge and Wordsworth, went made like Hölderlin, or became apologists of the most reactionary regime in Europe like Friedrich Schlegel. The fundamental aesthetic doctrine of the Romantics is an identity of work and life: their failure is already acted out within their poetry.

Separating Life and Art: Romantic Documents, Romantic Punctuation

Gustave Flaubert, George Gordon Byron

Writing to his exasperated and exasperating mistress, Louise Colet, the twenty-five-year-old Flaubert makes a sharp distinction between his taste in art and life:

> . . autant j'aime dans l'art les amours désordonnées, et les passions hurlantes, autant me plaisent dans la pratique les amitiés voluptueuses et les galanteries sentimentales. Que tu trouves ça rococo ou ignoble, c'est possible. Avec de l'ardeur il y a moyen que ce ne soit pas ennuyeux, avec du coeur que ce ne soit pas sale. (To Louise Colet, February 27, 1847, p. 443)

> . . . as much as I want in art disordered loves and howling passions, just so much in practice do I like sensual friendships and sentimental affairs. You may find this rococo or ignoble. With some warmth it does not have to be boring: with some heart, it does not have to be dirty.

This separation between art and life is made to order for keeping Louise Colet at bay. Elsewhere, and a few years later, Flaubert makes the distinction more definitive:

Originally written in 1975 as a review of Jean Bruneau, ed., *Flaubert: Correspondence, Tome I, 1830–1851* and Leslie A. Marchand, ed., *Byron's Letters and Journals*, vols. 1–3.

Quand on veut, petit ou grand, se mêler des oeuvres du bon Dieu, il faut commencer, rien que sous le rapport de l'hygiène, par se mettre dans une position à n'en être pas la dupe. Tu peindras le vin, l'amour, les femmes, la gloire, à condition, mon bonhomme, que tu ne seras ni ivrogne, ni amant, ni mari, ni tourlourou. Mêlé à la vie, on la voit mal, on en souffre ou en jouit trop. L'artiste, selon moi, est une monstruosité,—quelque chose de hors nature. (To his mother, December 15, 1850, p. 720)

When one wants, small or great, to meddle with the works of God, one must start, if only for hygienic reasons, by finding a vantage point from which one cannot be fooled. You can paint wine, love, women, glory only if you yourself, old fellow, are not a drunkard, nor a lover, nor a husband, nor a soldier boy. Involved in life, we see it badly, suffer or enjoy it too much. The artist, as I believe, is a monstrosity—something outside nature.

Posterity has played tricks with Flaubert's distinction: many of his admirers today consider the greatest of his masterpieces to be his letters, entangled in his immediate affairs and innocent of the single-minded purity of line and form that he worked so hard to impose on his novels.

The editor of the new edition of the correspondence (of which the first volume has recently [1973] appeared), Jean Bruneau, wishes to put things back in their proper categories, to restore the barrier between life and art. He makes, however, a curious but revealing slip. Flaubert, he claims, would have been dismayed by our view of his correspondence as a work of art. We may converse with Flaubert, through his letters, as Flaubert himself conversed with the *Essays* of Montaigne, but—Bruneau adds—there is a fundamental difference: the *Essays* of Montaigne are a work of art, and the correspondence of Flaubert is not.

Montaigne, however, would have been equally dismayed by this judgment. He preferred to draw the line between art and nature quite differently, although he was perhaps the first writer who fully understood that the line was indefinitely displaceable. If habit was second nature, he observed, perhaps nature was only first habit.

To view the *Essays* as art is perfectly legitimate, of course, the post-humous consternation of the writer notwithstanding. Like the letters of Flaubert, the essays of Montaigne have altered in their function as the years have passed. The aesthetic form of Flaubert's correspondence, too, is now there for everyone to see.

In the worst sense, first of all. There is a lot of fancy artistic writing in the letters of a kind that Flaubert disdained to admit even to the early versions of the *Temptation of Saint Anthony*. In a letter to Louise Colet, we find:

> Voilà l'hiver, la pluie tombe, mon feu brûle, voilà la saison des longues heures renfermées. Vont venir les soirées silencieuses passées à la lueur de la lampe à regarder le bois brûler et à entendre le vent souffler. Adieu les larges clairs de lune sur les gazons verts et les nuits bleues toutes mouchetées d'étoiles. Adieu ma toute chérie, je t'embrasse de toute mon âme. (September 28, 1846, p. 368)

> Winter is here, the rain is falling, my fire burns, this is the season of long, indoor hours. Now are to come the silent evenings when, by lamplight, we watch the wood burn and hear the wind blow. Farewell to the large patches of moonlight on the green lawns, to the blue nights flecked with stars. Farewell, my darling, I kiss you with all my heart.

Probably he assumed she would like this kind of purple style: perhaps he even thought she deserved it. There are not many such passages, but they were evidently a kind of release to the young Flaubert.

The significance of these rare passages is more complex, however, and central to Flaubert's philosophy:

> Encore maintenant ce que j'aime par-dessus tout c'est la forme, pourvu qu'elle soit belle, et rien au-delà. Les femmes qui ont le coeur trop ardent et l'esprit trop exclusif ne comprennent pas cette religion de la beauté abstraction faite du sentiment. Il leur faut toujours une cause, un but. Moi j'admire autant le clinquant que l'or. La poésie du clinquant est même supérieure en ce qu'elle est triste. (To Louise Colet, August 6 or 7, 1846, p. 278)

> Even now what I love most of all is form, provided it be beautiful and nothing more. Women, their hearts too passionate and their minds too exclusive, do not understand this religion of beauty with the sentiment removed. They always want a cause, a purpose. I myself admire tinsel as much as gold. The poetry of tinsel is even superior in that it is sad.

We arrive here at the frontiers of the grotesque. The sadness of the poetry of tinsel paradoxically brings back the sentiment that has been abstracted from the religion of beauty, and returns the sense of life to the beautiful forms, from which it was banished by Flaubert's touchingly puerile ideal of aesthetic purity. Nevertheless, the sadness can come into being only as a measure of the distance of art from life.

For the early Romantics, even for Hugo, the grotesque was the eruption of life into art, the refusal to admit a separate sphere for art in which it could impose its own standards. For Flaubert, it has become a means of isolating art, of removing the possibility of "a cause, a purpose" for art. The Romantic tradition has begun to turn sour for Flaubert, and the tensions between literature and life have grown more difficult to control.

Tinsel becomes here the symbol of his art not only because it has no practical value, but no cultural value as well. The poetry of tinsel resists all the demands of morality, culture, and the ordinary commerce of life; its sadness is a function of its purity and its isolation. Protected by its barrier of grotesque bad taste, it can withstand all other pretensions.

For Flaubert, the grotesque is not, therefore, the natural monsters (dwarfs and gargoyles) of E. T. A. Hoffmann and Victor Hugo that testify to the irrepressible creative forces of reality which can never be contained by the rules of classical art: it is rather the simple ordinary human act drained of all sense, of all cultural meaning. Flaubert hangs on the wall Callot's etching of the *Temptation of Saint Anthony,* a work he loved and wanted to own for a long time, and writes to Louise Colet:

Le grotesque triste a pour moi un charme inouï. Il correspond aux besoins intimes de ma nature buffonnement amère. Il ne me fait pas rire mais rêver longuement. Je le saisis bien partout où il se trouve et comme je le porte en moi ainsi que tout le monde voilà pourquoi j'aime à m'analyser. C'est une étude qui m'amuse. Ce qui m'empêche de me prendre au sérieux, quoique j'aie l'esprit assez grave, c'est que je me trouve très ridicule, non pas de ce ridicule relatif qui est le comique théâtral, mais de ce ridicule intrinsèque à la vie humaine elle-même et qui ressort de l'action le plus simple, ou du geste le plus ordinaire. Jamais par exemple je ne me fais la barbe sans rire, tant ça me paraît bête. (August 21–22, 1846, pp. 307–308)

The sad grotesque has an extraordinary charm for me; it corresponds to the inner needs of my clownishly bitter nature. It does not make me laugh but dream at great length. I seize it wherever it is found and as I carry it within me as everyone does, that is why I love to analyze myself. The study amuses me. What prevents me from taking myself seriously in spite of a solemn temperament is that I find myself quite absurd, not with that relative absurdity which is the theatrically comic, but with that intrinsic absurdity of human life itself that appears in the simplest action or the most ordinary gesture. For example I never shave without laughing, as it seems so idiotic to me.

This conception of the grotesque transforms it from the counterweight to classical beauty into the guarantor of classical perfection. The beauty of Flaubert's art appears above all when the subject is understood as absurd, senseless, drained of meaning: the beauty can then be perceived free from all other pressures. In his last novel, the two clerks, Bouvard and Pécuchet, create a wonderfully eclectic garden out of their studies of landscaping, one of their many attempts to understand culture: the center of it is a romantically shaped rock, laboriously pieced together with cement, which rises "like a gigantic potato." They invite their friends to dinner; with the champagne they open the curtains of the salon, and reveal the garden:

> C'était, dans le crépuscule, quelque chose d'effrayant. Le rocher, comme une montagne, occupait le gazon, le tombeau faisait un cube au milieu des épinards, le pont venitien un accent circonflexe par-dessus les haricots, et la cabane, au delà, une grande tache noire, car ils avaient incendié son toit de paille pour la rendre plus poétique.

> It was, in the twilight, something frightening. The rock dominated the lawn like a mountain, the tomb made a cube in the middle of the spinach, the Venetian bridge a circumflex accent over the beans, and the rustic hut, beyond, a large black blot, as they had burned its thatch to make it more poetic.

The perfection of Flaubert's cadences, their relentless and untranslatable beauty, is not in contrast to the absurdity of the scene but indifferent to it; the beauty is, if at all, only intermittently ironic as these cadences are spread indiscriminately over everything. All human activity is equally senseless, a kind of neutral material apt without exception for transformation into art.

This transformation into art is not for Flaubert a special human activity, privileged unlike any other. The separation of art and life breaks down totally here; Flaubert is emphatic:

> J'écris pour moi, pour moi seul comme je fume et comme je dors.—C'est une fonction presque animale tant elle est personnelle et intime. Je n'ai rien en vue quand je fais quelque chose, que la réalisation de l'Idée, et il me semble que mon oeuvre perdrait même tout son *sens* à être publiée. (To Louise Colet, August 16, 1847, p. 467)

> I write for myself, only for myself as I smoke and sleep.—It is an almost animal function, to such an extent is it personal and intimate. I have nothing in view when I make something except the realization of the Idea, and it seems to me that my work would lose all its *meaning* on being published.

The last claim is no doubt the bravado of the shy young writer, but it takes a curious form which calls upon the Romantic concept of the work of art as a purely personal document unintelligible to anyone except the author. The artist—that monster outside

nature, according to Flaubert—produces his work as a product so absolutely natural that it cannot rise to the level of artifice, but must stay within the sphere of the totally subjective understanding.

The fundamental paradox appears only when Flaubert claims for this "subjective" product an almost scientific objectivity—a claim he was never to abandon for the rest of his life. What he portrayed was given to the reader *exactly as it really was* by means of the dispassionate beauty of the style: the Commune of 1871, he said, would never have happened if his novel about the revolution of 1848, *L'Éducation sentimentale,* had been read and understood. Flaubert intended this work, and the other novels as well, to have the status of a historical document, an accurate and impartial witness to an objective reality.

This scientific accuracy, however, is attained subjectively through the intensity of the imagination:

> Ton histoire de forçat m'a ému jusqu'à la moélle des os. Et hier, toute la journée, j'y ai rêvé avec une telle intensité que j'ai repassé pas à pas par toute sa vie. Peut-être l'ai-je reconstruite telle qu'elle s'est passée (ainsi qu'il m'est arrivé de tomber juste en écrivant un chapitre d'entregent, comme on disait jadis, dialogues et poses, et avec une fidélité si exacte, quoique je n'avais rien vu de pareil, qu'un ami a failli s'en évanouir à la lecture, car il se trouvait que c'était son histoire). (To Louise Colet, July 14, 1847, p. 461)

> (Your story of the convict moved me to the marrow. And yesterday, all day, I dreamed about it with such intensity that I went step by step over his whole life. Perhaps I have reconstructed it such as it took place (as it happened to me to get it right when I wrote a chapter of "social grace,"[1] as one said of old, dialogues and poses, and with a fidelity so exact, although I had never seen anything of the sort, that a friend almost fainted on reading it, for it turned out to be what had happened to him).

The work of art becomes a real object, scientifically exact, because of the power of the dream-work that has gone into its creation.

1. Flaubert may be alluding to the pun in *Le Moyen de Parvenir* made on *entregent* (between people; tact, social manners), and *"entrejambes"* (between legs).

"*Madame Bovary, c'est moi*" (Madame Bovary is myself), as Flaubert proclaimed many years later, does not mean that he put himself into the work (although he did), but that he could only create her by forcing himself to become her to the point of imaginative identity. Flaubert's novels reconstruct the deterministically ordered chain of events of history: the intensity of thought and the precision of the style validate the scientific pretensions.

Madame Bovary starts with little Charles Bovary's hat, that crazy artifact as eclectic as the garden of Bouvard and Pécuchet. We, his school-fellows (the only narrative use of the first person in the book), greeted the new boy and his silly hat with howls of laughter. "We" are the determining forces of society: from this moment, Charles Bovary's nature—his timidity, indecision, lack of character—is fixed and the suicide many years later of his wife inexorably preordained. The theory of history may seem naïve, but its purity makes it still almost as attractive today as it was in the nineteenth century. The hat of Charles Bovary stakes the claim of the novel to absolute conformity to things as they are, the artist's claim of dreaming the scientific truth.

The novels of Flaubert—all of them—demand to be read as documents: the free play of imagination that we expect of works of art is to be found in the letters. On the other hand the subjective intensity of the novels is absent from the correspondence: the letters are loose, expansive, the most beautiful of them concerned with literary theory. It is only by swallowing whole the untenable, paradoxical, and fascinating aesthetic theories of Flaubert that we can refuse to recognize the artistic nature of these other "documents," the letters—above all the correspondence with Louise Colet from 1846 to 1848.

Flaubert liked his women fat: Louise Colet was at least buxom. With grandiose literary pretensions of her own, she amassed a collection of lovers almost the equal of Alma Mahler's: they included (besides Flaubert) Alfred de Vigny and the philosopher Victor Cousin. According to her own account, Alfred de Musset nearly succeeded in raping her, in a carriage. Her own letters and diary have no literary interest: they are true human documents, embarrassing and touching. Taking one lover to a railway station, she is

reminded of all the others she has seen off in the same way. Infatuated with Flaubert, and eleven years older than he was, she wrote a poem about his way of making love: "*Comme un buffle indompté aux deserts d'Amerique*" (Like an untamed buffalo in the American deserts), a line that amused Flaubert.

He, for his part, wanted a passionate literary relationship: she was upset that he never came to Paris to see her (they only met five or six times in all), and puzzled that he kept writing to her about literary theory. He tried to cut their relationship down to more artistic proportions, and gave her up after a tremendous public scene on the quai Voltaire, which provoked one of his epileptic fits. He refused to see her again until his return from a trip to the Orient in 1851. It was like creating a work of art with intractable material, and he finally abandoned the attempt.

The young Byron wrote on November 6, 1812, to his elderly confidante Lady Melbourne:

> I never laughed at P—(by the bye this is an initial which might puzzle posterity when our correspondence bursts forth in the 20th century) . . . (Vol. 2, p. 240)

It is indeed one of the rare allusions in Byron that has not been identified. Most of them present no problem: C for Lady Caroline Lamb, Φ for Lady Frances Webster; — for Byron's half-sister Augusta, and Thyrza for John Edleston, the Cambridge choirboy. Only the last was genuinely intended to defy conjecture.

The correspondents understood how transparent most of these devices would be. A writer often leaves instructions that his letters be destroyed after his death, and yet lavishes all his literary gifts upon them, aware that most of the time no one—much less himself—will have the heart to cast them into the flames. Byron's most compromising letters are not signed, the salutations often omitted, the letters addressed through a third party, names left blank with initials substituted—all innocent subterfuges easy enough to see through. Today these letters, set by time and pub-

lication at a distance from the life in which they were involved, demand to be transformed into literature and challenge posterity to make the Romantic myth come true.

The Romantic myth is that the work of art is a spontaneous and partially unconscious crystallization of feelings too deep and intense to be released directly into action. It is a myth so powerful that it can, at moments, create a reality when there is none at hand. Byron, Chateaubriand, Goethe, and many others were condemned to live out in later years the literary roles they had created for themselves with the earliest works: they read these works into their lives. We, today, read the life into the works, often imaginatively confusing the two. However absurd this confusion may be, with the artists and writers of the early nineteenth century it is both necessary and legitimate: they deliberately created it for us with the works themselves.

Byron had an international reputation as a Don Juan when he wrote *Don Juan:* so did Liszt when he wrote the fantasy on themes from Mozart's *Don Giovanni.* We cannot directly identify Byron with his hero any more than we can believe that Liszt wrote the tunes in the fantasy, but both works are autobiographical in intent, if ironically so.[2] The music recalls the events of the opera with a new emphasis on the daemonic aspect, and the virtuosity of Liszt's fantasy acts as a symbol of virility and dominance, a displacement of erotic mastery: on the other hand, in Byron's poem, Don Juan (like Byron) is more often fascinated victim than seducer, and the work is both parody of the old Spanish legend and revenge on the legend of Byron's life, which he had yielded to as much as created.

A direct identification of life and work was rarely the intention of the artist. Schumann claimed that the cryptic autobiographical titles that he gave to some of his pieces were invented after the works themselves were written. Byron observed in his diary on November 23, 1813:

2. Nothing of the sort can be claimed about the earlier versions of Mozart and Molière, the later version of Lenau, however, presents itself as direct self-expression. Lenau's conception of the legend is the one used by Richard Strauss, who followed his *Don Juan* with an autobiographical symphony that celebrates the domestic virtues of marriage.

I have burnt my *Roman*—as I did the first scenes and sketch of my comedy—and, for aught I see, the pleasure of burning is quite as great as that of printing. These two last would not have done. I ran into *realities* more than ever; and some would have been recognized and others guessed at. (Vol. 3, p. 217)

This is a warning that the surviving works should not be given too simple-minded a biographical interpretation.

In spite of these cautions, it is often assumed as self-evident that the greatest works reflect most directly the emotions and experience of the author. This dubious axiom recently led to a controversy in the columns of the *Times Literary Supplement* over Wordsworth's "Lucy" poems that almost rose to the level of Samuel Butler's theory that Wordsworth had murdered Lucy, which was why her death made such a difference to him. Could Lucy be identified with Wordsworth's sister Dorothy, and the poems characterized as incestuous (thereby refueling Professor Bateson's account of the sources of Wordsworth's genius)? If so, did William really sleep with Dorothy or was he only imaginatively exploring "other avenues" and recording "the emotional impact of possible alternative behavior," as Dr. Donald Reiman put it.[3]

These speculations were reminiscent of an exchange some years ago in the *New Statesman,* about what Shakespeare and the Earl of Oxford actually did together—a controversy that was stopped dead in its tracks by William Empson's personal assurance[4] that there could have been nothing more than a little mutual masturbation. No doubt Shakespeare and Wordsworth have only themselves to blame for all this tomfoolery. The intensity of a work—given this critical bias apparently convinces many critics that it must be a faithful mirror of the artist's life. In music, the most "personal" works are generally supposed to be in the minor mode and of a tragic character; this works admirably as composers are generally sick, in debt, or crossed in love, if not all three at once.

. . .

3. Letter in the *Times Literary Supplement,* November 1, 1974.
4. See page 227.

The confusion of biography and art implicit in early Romantic style is made possible by the reciprocal movement from public to private writing and the way each is transformed into the other. For Byron, writing was a refuge from life, and therefore an activity as "animal" and as necessary to him as to Flaubert. On November 27, 1813, he wrote in his Journal,

> To withdraw *myself* from *myself* (oh that cursed selfishness!) has ever been my sole, my entire, my sincere motive in scribbling at all; and publishing is also the continuance of the same object, by the action it affords to the mind, which else recoils upon itself. (Vol. 3, p. 225)

Self-consciousness is the basic Romantic form of alienation, the subjective mind taking itself as its own object. Byron's form goes one step further: literature is an alienation, a withdrawal and an escape from self-consciousness, leading even to the final objective form of publication, the final escape from the self.

The relation of Byron's private writing, above all his diaries, to the public work, the verse, makes the movement of evasion still more sophisticated. As he writes on December 6, 1813, the diary is itself a refuge from poetry:

> I am so far obliged to this Journal, that it preserves me from verse,—at least from keeping it. I have just thrown a Poem into the fire (which it has relighted to my great comfort), and have smoked out of my head the plan of another. I wish I could as easily get rid of thinking, or, at least, the confusion of thought. (Vol. 3, p. 235)

This makes a grand, circular movement as well as a happily creative muddle. Poetry is an escape from the consciousness of self, while at the same time the Journal—for Byron the embodiment of this consciousness[5]—is an escape from poetry. Byron is amused at the idea of bringing his verse into life by burning it. It is the triumph

5. "This journal is a relief. When I am tired—as I generally am—out comes this, and down goes everything. But I can't read it over," (December 6, 1813, Vol. 3, p. 233). The diary is the unreflective consciousness, freed from control.

of Byron's style that the Romantic "confusion of thought" is mirrored in every aspect of a prose which ostensibly lays claim to an eighteenth-century clarity and irony.

It is in the private writing—letters and Journal—that Byron distills out of this confusion a "camp" elegance closer to Wilde than to Byron's beloved Sheridan or Pope. "Every day confirms my opinion on the superiority of a vicious life," he writes to a friend.[6] He describes another friend's house as "very well and quiet and the children only scream in a low voice."[7] Best of all is his portrait of Lady Frances Webster: "She is a thorough devotee—and takes prayers morning and evening—besides being measured for a new bible once a quarter—"[8]

In his account of the successful but unconsummated seduction of Lady Frances Webster, Byron transforms the art of the private letter. His long series of letters to Lady Melbourne about this adventure dramatizes the art of writing as well as the scenes described. Only a long quotation will convey Byron's revolutionary achievement. From the letter of October 8, 1813, we have:

> —I have made love—& if I am to believe mere *words* (for there we have hitherto stopped) it is returned.—I must tell you the place of declaration however—a billiard room!—I did not as C[aroline] says "kneel in the middle of the room" but like Corporal Trim to the Nun—"I made a speech"—which as you might not listen to it with the same patience—I shall not transcribe.—We were before on very amiable terms—& I remembered being asked an odd question—"how a woman who liked a man could inform him of it—when he did not perceive it"—I also observed that we went on with our game (of billiards) without *counting* the *hazards*—& supposed that—as mine certainly were not—the thoughts of the other party also were not exactly occupied by what was our ostensible pursuit.—Not quite though pretty well satisfied with my progress—I took a very imprudent step—with pen & paper—in tender & tolerably turned *prose* periods (no *poetry* even when in

6. Letter to Henry Drury, December 18, 1813 (vol. 3, p. 202).
7. Letter to Lady Melbourne, September 21, 1813 (vol. 3, p. 116).
8. Letter to Lady Melbourne, October 10, 1813 (vol. 3, pp. 137–138).

earnest) here were risks certainly—first how to convey—then how it would be received—it was received however & deposited not very far from the heart which I wished it to reach—when who should enter the room but the person who ought at that moment to have been in the Red Sea if Satan had any civility—but *she* kept her countenance & the paper—& I my composure as well as I could.—It was a risk—& *all* had been lost by failure—but then recollect—how much more I had to gain by the reception—if not declined—& how much one always hazards to obtain anything worth having.—My billet prospered—it did more—it even (I am this moment interrupted by the *Marito*—& write this before him —he has brought me a political pamphlet in M.S. to decypher & applaud—I shall content myself with the last—Oh—he is gone again)—my billet produced an *answer*—a very unequivocal one too—but a little too much about virtue—& indulgence of attachment in some sort of etherial process in which the soul is principally concerned—which I don't very well understand—being a bad metaphysician—but one generally *ends* & *begins* with Platonism—& as my proselyte is only twenty—there is time enough to materialize—I hope nevertheless this spiritual system won't last long—& at any rate must make the experiment. . . .
(Vol. 3, pp. 134–135)

There is a continuous interlacing of narrative and moral observations, and the commentary is not objective but consistently intimate. The tone of private conversation, direct and immediate, calls attention not to the story but to the moment of writing. Passages of objective narration and others of immediate subjective expression had existed side by side in letters before this, but never so fused.

The entrance of the foolish husband at the exact instant of writing the letter echoes his equally unwelcome entrance when the other letter is given to Lady Frances. The letter actually before us becomes part of its own drama, a prop in the comedy it describes. This detail, however, is only an extension of the technique developed throughout the letter of telescoping action and commentary. The source of Byron's method is the novels of Richardson and Laclos, where we move with equally characteristic ambiguity

from the scene described to the writer interrupted in the act of writing.

Saintsbury complained of the "staginess" of Byron's letters and, more perceptively, about their "violence"; but there is nothing factitious about them. Neither here imitates art naturally and with great gusto. The combination of stagecraft and intimate confession, of objective and subjective elements of tone and structure, turn these private documents into literature, the counterpart of Byron's greatest poems, *Childe Harold* and *Don Juan,* where public art assumes the character of the private document.

Byron's Journal makes a similar synthesis of objective and subjective modes. These are not only private jottings, a record of his life, but conversations with himself, staged and fully visualized:

> Talking of her, he said, "she was the truest of women"—from which I immediately inferred she could *not* be his wife, and so it turned out. . . .
>
> [Crib] is the only man except [Webster?], I ever heard harangue upon his wife's virtue; and I listened to both with great credence and patience, and stuffed my handkerchief into my mouth, when I found yawning irresistible—By the by, I am yawning now—so, good night to thee.—Μπαιρων[9] (November 24, 1813, Vol. 3, p. 221)

The more private the writing of Byron, the more literary it becomes: the Journal contains passages with an extraordinary collage of quotations, fragments he shored against his ruins. Not only Byron's private letters and diaries are transformed into art, but his life as well. The seduction of Lady Frances is staged by Byron, *invented* by him to distract himself from his love for his half-sister Augusta. He muses upon the possibility of his being shot by Lady Frances's silly husband ("in my case it would be so *dramatic* a conclusion"), and adds:

> C[aroline] would go wild with *grief* that—*it did not happen about her* . . .—*and*—— [Augusta] poor —— [Augusta] she would be really uncomfortable—do you know? I am much afraid that that

9. The Greek transliteration of "Byron."

perverse passion was by deepest after all.—(To Lady Melbourne, November 25, 1813, Vol. 3, p. 174)

This advertisement of his incestuous love, for all its regretful nostalgia, is a sign that even here we have a phenomenon as much a part of public life as private.

Incestuous love for a sister was the forbidden Romantic aspiration. In life, Chateaubriand loved his sister with the respectable devotion of Wordsworth or Charles Lamb (family relations at that time could indeed be very close); in *René,* however, the climax is the whispered confession of the criminal passion at the moment that Amelie takes her vows as a nun, followed by the frenzied embrace of brother and sister, and the subsequent scandal and death. Shelley's first mature poem, "The Revolt of Islam," originally treated of incest, but he was forced to bowdlerize it, only to return to the subject later with *The Cenci;* in life, he was forced to content himself with adultery. Byron alone was able to live the Romantic ideal in all of its essential aspects: poet, Don Juan, incestuous lover, bored dandy, warrior for freedom. It is now clear that even Byron's early death in Greece was half-consciously willed, a final glorious synthesis of life and art.

In his Journal on Wednesday, December 1, 1813, he had written:

I shall soon be six-and-twenty. Is there anything in the future that can possibly console us for not being always *twenty-five?* (Vol. 3, p. 229)

~~~

"That's my opinion, and I share it" ("*c'est mon opinion, et je la partage*"), said Monsieur Prudhomme, the great symbol of the nineteenth-century bourgeois created by Henri Monnier. In this grand example of the confusion between subjective and objective viewpoints which is the touchstone of Romantic art, we can see the source of that peculiar form of stupidity so characteristic of the nineteenth century.

The Romantics did not invent stupidity, of course, but they could have taken out a patent on an individual and specially fatu-

ous variety. Almost no one was immune from it, even the most intelligent. "Read Aristotle for the first time last night," noted the young Stendhal in his notebook, "and was delighted to find that he had the same ideas as I do." Dorothy Wordsworth admired Pascal, but thought he would have been more dignified and more impressive if he had expressed himself in English. It is difficult to conceive of such utterly natural and charming reactions being written down by such acute minds before 1800.

The grandmaster of Romantic fatuity, as of so much else, was Victor Hugo: he raised it to heights unknown before. In a letter to Baudelaire to thank him for his book on hashish, we find:

> Je vis ici dans ma solitude face à face avec l'infini, les rayons de l'impossible et de l'idéal me traversent à chaque instant de part en part, *il éclaire* à tout moment dans mon âme et sur ma tête, je vois de l'invisible, j'habite entre la vague et l'astre; ceci vous dit à quel point les livres comme le vôtre me vont, et toutes les préparations qu'ils trouvent en moi. Je passe ma vie à boire ce haschisch qu'on appelle l'azur et cet opium qu'on appelle l'ombre.[10] (July 19, 1860)

> I live here in my solitude face to face with the infinite, the rays of the impossible and the ideal pass across me through and through at each instant, *there is lightning* at every moment in my soul and over my head, I see the invisible, I inhabit a region between wave and star: this tells you how much books like yours suit me, and how far I am already prepared within myself for them. I pass my life drinking that hashish called the blue of the sky and that opium called shadow.

This makes a wonderfully bathetic identification between Hugo and the stormy isle of Guernsey from where the letter was sent. A year earlier Hugo had written to Baudelaire:

> L'Art n'est pas perfectible, je l'ai dit, je crois, un des premiers, donc je le sais. (October 6, 1859)

> Art is not perfectable: I was one of the first, I believe, to say it, therefore I know it.

10. *Lettres à Baudelaire,* edited by Claude Pichois (Neuchâtel, 1973), pp. 192–193.

Hugo's fatuity was contagious; it rubs off even today on those who read him too often. Baudelaire, who could be silly but almost never fatuous, wrote that he repeated every night the prayer of the Philistine, and thanked God for not making him as stupid as Victor Hugo. This form of fatuity, however, evidently transcends the individual. It is a trait of style, an attribute of the period, a characteristic aberration of what Keats, in speaking of Wordsworth, called the "egotistical sublime."

Romantic subjectivity is not necessarily personal expression. Its most impressive manifestations are profoundly impersonal. For Wordsworth, what separated one man from another was the exterior, objective aspect of personality: at the deepest, unconscious subjective level all men are one, and the source of fraternity was to be found here.

The peculiar nature of Romantic fatuity comes not from the projection of the subjective mind upon the objective world—that is only a method for understanding the world, for putting it into words—but from the confusion of personal with impersonal, from the identification of the tiny, individual ego with the subjective process in general, with the universe conceived under the aspect of mind, to use the terms of Spinoza relished by the early nineteenth century. The fatuous is the misplaced grandiose, the identification of the subjective vision with one's personal idiosyncrasies. It was a trap only too easy to fall into, and could be avoided only when the omnivorous identification of the self with the universe was seen as tentative and fallible, when the striving after the infinite was recognized as unpretentious, ordinary, and always incomplete.

To make the familiar seem strange, the marvelous appear commonplace, was Novalis's definition of Romanticism. We need to keep our grasp on the commonplaceness, and on the fundamental and acknowledged imperfection of the stylistic devices and the modes of thought of the early nineteenth century, or they turn into hollow clichés. For this reason, we have rightly come to prefer the sketches, the first versions of the works of that period. Roman-

tic hyperboles are conceivable here as provocations, stimuli of a never-ending creative process (as they were intended to be seen), and not as absurdly definitive institutionalized formulas. The most satisfactory editions of Romantic works are those that retain the sense of the spontaneous draft, the developing improvisation, and reject the aspect of the final, arrested statement.

Letters, journals, and notebooks present, as always, a special problem for the editor, one which is particularly acute for the nineteenth century, when works of art lay claim to the status of autobiographical documents, when the exhilarating confusion between art and non-art that still plagues us today was first innocently developed. There is, however, no consensus about principles of editing and annotating nineteenth-century letters and diaries, but rather a good deal of comic inconsistency.

The editor of these texts is faced first of all by an extraordinary development starting in the last decade of the eighteenth century, at which time it would appear as if the literary world had forgotten how to spell or to punctuate. After punctuation and spelling had become relatively stabilized in the course of the eighteenth century, a group of writers arose who systematically sabotaged both. Not only a half-educated poet like John Clare, but Wordsworth, Coleridge, Byron, Charles Lamb, Shelley, and Keats all spelled anywhere from erratically to appallingly, and punctuated in the way presumed typical of Victorian ladies—largely by dashes. So, in France, did Flaubert and Baudelaire, as is made clear by the variant readings in the new critical editions of the correspondence that have recently been issued. It was evidently an international and persistent phenomenon.[11]

The traditional way of printing an author's letters after his death used to involve selection and "normalization." They were bowdlerized, corrected, licked into shape, and inserted in chronological order in a biography, where the context made them intelligible.

---

11. The one major eighteenth-century author famous for not being able to spell is significantly the one with the greatest influence on Romantic thought, Rousseau.

The duller passages were cut along with the more scandalous, libelous, and discreditable details. Today we may rejoice that nothing is too tiresome or too disgusting to print; everything from the account book to the medical report which will shed some light on the artist and his work is put forth. In this setting, which presents even the most accomplished letters in a new light, the normalization of texts becomes unsuspectedly odd.

Just how odd is best seen if one asks what to do about the letters written by the author as a small child. Claude Pichois, in his edition of Baudelaire, corrects the spelling and punctuation of all the letters, including those written when Baudelaire was ten years old. This may be absurd, but another solution—chosen by Bruneau in his edition of Flaubert—is even more ludicrous. A faithful transcription is given of all letters written before the author was twelve, after which point everything is corrected. Did Bruneau feel that twelve is the age of reason, the moment when Flaubert should have known better, and that from this point on his graphic vices must be covered up?

According to Bruneau, Flaubert's spelling betrays his Norman pronunciation. Surely, since one of the pleasures of reading correspondence is to catch echoes of the writer's voice, this should not have been obliterated. As for Baudelaire, in one of his frequent attempts to play the fool by a violent declaration of reactionary politics, he declared the greatest crimes of liberalism to be the abolition of the death penalty and spelling reform. He himself preferred old-fashioned spelling and it would only be simple justice to allow his faults to remain visibly upon his head.

The stumbling block for many of the editors of early nineteenth-century texts is the dash, omnipresent and polytropic. Leslie Marchand has no fear of the dash: he reproduces Byron's letters almost exactly as they were written whenever he has access to the original manuscript. Many other editors, however, are filled with trepidation: at the sight of so many dashes their nerve fails. When he edited Wordsworth's letters, de Sélincourt, who reproduced all of Wordsworth's misspellings, took a high moral tone with the dash:

I have not everywhere retained the dash, which a rapid writer employs for purposes other than that for which it is intended.[12]

We arrive here at the metaphysics of the dash, and the faith that signs of punctuation have fixed, invariable uses determined for all time.

In her magnificent edition of Coleridge's *Notebooks,* which has now reached its third volume, Kathleen Coburn is less intransigent. She reproduces everything as Coleridge wrote it, including his shorthand squiggles and the dashes—but amusingly she rations these last. When Coleridge writes several dashes, she only allows him one. (A glance at Marchand's edition of Byron's letters, however, will show that there is a considerable difference between the use of one and three dashes.) In his edition of Baudelaire's correspondence, Pichois adds commas or periods to the dashes, while Bruneau translates Flaubert's dashes painstakingly into the accepted hierarchy of commas, semicolons, colons, and periods.

This hierarchy, however, is deliberately rejected by the Romantics; it represents a logical division of thought which they clearly found antipathetic and to which they would not bend. We have returned today to the eighteenth-century use of the stops as logical symbols, but the early nineteenth century preferred to ignore or to blur logical distinctions. The clear logical divisions of thought imply that the concept and its expression exist in a complete form at a given moment: it can then be conveniently ordered and divided up into its main and subordinate clauses, and the proper value assigned to the intervals which determine the stops. This was not how Coleridge, for example, determined the function of the pauses to be indicated by the punctuation. He wrote in his notebook (vol. 3, p. 3504, f8–f8ᵛ)

I look on the stops not as logical Symbols, but rather as dramatic *directions* representing the process of Thinking & Speaking con-

---

12. *The Letters of William and Dorothy Wordsworth,* E. de Sélincourt, ed., second ed. revised by C. L. Shaver (Oxford, 1967), p. xv. Professor Shaver's revision does not inspire confidence. A comparison of the photograph of a letter printed as a frontispiece with the text reveals two mistakes in transcription.

jointly. . . . [The speaker] pauses—then the activity of the mind, generating upon its generations, starts anew—& the pause is not, for which I am contending, at all *retrospective,* but always prospective—that is, the pause is not affected by what actually follows, but by what anterior to it was foreseen as following—

Made to fit a dynamic and modern conception of language as still being generated and altered even in mid-sentence, this is a complex and exalted view of punctuation; it is understandable, however, that most writers of that period, including Coleridge himself, simply used the dash most of the time.

The dash had a double advantage: it was, as Coleridge said, an "expression of the indefinite or fragmentary—" For some years around 1800, the fragment became the dominant fashionable artistic form. It bore an ideological charge, expressed cryptically and ironically with great charm by Friedrich Schlegel in 1798:

Ein Fragment muss gleich einem kleinem Kunstwerke von der umgebenden Welt ganz abgesondert und in sich selbst vollendet sein wie ein Igel. (Athenäum Fragments 206)

A fragment must be like a small work of art completely separated from the surrounding world, and complete in itself like a hedgehog.

This paradoxically saves both the integrity of the work of art and the interpenetration of life and art, as the perfectly defined circular form of the hedgehog, rolled up into a ball, sticks out its quills into the surrounding world.

The indefiniteness of the dash, too, was an aid for the fluid representation of reality. It corresponds to the contemporary tendency to blur figures of speech, to the abandonment of the strictly systematic rhetorical distinctions. Schlegel once again gives the doctrine in its purest and most concise form:

Das alles muss in der Historie verschmolzen sein, wie auch die Bilder und Antihesen nur angedeutet oder wieder aufgelöst sein müssen, damit der Schwebende und fliessende Ausdruck dem lebendigen Werden der beweglichen Gestalten entsprche. (Athenäum Fragments 217)

Everything in history must be blended, as even the images and the antitheses must be only suggested or dissolved, so that the wavering and flowing expression will correspond to the vital continuous change ( = Becoming) of the mobile forms.

Coleridge, however, puts it even more persuasively in a letter[13] as he describes his own youthful style of political oratory:

> . . . with an ebullient Fancy, a flowing Utterance, a light & dancing Heart, & a disposition to catch fire by the very rapidity of my own motion, & to speak vehemently from mere verbal associations. . . .

This style implies a logic of movement, and to impose a static system is a betrayal.[14] It is a metaphysical absurdity to assume that the logical relation of different phrases separated by dashes can be coherently translated into a rational order without a loss of meaning and power.

The aesthetics of editing would make a curious study. The excuse for emendation is always the necessity of a legible text. Nevertheless, Marchand's new edition of Byron's letters and diaries, Coburn's edition of Coleridge's notebooks, and Hyder Rollins's famous edition of Keats's letters are all a delight to read although (or, rather, *because*) they reproduce everything in the original—words crossed out, misspellings, and all. Yet Keats and Byron spelled and pointed more erratically and whimsically than any of the others, and Coleridge's favorite mark of punctuation is the oblique stroke / that he derived from his German books.

The preference for a clean, "normalized" text free of footnotes

13. To Sir George and Lady Beaumont, October 1, 1803, in *Letters,* Earl L. Griggs, ed., (Oxford, 1956), vol. 2, pp. 1000–1001.

14. The argument sometimes heard that many of these authors, Byron and Shelley in particular, expected the printer to impose a standard system of punctuation on their works is not an impressive one. That is the condition they had to accept in order to be published. Their failure—their refusal, indeed—to learn such a system is more revealing. Two authors, however, had their texts presented to the public without the standard punctuation that fits early nineteenth-century writing so badly: Blake and Lamb. Blake could allow himself this luxury because he was considered mad, Lamb because he wrote the familiar, conversational essay which did not have to conform to the standards expected of high style. The *Essays of Elia* are strewn with as many dashes as Byron's letters. (Shelley, incidentally, preferred three dots to the dash in order to indicate the vague and the fragmentary.)

is an aesthetic preference, but it is one that hides a philosophical prejudice—the belief that the meaning of a text can be detached without loss from its appearance on the page, the belief that perfect translation is possible. But translation is never perfect, only inevitable: even a facsimile reproduction represents a slight loss of significance.[15]

The controversy between those who normalize and those who prefer the original text raw and unadulterated is, in fact, a heritage of the Romantic movement. It begins in 1765 with Bishop Percy's publication of the *Reliques of Ancient English Poesy,* which initiates the Romantic revival of medieval folk literature. At that time documents were often literally reproduced, even in facsimile (by means of tracing), but works of literature were freely modernized although perhaps not often with so cavalier a disregard for the original as Bishop Percy showed.

An irascible bibliographical genius, Joseph Ritson, protested Percy's ruthless handling of the ballads. For him the original should have been reproduced in all its purity. He partly considered the old poems as documents of antiquity, but he evidently loved them in spite of their rubbing his eighteenth-century taste the wrong way. The distinction between document and work of literature is beginning to crumble.

The Romantic movement gave rise to two extremes: the absolutely faithful reproduction of a text (Grey's *Elegy* was printed in a facsimile of the manuscript early in the nineteenth century) and the forgeries of Chatterton and of *Ossian.* The violence of the opposition may be judged from a letter of Ritson:[16]

> I have not the pleasure to agree with you that an editor has the right "to avoid a disgusting orthography of a common word"—at

15. The ideal editions, indeed, are like the recent one of *The Notebook of William Blake* (Oxford, 1973), which juxtaposes a photograph of each page with a typographic transcription (including a reading by means of infrared photography of everything that Blake erased and altered). This, however, represents a considerable expense that would be unjustified for most publications, necessary here because of Blake's many drawings. It has been brilliantly edited by David V. Erdman and Donald K. Moore.

16. Quoted from Bertrand H. Bronsen, *Joseph Ritson Scholar-at-arms* (University of California Press, 1938), vol. 2, pp. 547–548.

least without affording his readers an opportunity of knowing whether it is disgusting or not. On the contrary I am persuaded that a strict adherence to ancient orthography, however rude, which I conceive is what you mean by disgusting, is the test of an editor's fidelity; and can place no confidence whatever in one who secretly innovates even in a single word. . . .

You will think me certainly singular, probably unjust, possibly scandalous; but in fact I have long entertained an idea that there is a more intimate connection between integrity in literary matters and what one calls common honesty than people in general are aware of—In short, that a man who will forge a poem, a line, or even a word will not hesitate, when the temptation is greater and the impunity equal, to forge a note or steal a guinea.

Edmund Wilson correctly observed that bibliographers were mad (although there is no call for lamentation). Mad on both sides of the controversy: the normalizers are as dotty as the faithful servants of the text. The obsessive replacement of almost every one of Flaubert's dashes by some other stop is not a completely rational enterprise. And as H. W. Garrod remarked in his edition of Keats, it may be pedantic to list all the variants but even more pedantic not to be interested in them once someone has done the work.

The real controversy lies deeper, however: it is whether these texts come closer to us cleaned up and in modern dress or in their original form. In modern dress, it seems to me, they direct our attention to their distance from us: they appear to be familiar only at first sight. In their strange, original form they force us to penetrate to their essential kinship with our own world. Above all for these autobiographical documents, only when they have been fully thrust back into the alien life from which they came, plunged back into history, can they commence to take on a significance that is not purely historical, and speak directly to us today.

# The Cookbook as Romantic Pastoral

## Elizabeth David

Some of the recipes in Elizabeth David's first book, "Mediterranean Food," published in 1950 and said to have completely transformed the eating habits of the British upper middle class, were picturesque rather than practical. The Greek dish called *picti* is one example:

PICTI

Picti is the Greek brawn [headcheese].

A pig's head is boiled for hours in water strongly
flavoured with bay leaves and peppercorns.

When cooked it is cut up into chunks, the juice of 3
or 4 lemons is added to the strained stock, which is
poured over the brawn, arranged in large earthen-
ware basins, and left to set.

Not very elegant, but usually very good.

Few of the readers for whom this was written can have tried their hand at *picti*. Nor can they have made use of the directions on how to skin an octopus ("Coat your hand with coarse salt, grab each tentacle hard, and pull. The skin peels off").

---

Originally written in 1985 as a review of Elizabeth David, *An Omelette and a Glass of Wine.*

Of course, many of the other recipes in the book are more easily negotiated, but the improbable ones are not beside the point if one wishes to understand Elizabeth David's charm. Within a few years of the appearance of "Mediterranean Food"—above all with the publication of "French Provincial Cooking" in 1960—she was accepted by many as the most important living writer on food. This position is confirmed by her new book of essays, "An Omelette and a Glass of Wine," a collection of her journalism over the last 35 years.

Mrs. David's supremacy does not come from her style, which is serviceable, plain and a little brusque, or from any attempt to write fancy prose. Although she often reminisces about places she has visited and meals she has eaten (particularly Provençal meals that represent the cooking she knows best), this is not a significant part of her writing. (There is more of this kind of travel literature in the new book than in the earlier volumes, which were all cookbooks; however, some of the best pages in the new work are reprints of practical booklets issued after the author opened a fashionable kitchen-utensil shop in London.)

Elizabeth David's basic medium of expression is the recipe. This is a form as strict and as loose as a sonnet, and it has as many varieties and styles. Mrs. David treats the form somewhat high-handedly, but her mastery of it is evident, and she presupposes a reciprocal mastery on the part of her readers. She does not tell them, for example, that eggplant acts like blotting paper with oil or when to add salt when making a ratatouille (too soon and the vegetables will not turn golden but only boil in their own liquid).

The directions tend to the laconic: "simmer until done"; "cook in a moderate oven." Beginners might be advised not to start with her books, but in any case one never learns to cook from printed directions any more than one learns to play the piano from a book on piano technique. Cooking is learned above all by watching other people and by trial and error. A good cookbook does not inform readers about technique so much as inspire them (it is true that technique and inspiration are as hard to separate in cooking

as in art and science, but we are all aware of the difference). More significantly, the finest recipes do not always inspire the most sympathetic reader to cook—or even to eat.

This is particularly true with Mrs. David. Not only were the more improbable recipes beyond the grasp of her original readers, so were most of the ordinary ones. She herself admits it in the preface to the Penguin edition of "Mediterranean Food":

> This book first appeared in 1950, when almost every essential ingredient of good cooking was either rationed or unobtainable. To produce the simplest meal consisting of even two or three genuine dishes required the utmost ingenuity and devotion. But even if people could not very often make the dishes here described, it was stimulating to think about them; to escape from the deadly boredom of queuing and the frustration of buying the weekly rations; to read about real food cooked with wine and olive oil, eggs and butter and cream, and dishes richly flavoured with onions, garlic, herbs, and brightly coloured southern vegetables.

The first book was clearly an escape—for the author as well as her readers—from the dullness of English life. Elizabeth David spent the war years in Cairo and Alexandria, Egypt, and had been a student in Paris. "Mediterranean Food" made the past come alive again, and it did so the way poetry evokes an exotic or long-vanished ambiance—by appealing to the reader's sense of sight as well as taste and smell. The recipes are disguised metaphors, poetic images of a way of life. This is why the most extravagant of Mrs. David's recipes are as revealing as those that can be more easily realized. In fact, some of the most difficult are, paradoxically, the simplest to carry out. Take, for example the one that created the most controversy. She herself describes the reaction in her new book:

> On page 96 of 'French Country Cooking' is a four-line description of *el pa y all*, the French Catalan peasant's one-time morning meal of a hunk of fresh bread rubbed with garlic and moistened with fruity olive oil. When the book first appeared in 1951, one reviewer remarked rather tartly that she hoped we British would never be

reduced to breakfasting off so primitive a dish. I was shaken, not to say shocked—I still am—by the smug expression of British superiority and by the revelation, unconscious, of the reviewer's innocence. Believing, no doubt, that a breakfast of bacon and eggs, sausages, toast, butter, marmalade and sweetened tea has always been every Englishman's birthright, she ignored countless generations of farm labourers, millworkers, miners, schoolboys, whose sole sustenance before setting off for a long day's work was nothing more substantial than a crust of coarse bread or an oatcake broken up in milk, buttermilk, or when times were good in thin broth, when bad in water.

We might notice here the perhaps unintentional contrast between the drab English life evoked by "a crust of coarse bread" and the simple but spicy existence of the Catalan peasant with his "hunk of fresh bread rubbed with garlic." This is not, of course, a breakfast difficult to make, except that the old-fashioned bread that makes a decent basis for rubbing with garlic is by now more nearly impossible to find in the French countryside than in New York or Paris and expensive wherever it turns up.

More important, it is difficult to believe that this deliciously primitive breakfast would be socially acceptable in London or New York for an office employee or even an executive: he would receive odd glances when he arrived for work. It is not the physical impossibility of obtaining the breakfast but the cultural improbability of doing so that stands out—and the author must have been aware of this. It was obviously included for ideological reasons, as a measuring stick for the value of the book's other dishes that we can reasonably serve our guests. The Catalan peasant breakfast conjures up a world of simplicity, calloused hands, a weary, satisfied contentment after hard physical labor and a closeness to nature and the naïve, uncorrupted pleasures of country life. It conjures up, in short, an ideal world of the past that never really existed.

Elizabeth David is a writer of pastoral—as are, in fact, many of the finest writers on cookery. Pastoral is a literary form that evokes a golden age, a time when life was uncomplicated and pleasures were simple. Shepherds and shepherdesses speak profound truths

unpretentiously, as if they were unaware of their own intelligence and sensibility. Good cookbooks may introduce us to exotic cuisines and transport us to the romantic Orient (or Scandinavia or Latin America) without our setting a foot outside the door, but the cookbooks that touch the heart most strongly are those that take us back in time—to mother's cooking and childhood memories or to an ancient and more splendid age. The deepest of all pastoral sentiments is nostalgia, a longing for a past that is ideally mythical. It is a past we can imagine and recreate with the odors of the kitchen and repossess symbolically only by eating.

Books like Elizabeth David's are the last gasp of the Romantic movement. In 1822 the great German art critic Karl Friedrich von Rumohr published a work with the very German title "The Spirit of the Art of Cooking" in which he advocated a return to natural, simple food where every ingredient retained its individual flavor and was undisguised by corrupt French gravy. This would be, he claimed, a return to the cooking of the Homeric age, and he was sure he knew what the cooking of the heroes of the *Iliad* was like: English roast beef. Mrs. David has a greater love for garlic than Rumohr did ("Peace and happiness begin, geographically, where garlic is used," she quotes one of her idols as saying), but she too wishes to return to a mythical past—when food was fresh, unadulterated by chemical preservatives, unspoiled by sham and pretentiousness. It is this mythical element in her work that explains its emotional power over so many uncritically adoring readers.

The greatest influence on her is perhaps Edouard de Pomiane, a researcher at the Institut Pasteur in Paris who gave informal talks about cooking on the French radio in the 1930s. There is a moving homage to Pomiane in "An Omelette and a Glass of Wine." He is addressed as "Pomiane, Master of the Unsacrosanct," which points out how much of the nouvelle cuisine is already to be found in his talks, including the now famous onion jam that came from the Jewish and Polish cooking of Pomiane's childhood (this is why so many of his recipes contain beets, that staple of the Polish kitchen).

Pomiane's was a cookery of friendship. He once wrote that

there are three kinds of dinners: business dinners, those given to return invitations and dinners for friends. Business dinners should be catered, he recommended (nobody will like the food anyway). As for dinners to return invitations, Pomiane knew nothing of them: his friends never invited him, he said, because they all wanted to eat at his house. His recipes are filled with his desire to please his friends, not to impress or dazzle them. He wanted a cuisine that was simple, copious, healthy, innovative and full of uncomplicated, strong flavors. The recipes proclaim their intimacy: one for cherry tart (quoted by Mrs. David) describes how "the edges of the tart are slightly burnt and the top layer of cherries blackened in places. . . . The cherries have kept all their flavour and the juice is not sticky—just pure cherry juice." This is not a public dish for a restaurant but a very private one made out of love for a small group of friends—who should be warned that to achieve such a wonderful if unimpressive-appearing result, the pits have been left in the cherries.

Elizabeth David's cookery is less generous than Pomiane's, although she has used his great recipe for saddle of hare with cream and acidulated beets for years and observes ironically that the star of nouvelle cuisine, Michel Guérard, has taken it up recently. She has, however, inherited Pomiane's offhand humor. In an essay entitled "Exigez le Véritable Cheddar Français" ("Demand Real French Cheddar"), she gives a recipe for a fondue Comtoise far less ingestible than the uncompromising Swiss version, and adds dryly, "Well, that is the authentic recipe. One of them anyhow."

She has an unparalleled feeling for the social ambiance of a dish and relates brilliantly how a peasant recipe can become classic French cookery ("Call it haute cuisine if you must," she writes with that combination of tolerance and disdain so characteristic of her style). She is less warmhearted than Pomiane, perhaps because it has become harder since 1945 to keep commercial foods and the commercial treatment of raw foods at bay, and there is a not always hidden strain of despair in her books. Honest cooking is the sign of honest living, but it cannot be achieved with dishonest and denatured ingredients. Take the recipe she gives for *pommes de*

*terre à la manière d'Apt,* where the poetry is in the simplicity and recalls the little French town of Apt, east of Avignon, in the mountains:

### POMMES DE TERRE A LA MANIÈRE D'APT

Potatoes cut in 1/4 inch rounds, 3 tablespoons olive oil, 5 tablespoons fresh tomato purée, salt, pepper, a bay leaf, 6 stoned black olives, breadcrumbs.

Put the olive oil into a shallow gratin dish, add the tomato purée, the potatoes, salt, pepper, and bay leaf, and simmer for 5 minutes.

Barely cover the potatoes with boiling water, and simmer another 30 minutes. Now add the black olives, and cover with a layer of breadcrumbs.

Put in a moderate oven for another 30 minutes.

Serve in the same dish.

What a simple recipe! One can taste it as one reads. There is a problem, however: none of the proper ingredients—except for salt, pepper, bay leaf and breadcrumbs—can be found easily in America or England, and it is becoming hard to obtain them in France or Italy. Almost none of the varieties of potatoes found commonly in America will do, as they generally dissolve after an hour's cooking and make a mealy and irregularly mashed purée. The tomato purée must be made from strong-flavored tomatoes that have ripened on the vine; even in France today the tomatoes are likely to have been refrigerated by the retailer and to have lost much of their taste. The olive oil must be fruity, from olives that have been treated respectfully and not heated while being pressed. The half-dozen olives must be the right ones—smallish, tangy and preserved in olive oil. Most of the time it is clearly more satisfactory to read such a recipe than to carry it out: there is no disappointment when we imagine and dream. And the rare occasion when one can reunite all the proper ingredients will probably be in a landscape, like that around Apt, smelling of wild thyme.

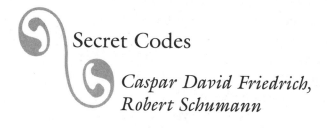

# Secret Codes

## *Caspar David Friedrich, Robert Schumann*

Does each art have its proper sphere, some aspect of reality that it may reflect or imitate that is closed to the other arts? The eighteenth century thought so and attempted to define the nature and the limits of each of the arts, and to fix the opposition between art and reality that seemed indispensable to the autonomous existence of art in general.

In the first decades of the nineteenth century, the writers and painters—to be followed shortly by the musicians—broke through these limits. "Does not pure instrumental music appear to create its own text?" wrote Friedrich Schlegel in 1798, thinking of the extraordinary development of symphonic music in the late eighteenth century. The ability of music to create meaning and significance out of its own elements, independent of any attempt to mirror the world outside, became the model for the other arts.

Originally written in 1973 as a review of William Vaughan, Helmut Börsch-Supan, and Hans Joachim Neidhardt, *Caspar David Friedrich, 1774–1840*: Romantic Landscape Painting in Dresden and Alan Walker, ed., *Robert Schumann: The Man and His Music*.

In his novel *Franz Sternbald's Travels,* Ludwig Tieck predicted an abstract art of pure colors with neither subject matter nor represented form. The poet-philosopher Novalis proposed tales and poems "without sense and without continuity . . . made up of associations like dreams . . . acting indirectly like music." The painter Philipp Otto Runge wrote that "music must exist in a poem through the words, as music must also be present in a beautiful picture or building or in any ideas whatsoever which are expressed through lines." When Schiller spoke of the musical effect of poetry, he meant not the sound but the order and arrangement of the images and the modulation of the whole poem. A generation later, Schumann and Berlioz were to integrate specifically literary techniques into their music.

Not only the barriers between the arts, but the autonomy of art itself was destroyed. This breakdown of the distinction between art and reality began playfully when, in one of Tieck's plays, the audience climbs onto the stage while the actors complain of their parts. Novalis, protesting the romantic justification of Shakespeare as a pure artist, is more in earnest: "Art belongs to Nature and is, so to speak, self-reflecting, self-imitating, self-shaping Nature. [Shakespeare's works] are emblematic, ambiguous, simple and inexhaustible, and nothing could be more nonsensical than to call them works of art in the limited mechanical sense of that word." In forms as different as Wordsworth's *Prelude* and Berlioz's *Symphonie Fantastique,* the work of art presents itself as autobiography, as fact, as part of Nature. Byron, with an international reputation as a Don Juan, wrote a poem called *Don Juan,* an open-ended work to which he continued to add as long as he lived. The characters in Brentano's novel *Godwi* speak about "the author of *Godwi,*" and, at the end of the book, describe his death and write poems about him.

The elements of these works have a double status, fact and art, real and fictive at once. Two recent books, *Robert Schumann: The Man and His Music,* edited by Alan Walker, and *Caspar David Friedrich,* the catalog of the recent [1972] exhibition at the Tate in London of the greatest of German landscape painters, show the

difficulty that this ambiguity has made in interpreting Romantic art.

The artistic revolution of the early nineteenth century was the replacement of history painting (large formal depictions of historical or religious scenes) by landscape. It is not only that painters turned their attention to landscape and away from the large-scale painting—frescoes or oils—of scenes from the Bible and the lives of the saints or from ancient or modern history. Their ambitions were much greater and more astonishing. They wished to make pure landscape without figures carry the weight, attain to the heroic and epic significance, of historical painting. Landscape was to be the vehicle of the Sublime.

In the seventeenth century, the landscapes of Poussin and Claude reached their full dignity only as depictions of classical Nature, with figures in antique dress, and often a mythological subject discreetly integrated into an ideally "Arcadian" countryside. The Romantics wished to make the elements of Nature alone carry the full symbolic meaning. Their project was, in fact, identical with the contemporary attempt of Wordsworth to give pure landscape poetry the force and gravity of Milton's epic style.

That the replacement of history painting by landscape had an ideological purpose directly related to the destruction of traditional religious and political values at the end of the eighteenth century cannot be doubted. The artists were themselves acutely conscious of this. In 1802, the most brilliant and articulate of the young German painters, Philipp Otto Runge, wrote:

> How can we even think of trying for the return of the art of the past? The Greeks brought the beauty of their forms and shapes to its height when their gods perished. The modern Romans brought historical representation to its farthest point when the Catholic religion was ruined.[1] With us again something is perishing, we stand

1. Runge is alluding here to the exact coincidence of the High Renaissance style of Raphael and Michelangelo with the beginnings of the Reformation.

at the brink of all the religions which sprang up out of the Catholic one, the abstractions perish, everything is lighter and more unsubstantial than before, everything presses toward landscape art, looks for something certain in this uncertainty and does not know how to begin. They grasp mistakenly at historical painting *(Historie),* and they are bewildered. Is there not surely in this new art—landscapery, if you like—a higher point to be reached? Which will be even more beautiful than before?

In one sense, the Romantic landscape was a return to the serious tradition of the seventeenth century and a revulsion from the largely picturesque styles of the eighteenth. A famous essay by Schiller (on the landscape poetry of a very minor versifier, Matthisson) appeared in 1794 and prepared the way. Landscape painting and poetry for Schiller could only be raised to the dignity of major arts by the awakening of sentiment and by the representation of ideas. We demand, he wrote, that the art of landscape should work upon us like music. Sentiment is created by the analogy of sounds and colors with the movements of the emotions. Ideas are stimulated in the imagination of the reader or spectator by the form of the work of art, and this form *controls* the imaginative response. For Schiller as later for Freud, the symbolic function of the imagination follows certain laws and can be both interpreted and predicted.

In 1808, the thirty-four-year-old Caspar David Friedrich painted a landscape as an altarpiece. The picture created a scandal, was fiercely attacked and as fiercely defended. The frame, with its angels that look down on the scene and with the ear of wheat and the wine branch below as symbols of bread and wine, body and blood of Christ, firmly defines the work as an altarpiece. Yet the crucifix in the landscape, which is the only piece of traditional religious symbolism in the picture itself, is clearly not a representation of a historical event, but almost a part of Nature, a crucifix upon a mountain such as one may still see today in the German countryside. Moreover, the figure of Christ is turned away from the spectator toward the setting sun, and ivy grows around the stem of the crucifix.

The firm rock upon which the crucifix stands and the evergreen trees that grow round it are symbols only too easy to read. This was Friedrich's first important oil painting: until then he had done only sepia wash, pen drawings, and designs for woodcuts. In later works the symbolism was far less intrusive, more nuanced and more dependent on the structure of the work—although even in this altarpiece an essential part of the effect comes from the perspective which seems to place the spectator in mid-air before the scene, a sensation about which early critics complained harshly.

"Here is a man who has discovered the tragedy of landscape," said the French sculptor David D'Angers after visiting Friedrich in his studio, and indeed Friedrich was one of the first European artists to restore landscape to the status of a major genre. The contemporary development in England with Constable and Turner as the major figures took place in a more empirical atmosphere, and gave landscape painting an explicitly scientific dignity as a means of investigating the visual aspect of Nature. The moral gravity is the same, however, and the explicit symbolism of Turner's work is comparable to Friedrich's. In return, Friedrich's later work moves toward a genuinely realistic study of cloud shapes and light.

Few paintings by Friedrich are to be seen outside Germany; the Louvre, for example, has none. The Tate exhibition last year was astonishingly the first large-scale showing of his work outside his native land. The catalog contains an excellent introduction by William Vaughan, but the entries by Helmut Börsch-Supan on each picture impose a doctrinaire reading that does the paintings disservice, and distorts the tradition of Romantic symbolism.

Börsch-Supan claims that "if one is to decipher Friedrich's pictorial symbolism, one has to look at his entire *oeuvre*," but we need not wait for his forthcoming book to protest. A study of the entire *oeuvre* may bring a deeper comprehension of Friedrich's art, but his symbols are to be read (not deciphered) within the individual works. That is, the meaning of the elements of Friedrich's style are revealed in each picture, and are not an esoteric, private code accessible only to the initiate.

Perhaps the masterpiece of Friedrich's last years is the *Large*

*Enclosure Near Dresden,* the inundated meadows where the Elbe overflows its banks. In the foreground is the water with a very small ship that drifts near the edge of the mainland. The point of view of the observer is from far above so that the body of water seems to have a gentle curve as if it were the curvature of the earth, and small plots of land stand out from the inundating water like continents on a globe. To the gentle curve of the foreground responds symmetrically the inverse curve of the horizon: the land between appears only as a few clumps of trees on a thin strip between the water and the immense sky. The broken agitated forms of the water are unified by the evening colors of the sky reflected inversely so that the cool, distancing blue is in the foreground. The painting is a religious meditation, an image of the relation of heaven to earth.

The picture has a significance, but no message: the concentration is visual, and the meaning is general and inexhaustible, diffused through the forms, which force a reading upon us by the strange symmetry and the unusual perspective. The catalog entry, however, is egregiously specific. I give it complete:

> Painted in 1832, this picture marked a high point in Friedrich's development as a colourist. It recreates with great vividness the atmosphere of the time of day just after the sun has set. The striking perspective of the foreground may well be the result of the view being taken from a bridge. Both the ship drifting over the shallow water where it is in danger of being stranded, and the abruptness with which the avenue of trees comes to an end in the open country, are images of approaching death. (No. 100, p. 89)

In similar fashion Börsch-Supan goes through the other works: every distant view represents paradise; every blade of grass, the transience of life; every birch tree, resurrection; every river, death.

There is no evidence that Friedrich thought a break in an avenue of trees or a boat in shallow water to be images of death. Even if we discover—improbably—that he actually believed this, then he was wrong: these symbols do not function that way within the total form of the *Large Enclosure,* whatever they may do in other

paintings.[2] The speculation about the view being taken from a bridge is gratuitous. We know that many of Friedrich's pictures were not drawn from life but constructed in his mind; he closed his eyes before he began to paint. The suggestion of a bridge serves only to obscure one of the characteristic effects of Romantic painting and poetry: the sense of being suspended in space, detached and poised over emptiness so that what is seen takes on the quality of a vision.

The ambition of the Romantic artist was to create a symbolic language independent of tradition.[3] It was no longer enough to initiate a new tradition which would in turn harden into an arbitrary system: what was needed was a natural symbolism which would remain eternally new. It is possible that the ambition was hopelessly impossible, its achievement a delusion; but to substitute a private esoteric code for the traditional iconographical one would have been absurdly self-defeating. What the artists and poets did was to attempt to disengage the latent meaning of the natural elements, the significance hidden in Nature herself.

When traditional iconography was rejected, then the symbols of Nature themselves had to be made to speak, and this they could only do when reflected through an individual consciousness. Nature was seen at once diffused with feeling and at a distance— the distance freed the senses from the distortions of a particular moment and made the significance of the work general and even universal in range. Wordsworth writes of the crag on which he waited anxiously, trying to sight the carriage which would take him home after the holidays. Ten days later his father died . . .

> And afterwards, the wind and sleety rain
> And all the business of the elements,
> The single sheep, and the one blasted tree,
> And the bleak music of that old stone wall,

2. A ship approaching a port has the natural connotation of the end of a voyage, and an association of this with death is clearly made in other pictures by Friedrich: but the meaning there is brought out by the pictorial content.

3. Cf. H. Zerner, "*Romantisme,*" in *Encyclopedia Universalis,* 1972.

> The noise of wood and water, and the mist
> Which on the line of each of those two Roads
> Advanced in such indisputable shapes,
> All these were spectacles and sounds to which
> I often would repair and thence would drink,
> As at a fountain. . . .

All the traditional paraphernalia of Nature poetry have disappeared; the rhetoric is hidden. In their place are a stone wall, a single sheep, one tree, and the music of Nature.

Wordsworth gives each of these elements an extraordinary significance merely by naming them in a certain order. They are barely described; by juxtaposing them, Wordsworth allows the associations to build. The narrative of his anxiety to return home followed by the death of his father acts like a frame around a landscape; it enriches the meanings but is not indispensable. The meanings come directly from the order and gravity of the list. Nor do the elements of Nature have an autobiographical significance for Wordsworth: he does not value them for their power to recall the past. On the contrary, that single moment in his life served to release the powers of speech in Nature. The ambition (and the achievement) of Friedrich and Constable are similar to Wordsworth's: the forms of nature speak directly, their power released by their ordering within the work of art.

The fundamental principle of Romantic symbolism is that the meaning can never be entirely separated from its symbolic representation: the image can never be reduced to a word. Börsch-Supan treats Friedrich as an enemy whose code must be cracked so that we may discover his strategy. But there is no code, no "idiolect," no totally private language to be deciphered and translated. Friedrich's art—like any art—resists translation: it can only be interpreted, and not even that without constantly returning to the specific images as they figure in each painting.

To read into Friedrich's painting an esoteric code is to falsify not only the art but even its religious meaning. It makes the works appear to convey a systematic doctrine, where they clearly reject religion as dogma. It is significant, as Vaughan remarks in his intro-

duction, that churches never appear in Friedrich's work except in the distance, as unreal visions, or as ruins. The visible Church is dead, only the invisible Church, in the heart or revealed through Nature, is alive. This is part of Friedrich's Pietist heritage, a personal religion that refuses all outward forms, all doctrine. To put a landscape on an altar is an aggressive act, as destructive of the old forms as it is creative of a new sensibility.

His contemporaries, even when they disliked his works, sometimes seem to have understood him better than we do today. A simple painting of leafless bushes in the snow inspires Börsch-Supan to thoughts of death and resurrection. A reviewer of 1828 was more down-to-earth:[4]

> . . . the greatest truth to Nature, but the selection of such a limited appearance from the whole of Nature can hold our attention as little as the aspect of the trifling detail in Nature generally does.

In his unsympathetic way, the reviewer had grasped the profound realism which links Friedrich to Constable: there was, for him, no phenomenon in Nature too insignificant for art. If this painting has a message that could be put into words, it was just that.

Schumann's music, too, forces one out of pure art. Strange initials appear after each piece of the *Davidsbündlertänze,* opus 6, along with directions like, "Quite superfluously Eusebius imagined what follows, and much happiness spoke from his eyes." In *Carnaval,* opus 9, musical anagrams are found, in old-fashioned notation with no indication of how they are to be played. In other works there are quotations of old dance tunes or of themes from Beethoven. There are pieces which appear to begin in the middle, others which seem to have no proper end, circular pieces which go round to the beginning and just break off. His opus 1 is a set of variations on the notes ABEGG, dedicated to a Countess Abegg. There are literary titles, poetic mottoes—in short, a highly devel-

4. *Caspar David Friedrich,* Irma Emmerich (Weimar, 1964), p. 106.

oped technique for making us ask for nonmusical interpretations and explanations of at least certain aspects of the works which cannot be ignored.

It is to the biographical sphere that we are immediately led. One of the anagrams of *Carnaval* is made up of the letters of Schumann's name which correspond to German musical notations; another anagram spells out the native city of a girl, Ernestine von Fricken, to whom Schumann was briefly engaged.[5] These anagrams provide the motivic basis for a kaleidoscopic series of pieces, some of which appear to be portraits: there is even a parody of Chopin which includes an example of typical Chopin fingering. Schumann seems to create, like Byron with *Don Juan,* a shadowy region somewhere between art and life.

His work at times takes the form of a private joke; at others it appears to be an expression so personal as to be incommunicable. These are essential characteristics of Schumann's style, and they have naturally stimulated critics to hunt for the personal or literary inspiration behind each work, in spite of Schumann's warning that the titles to his pieces were conceived after the music was written. Much of the research is weakened by the failure to recognize the extent to which Schumann's attempts to find literary analogues for his music are not personal but based on commonplace Romantic theory about the relations among the arts. Just as the Romantic painters were to attempt to make landscape become the vehicle for the expression of feelings and ideas without taking on the character of an emblematic language and losing its existence as pure landscape, so Schumann was to create a musical technique that allowed music to assume the functions of literature without taking on a literary meaning—that is, without losing its status as music.

The new collection of essays on Schumann, edited by Alan Walker, contains an important discussion by Leon Plantinga of

5. S (Es, or E flat in German), C, H (the German for B) and A; A,S,C,H (or in another form As [A flat in German], C,H).

Schumann's work as editor of the most significant musical journal of its time, and there is an entertaining and very readable biographical sketch of Schumann by Walker. Many of the other contributors attempt a reassessment of Schumann's later years when he largely abandoned the piano music and the songs which remain his greatest achievements.

In his practice, Walker claims that the case for a new major study of Schumann rests largely on the information about him which has recently come to light. He gives only three examples: the diagnosis of Schumann's fatal disease as syphilis, not hereditary insanity; the evidence that there was nothing wrong with his metronome; and the recent understanding that Schumann's music springs from the source of "Schumann's special interest in symbols, codes, crosswords, chess, and even acrostics." Only the third example seriously affects our understanding of the music, and in recent years a specialized musicological industry has arisen, devoted to the deciphering of Schumann's "code."

Chief of the new Schumann cryptographers is Eric Sams, who contributes two essays to the symposium, one on the songs and another on the literary and biographical references of Schumann's short motifs. For Sams, Schumann's style is notable above all for its reliance upon tiny four- and five-note themes, "its structure of music *qua* mosaic, an aggregation of small-scale motifs." Sams is not interested in how these mosaics are put together, although what is most original in Schumann is his ability to make apparently fragmentary pieces hang together as a whole. Every composer since Bach has used short motifs as the essential element in creating any musical texture; and these motifs are as apparent in Beethoven as in Schumann, and even as obsessive. Schumann, nevertheless, found a new way of using them.

What Sams wants to know, however, is what these motifs mean. Unfortunately, that is the wrong question: what we should ask is how these motifs convey a meaning, how they function within the work so that their latent power is released. Sams claims that thanks to Susanne Langer it has only in modern times become "intellec-

tually respectable" to imagine "musical sounds as semantic symbols." This was, however, the conviction of most of the Romantic philosophers. In the essay on landscape quoted above, Schiller writes that "every continuity with which lines in space or sounds in time follow each other is a natural symbol of the inner consistency of the mind *(Gemüt)* and of the moral connection between action and emotion." Schiller was followed in this by Novalis, Schelling, and others, but they all held that the symbolic meaning is only comprehended within the framework of a larger form—within a specific context from which the individual motif draws its meaning: that is why they are at least as respectable as Susanne Langer. Schumann could not, in spite of Sams's contention, have been bewildered by his own belief that musical sounds were symbols: everybody agreed with him.[6]

Symbols are not simple associations; a madeleine in a spoonful of tea may signify Combray to Marcel, but it does not automatically work for anyone else. Schumann gallantly wrote many times to Clara that his latest piece was about her. It was a handsome sentiment, but are we to take it on trust? Music is not like mathematics where definitions (let x equal Clara) are accepted in advance.

Does the opening of the eleventh piece of the *Davidsbündlertänze* signify Clara? Sams, following Roger Fiske, claims it does. He points out that it is the retrograde, transposed form of a five-note theme in which the first, third, and fifth notes are C, A, and A. But why is Clara played backward?

In the *Davidsbündlertänze,* she is not only always played backward (except when heavily disguised with musical ornaments), she is always transposed, generally up a whole tone. In *Carnaval,* she is named *Chiarina,* but she gets played backward again, hung with grace notes, and, worse yet, her first three notes spell out the home town of Ernestine von Fricken.

After Schumann married Clara, she was at last played forward

6. Sams's position is complicated by his accepting the claim of several English musicologists that a succession of pitches, independent of rhythm or harmony, has a precise emotional content, but this idea is too nonsensical to be considered here.

at her right pitch in the Piano Concerto and in the Fourth Symphony.[7] He told her (as so often) that the symphony would be about her. Her theme dominates the work, indeed, and is played at the right pitches (C,b,A,g,A) in the slow movement, although she is transposed throughout the first movement until near the end (unless one counts a hidden appearance in an inner voice, with the third note repeated so she would come out *Claara*).

In a brilliant and very astute observation about Schumann's ABEGG variations, opus 1, Sams has dynamited his own method of analysis. He asserts, and he has very good evidence, that there was no Countess Abegg—she was an invention of Schumann based on his reading of the novelist Jean Paul.

In other words, the ABEGG theme was a purely musical inspiration, to which Schumann later attached a literary association, even inventing a character and dedicating the piece to her. We may now believe that Schumann told the literal truth when he claimed to think up his titles after writing the music. To see the extent to which he may, in turn, have been inspired by these extramusical connotations, we would need to study Schumann's manuscripts. These are questions, however, that concern only the psychology of composition, and we must reject the naïve identification of this with the significance of music. Books and anagrams stimulated Schumann to creation: with Schiller it was the smell of rotten apples, with Wagner a velvet dressing gown, but no one has yet seriously pretended to read these into their works. (None of this reckons with Schumann's humor, his sense of fun, what must have been his delight at discovering anagrams, cross references, and affinities in works of music originally created without any of the elaborate hocus-pocus he enjoyed adding to them.)

All this cryptographic research is sad, above all because it obscures the fact that Schumann's music does go beyond the limits

---

7. She is also played upside down throughout Schumann, and at her right place going forward in the finale of Mozart's A minor Sonata; in fact, she appears often in Mozart and in any other tonal composer. The "Clara" theme is so basic to tonal music that it would be hard to find any considerable work in which it does not often appear in some form or other.

of what was thought possible for music until his time, and it prevents us from understanding how.

Schumann's originality is perhaps most easily seen with his musical quotations. As a motto to the C major Fantasie, opus 17 (written as a memorial to Beethoven), he put some verses of Friedrich Schlegel which speak of one soft note that sounds through all else for the secret listener. Then he wrote to Clara: "Are you not the note in the motto? I almost think you are." The "almost" goes disregarded by the commentators. But the themes of the first movement seem to be derived from a common source. At the very end of the movement, we find out what the source is: Schumann quotes the opening of the last song of Beethoven's cycle: "To a distant beloved."

This quotation is relevant since Schumann has found a way of making it sound like a quotation; he invented musical quotation marks. The phrase of Beethoven is set off in several ways. First, it occurs at the first moment of complete stability and of full large-scale resolution in the entire movement. In this C major piece, Schumann withholds the central chord of C major in its fundamental position until this last moment.[8] This is the first work in history to postpone a stable tonic until the end of a long movement; the harmonic conception is a revolutionary act. In addition, this quotation sounds like a memory: it recalls most of the principal themes, and it at last presents the material that went into these different themes in its simplest form.

These qualities of recollection, simplicity, and long-awaited stability set the quotation from Beethoven in relief.[9] It appears as a

8. It is actually anticipated a few measures before, but does not function there as a stable tonic, but as a movement to the subdominant.

9. Yonty Solomon, who writes on the piano music, believes that Schumann abandoned his plan to quote from Beethoven's Seventh Symphony in the finale of the Fantasie. The quotation, however, is there, and Schumann even chose the few measures of Beethoven's slow movement which he found repulsive and irritating. He transformed these measures although keeping the theme intact, perhaps to show how it should be done. But it does not sound like a quotation and is therefore not significant *as a quotation*. Interestingly enough, however, it is almost certainly the passage from his own Fantasie that Schumann loved best, perhaps because he had made it so much his own.

new theme introduced at the very end of the movement and yet it sums up melodically everything that has gone before. It was also a tune recognized by every cultivated musician.[10] The first movement of the Fantasie in this way carries us from the literary conception of Schlegel's motto, which is itself about music, to an almost purely musical significance.

Schumann quoted from himself in much the same way. A theme from the *Papillons,* opus 2, appears in *Carnaval,* with the same effect of quotation marks, here achieved by a brutal change of tempo as a fragment of the theme is played: then the original tempo returns, again changes without warning, and the whole theme is now given. The effect of quotation does not depend upon the listener's having heard it before. The structure is designed to make the phrase sound like an intruder from outside the work. These are not private allusions, comprehensible only to the composer and a few of the elect, but public, an essential part of the structure of the music, and of the effect the music makes upon us. Recognizing the source of the "quotations," in fact, adds very little to what the music itself tells us: they work from within. (For this reason, the interest of the resemblance Alan Walker finds between a children's piece by Schumann and a Beethoven violin sonata is minimal. If Schumann really had Beethoven's theme in mind here, he was not quoting but plagiarizing.)

Is Schumann's music what is called "program music"? Does it continually depict, illustrate, or evoke extramusical scenes or ideas? In one important respect, the most clearly programmatic elements in Schumann differ radically from those in composers before and after him. The creation of light and of the different animals in Haydn's *Creation,* the nightingale, the flowing brook, the thunderstorm of Beethoven's *Pastoral* are all imitative effects whose program is completely intelligible outside their respective works: when they are pulled out of context we can still recognize what

10. The authors of the symposium seem to believe that Abert in 1920 was the first to recognize the source. But in 1838 it must have been heard by most musicians, certainly by Liszt, to whom the Fantasie was dedicated.

they portray, as we recognize the sheep and the windmills of Strauss's *Don Quixote* without listening to the rest of the work.

But Schumann's programs—if that is what to call them—are not comprehensible outside their works. The quotation from Beethoven in the C major Fantasie makes sense only if the whole first movement is taken into account: otherwise it would be a meaningless plagiarism. The title "Kreisleriana" Schumann gave to a set of piano pieces derives from a work by E. T. A. Hoffmann; it applies to no one piece but to the violent, satirical contrasts of passion and humor of the set as a whole.

The melancholy opening song of the *Dichterliebe* begins as if in the middle and ends, as if unfinished, on an unresolved dissonance with its opening phrase. Do we need Heine's words about the return of spring with desire and longing to understand this? The words make an already clear meaning only a little more explicit. By attacking the traditional concept of the beginning and end of a song, Schumann appears to step outside of music; but the dissolution of traditional limits which gives the work its extramusical significance becomes a formal device which transforms and reincorporates this significance into the music.

An attempt to describe these "extramusical" meanings of Schumann's in other than purely musical terms always breaks down. His direction "As if from a distance" in the *Davidsbündlertänze* is a musical direction: the effect of spatial distance comes from the resonance in the wide spacing of the chords, the wash of pedal that slightly blurs the sound, and the soft echoes. The concept of space is integrated here directly into music, an element outside of the art brought within. We cannot therefore treat the music as form and the spatial effect as content or meaning, as we could with traditional examples of program music. The idea of space has been turned into an aspect of musical form.

The programmatic effects of Haydn, Beethoven, Strauss, and others are musical expressions of things that are as easily rendered by words or images. Schumann wanted an immediacy of expression, in which there is no possibility of verbal intrusion between the music and its meaning. We may interpret Schumann's music

but we cannot translate it. His literary titles are not extramusical significances: they are merely poetic resonances added after the fact or, most often, directions to the performer to guide the interpretation.

Even in the songs where the music directly illustrates the poetry, Schumann reaches out in a purely musical way. His song, *Im Rhein,* about the painting of the Virgin in Cologne Cathedral, begins with an image of the cathedral mirrored in the river. Sams believes that the rhythm in the right hand of the piano accompaniment imitates the waves of the Rhine. If the Rhine ever flowed with that jagged rhythm, the authorities of Cologne would do well to evacuate the city. The right hand is indeed imitative, however: it is intended to recall the dotted rhythm of early eighteenth-century music. For the nineteenth century, Bach was like Gothic architecture (an idea no longer acceptable to cultural historians with more rigid ideas of chronology, but widespread between 1780 and 1850), and Schumann is portraying Cologne Cathedral by quoting a style.[11]

Most radical is Schumann's treatment of the relation of voice and piano. It is the piano that generally carries the full melody, while the voice, sometimes out of phase, picks up some of the notes, appearing to respond with words. For the Romantic writers, above all J. W. Ritter and E. T. A. Hoffmann (the latter one of Schumann's best-loved authors), music is the primary, generalized form of speech. Languages are only individualized versions of music. Schumann's songs carry out this philosophy, turning it into a radically different conception of the *Lied.*

A small detail in the Humoreske of 1839 for piano anticipates Schumann's triumph in 1840 in combining words and music. Sams writes that one section of the Humoreske is written on three staves instead of two in order to set off the melody on a separate staff of its own. But Sams never mentions that the third staff is not intended to be played at all. There is one staff for the right hand,

---

11. The occasional explicitly programmatic moments in Schumann are generally imitations of music: oboes (in the F sharp minor piano sonata), dances and balls (in *Papillons, Carnaval,* and the song cycles).

one for the left, and a third between them for an inaudible music: in her edition, Clara Schumann firmly marked this staff "not to be performed." The melody (marked "Inner voice") is only to be imagined. What the listener hears is an accompaniment which is clearly nothing more than that, but which appears to echo and respond to an absent melody.

There are larger forms by Schumann that appear to step outside music, but in no other detail does he so clearly indicate his ambition to create music that is beyond the limits of the merely audible. Yet his method is itself immediately absorbed back into the art it has transgressed: this shadowy evocation of the immaterial can only be conceived and understood in specifically musical terms.

There are, indeed, in both Friedrich and Schumann a few works in which a verbal message or a private reference is implied. A pair of pictures by Friedrich may be mentioned here. In one, a man on crutches stands in a winter landscape with dead oaks and tree stumps; in the companion piece, the man has thrown away his crutches, the oaks are replaced by evergreens, and the shape of a visionary church in the distance clearly resembles an evergreen tree. The allegory is all too painfully clear. But there are not many of Friedrich's pictures, and none at all after 1815, in which the symbolism operates so crassly, and there is no justification for trying to reduce the greater works to this level. Similarly, the appearance of the words of Gretchen's Song from *Faust* over some notes in Schumann's Intermezzi for piano suggests a reference to a private world that the music does nothing to explain. But this kind of detail is rare in Schumann, and the heroic successes are not to be elucidated by an appeal to Schumann's biography.

The criticism of art which claims to break a private code and to provide a dictionary of the meaning of the encoded elements embodies two misconceptions about art and language which are generally benign and sometimes even useful, but which are particularly harmful when dealing with the early nineteenth century. The first is that art is in all respects a language. The analogies of

art and language are many and suggestive, they are indispensable to any serious view, but art lacks exactly that characteristic of language that enables one to compile a dictionary: translatability, or the possibility of substituting one sign or set of signs for another.

Translation in the arts creates an immediate sense of discomfort, a decided uneasiness. We are not sure what proper translation would be. Does an engraved illustration of a poem translate even part of it? Can one be substituted for the other as we can substitute a definition for a work or a French expression for an English one, and still keep approximately the same meaning? Can Schumann be translated into Mozart? Can a picture by da Vinci be translated into one by Rubens—to take the famous example of Ruben's transformation of da Vinci's Anghiari cartoon? Is one a proper substitute for the other?

The last question moves toward nonsense, as if it were not already clear that the place of substitution in art is indeed very dubious. But the possibilities of substituting one set of signs for another is necessary to the functioning of language, and fundamental to the concept of a dictionary. The idea of compiling a glossary of meanings for art seems to challenge one essential aspect of art which insists on the uniqueness of each use of a symbol.

The second misconception is about language: the conviction that meanings can be isolated outside of any situation or context. A dictionary is only a convenient fiction, "What royal decree," wrote Lichtenberg, "ordained that a word must have a fixed meaning?" Meanings fluctuate, although not absurdly or unpredictably: they redefine themselves in new situations. The dynamics of this fluctuation may be studied and controlled, but we cannot maintain that a sign or word is always used with only one of the senses of the dictionary at a time. All the more reason to see that the signs in Friedrich and Schumann, pictorial and musical, cannot be given single, simple meanings in isolation: they take their meaning from a great variety of forces, few of them as direct and as easily definable as we might like to imagine.

This flexibility (or instability) of meaning is as essential to language as the possibility of substituting one word for another,

which helps to stabilize meaning. But each use of a word may, if we choose, be considered as unique—related to all other previous and possible uses, but individual and irreplaceable, as untranslatable as a work of art.

In this sense, the *possibility* of art is always present in language. No one was more conscious of this than the poets and artists of the early nineteenth century for whom it had become dogma. Everything for them was potentially language, and therefore potentially art. "Anything can be a symbol," wrote Novalis, and added that the relation of a symbol to its meaning could always be reversed: the meaning could become the symbol, the content could become symbolic form. The freedom of the symbolizing power of the imagination implied a radically new vision of language.

Above all, the symbolic language they wanted for art was to be a natural one—that is, not derived from the arbitrary conventions that were handed down by tradition. If the elements of Nature—sounds, shapes, forms—had an inherent meaning, as they believed, then the traditional accretion of ascribed meanings had to be abandoned as far as possible. The painters threw overboard much of the traditional religious iconography, with its rich complexity and its resources of meaning. The poets ignored, or tried to ignore, the whole traditional baggage of rhetoric that had been taught over the centuries.

What they tried to destroy, in fact, were those aspects of the "language" of art which could be codified, which were susceptible to lexicography. Useful dictionaries of traditional religious iconography have been published; but so far as a dictionary of Romantic iconography could be compiled—at least for the years 1800 to 1835—it would be chiefly a measure of the artists' failure. This early nineteenth-century philosophy of art may appear today like an aesthetic of crisis, a measure of desperation when traditional forms had broken down. We may doubt that forms have a meaning independent of culture, that language is immanent in Nature. But there is no question of the achievement: Wordsworth, Hölderlin, Constable, and Friedrich contrived to let the elements of Nature

appear to speak directly and without intermediary; Schumann and Berlioz caused elements of abstract musical form to bear meanings that are analogous to verbal meanings (if rarely coincidental with them).

Perhaps the most radical of these artists are Friedrich and Schumann. Each one expanded the limits of his art, triumphed over his medium by playing the conceptions of art and language against each other. For this reason, when dealing with their achievement, we must be doubly conscious of the limitations of both art and language: it was with these limitations that they worked. They counted on our sense of their art's going beyond what was possible, only to find it once more reintegrated in a purely pictorial or musical form. The interpretation of each work can never be imposed from outside, even by means of a generalization about the artist's total style; it must begin again each time from within.

## Postscript, 1998

In reply to this review, Helmut Börsch-Supan wrote to insist that Friedrich "speaks a very private language," referring, although without any specific detail, to contemporary interpretations by Ludwig Tieck and G. H. Schubert, and to reiterate the claim I was contesting—that is, that the significance of a motif in Friedrich remains identical from one painting to another. For him, "the meaning of an abruptly ending avenue becomes clear when one examines this motif in the artist's total *oeuvre*." I tried to clarify my position:

> Börsch-Supan, understandably aggrieved, is unwise to call attention to the appendix of his catalog. The documents which are printed there do not at all bear witness for his side in the matter upon which we disagree. He is mistaken in imagining himself in the company of Tieck and G. H. Schubert: neither of them claims, as he does, that the meaning of the elements in Friedrich's art remains fixed from picture to picture.
>
> The point at issue is not whether Friedrich's pictures have religious and, sometimes, "allegorical" meanings (although that is a

word whose meaning has often shifted radically, and was given different interpretations during Friedrich's own lifetime). That much is fundamental and obvious and admitted by anyone. What is debatable is how these meanings are to be read.

Börsch-Supan claims that Friedrich's language is "private"; but this is true only in so far as it is not a traditional one. It is astonishing and even sad that he has not drawn the logical and immediate conclusion: that the meanings of the elements of Friedrich's language cannot be discovered as if they were parts of a traditional, completely public, but not yet understood tongue, by comparison and decoding. That is why the documented comparisons he promises in his forthcoming book hold out no hope for understanding. They represent the way of finding out the meanings of the traditional iconography of previous centuries, the traditional iconography that Friedrich, like most of his contemporaries, rejected because the meanings were "arbitrary," imposed from without. They had to be learned, as Börsch-Supan proposes to learn Friedrich's; and if he is right, then Friedrich's pictures do not work. Börsch-Supan, in fact, can only illuminate Friedrich's failures. Tieck, in a passage that Börsch-Supan does not print but which follows closely upon the one he does, calls attention to the failures, to the occasional works by Friedrich whose meaning is arbitrary, private, unrevealed through the pictorial forms.

Friedrich's greatness—and he was a very great painter—lies elsewhere. Of all the documents printed in the appendix, the closest to Börsch-Supan's view is that of the painter Ludwig Richter, who hated Friedrich's work. It is the misunderstanding of men like Richter that made Friedrich's work forgotten for so long. I see no point in trying to revive his view. Friedrich's own opinion was that his language was not private but accessible. As he himself wrote (and as Börsch-Supan prints in the appendix): "Just as the pious man prays without speaking a word and the Almighty hearkens unto him, so the artist with true feeling *paints* and the sensitive man understands and recognizes it; while even the less sensitive gain some inkling of it." There is not a word here of a private language. A comparison of Friedrich's pictures will tell us *how* he conveyed meanings, not *what* meanings: only an interpretation of the forms of each work can lead us to that.

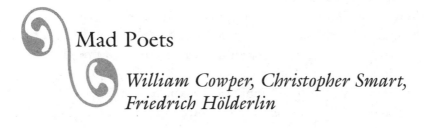

# Mad Poets

## *William Cowper, Christopher Smart, Friedrich Hölderlin*

The first severe attack of the depression that was to make so much of the life of the poet William Cowper an unbearable torment occurred when he tried to take up the practice of the law. Born in 1731, the son of a Hampshire rector, he was unstable from infancy; he lost his mother when he was six and he was mercilessly bullied at school. His elegant poetic talent was late in appearing. In the moving account of his melancholy and his religious faith, *Adelphi,* he writes:

> I became in a manner complete master of myself and took possession of a set of chambers in the Temple at the age of twenty-one [in 1753]. . . .
>
> I was struck not long after my settlement in the Temple with such a dejection of spirits as none but they who have felt the same can have the least conception of. Day and night I was upon the rack, lying down in horrors and rising in despair.

Originally written in 1992 as a review of James King and Charles Ryskamp, eds., *The Letters and Prose Writings of William Cowper,* vols. 1–5; James King and Charles Ryskamp, eds., *William Cowper: Selected Letters;* and Karina Williamson and Marcus Walsh, eds., *The Poetical Works of Christopher Smart,* vols. 1–4.

The religious poetry of George Herbert provided some consolation, although by 1753, the poems of the previous century were bound to seem, as Cowper called them, "gothic and uncouth." Cowper was related on his mother's side to John Donne, who also, no doubt, seemed gothic and uncouth.

Cowper's own poetry enjoyed a great reputation for at least a half century after his death: it has since lost much of its luster. The new critical edition, of which only the first volume has been issued, may restore it. However, most of his verse is probably too amiable and diffuse for modern readers—it retains some of the elegance of Pope's style without the extreme formality, but also without the malice or the bite. His correspondence, once as famous as his poetry, is in many ways a more impressive achievement. He seizes the tone of conversation without mannerism, and makes the people to whom he wrote live for us.

During this initial onset of madness, prayer was some help, but the temporary cure, when it came a year later, was achieved in true eighteenth-century fashion by landscape, the sight of the sea near Southampton:

> Here it was that on a sudden, as if another sun had been kindled that instant in the heavens on purpose to dispel sorrow and vexation of spirit, I felt the weight of all my misery taken off. My heart became light and joyous in a moment, and had I been alone, I could have wept with transport.

Ten years later, in 1763, the second professional crisis of Cowper's life was the occasion for his second point of depression. A member of a popular group of young writers (called "the Geniuses") who founded the Nonsense Club, where they read aloud their works, he spent the decade writing light poetry. He had not been a success as an attorney and had wasted most of his patrimony, but there was a chance of his being named Clerk of the Journals in the House of Lords, a lucrative position that was at the disposal of one of his kinsmen. "The business of that place, being transacted in private, would exactly suit me," observed Cowper. A rival for the post appeared however and opposed the

nomination, and Cowper was told that he would have to appear for an examination at the Bar of the House to see if he was qualified.

> Being necessarily ignorant of the nature of that business, it became expedient that I should visit the office daily in order to qualify myself for the narrowest scrutiny. All the horrors of my fears and perplexity returned. A thunderbolt would have been as welcome to me as this intelligence. I knew to a demonstration that upon these terms the Clerkship of the Journals was no place for me. To require my attendance at the Bar of the House that I might there publicly entitle myself to the office was in effect to exclude me from it. . . .
>
> My continual misery at length brought on a nervous fever. Quiet forsook me by day and sleep by night. A finger raised against me was now more than I could stand against.

Once again Cowper tried prayer, but without hope: "I saw plainly that God alone could deliver me, but was firmly persuaded He would not and therefore omitted to ask it." Finally, Cowper reached the limits of his despair:

> I now began to look upon madness as the only chance remaining. I had a strong foreboding that it would fare so with me, and I wished for it earnestly and looked forward to it with impatient expectation.

Madness seemed to Cowper a solution—in fact, as he writes, his "only chance." It is, of course, a solution like suicide, and depended equally on a strange mixture of cowardice and courage. Cowper did indeed attempt suicide several times, and his detailed accounts of his failures are painful to read. The report of his attempt to hang himself lost him the post in the House of Lords that he had both hoped for and dreaded. It was at this point that Cowper's depression took a new and most terrifying form: religious despair. Awareness of sin brought him the sudden conviction that he was eternally damned. Everything he now did only seemed to confirm this:

In every book I opened I found something that struck me to the heart. I remember taking up a volume of Beaumont and Fletcher which lay upon the table in my kinsman's lodging and the first sentence I saw was this, "The justice of the gods is in it." My heart immediately answered, "So it is of a truth," and I cannot but observe that as I found something in every author to condemn me, so it was generally the first sentence I pitched upon. Everything preached to me, and everything preached the curse of the Law. . . .

Cowper's madness led him to devise clever tests to confirm his ultimate damnation:

I made many passionate attempts towards prayer, but failed in all. Having an obscure notion about the efficacy of faith, I resolved upon an experiment to prove whether I had faith or not. For this purpose I began to repeat the Creed. When I came to the second period of it, which professes a belief in Christ, all traces of the form were struck out of my memory, nor could I recollect one syllable of the matter. While I endeavoured to recover it, and just when I thought myself upon the point of doing so, I perceived a sensation in my brain like a tremulous vibration in all the fibres of it. By this means I lost the words in the very instant when I thought to have laid hold on them.

The assurance by a clerical friend of "the corruption of every man born into the world, whereby we are all the children of wrath, without any difference" brought Cowper some consolation, as it has comforted generations of Puritans. "This doctrine set me more upon a level with the rest of mankind and made my condition appear to me less desperate." The moments of confidence, how-ever, were very brief and Cowper's torments were to last another eight months. They were no less painful for being self-inflicted:

I slept my usual three hours well and then awakened with ten times a stronger sense of my alienation from God than ever. Satan plied me close with horrible visions and more horrible voices. . . . A numbness seized upon the extremities of my body, and life seemed to retreat before it. My hands and feet became cold and stiff; a cold sweat stood upon my forehead; my heart seemed at every pulse to

beat its last and my soul to cling to my lips as if upon the very point of departure.

For Cowper, total madness still seemed a solution, and when it came and he finally achieved what he had longed for, the moment was the most terrifying of all:

> At eleven o'clock my brother called on me, and in about an hour after his arrival that distemper of mind which I had before so ardently wished for actually seized me.
>
> While I traversed the room in the most terrible dismay of soul, expecting every moment the earth would open her mouth and swallow me, my conscience scaring me, the avenger of blood pursuing me, and the city of refuge out of reach and out of sight, suddenly a strange and horrible darkness fell upon me. If it were possible that a heavy blow could light upon the brain immediately without touching the skull, such was the sensation I felt.

Cowper was taken by his brother to an asylum where he was treated with a humanity as rare in our time as it was in the eighteenth century. Even there, he attempted suicide. This period of depression lasted eighteen months, after which he renounced all his professional life and most of his income, and retired to live quietly in the country.

Another decade passed quietly, while Cowper was lodged in the house of friends, the Reverend Morley Unwin and Mrs. Unwin, whose piety resembled and sustained his own. During this time, Cowper was persuaded to write hymns by the evangelical preacher John Newton, a former slave-trader whose brutal and fanatical character cannot have helped Cowper's mental instability. The evangelicals were believed by their High Church enemies to encourage insanity. "There is not a madhouse in England," wrote Sydney Smith, "where a considerable part of the patients have not been driven to insanity by the extravagance of these people."[1]

On the death of the Reverend Unwin, Cowper's neighbors and friends felt that it was improper for him to continue to live in the same house as the widow without marrying her. Accordingly, he

1. From the first of two articles entitled "Methodism," *The Edinburgh Review*, 1808.

became engaged to Mrs. Unwin, who was, as he said, like a mother to him. The engagement was broken by his third period of depression in 1773. It would appear as if his crises were each neatly calculated to release him from the need to face his responsibilities—or what his society held to be his responsibilities, an opinion to which Cowper mildly subscribed. Nevertheless, his madness gave him the leisure to write his poetry and his correspondence, while driving him from his profession and from the distractions of London. "God made the country, and man made the town," he wrote resignedly after madness had reduced him to poverty, and he was living largely upon the charity of the friends who loved him.

Cowper did not choose madness: it chose him, and he acquiesced. The words "voluntary" or "involuntary" cannot be made relevant in his case. The full extent of his madness is revealed by his belief that God had commanded him in a dream to commit suicide. He was not able to carry out the command, and this was his unforgivable sin. God had rejected him for this, and from then on Cowper, deeply and fanatically religious, never attended a church service and never uttered a prayer. There was no use in prayer: he no longer existed for God.

In his poetry, which always displays a delicate balance of the didactic and the playful, and in his exquisite correspondence with friends and relatives, he deals with his pathological melancholy for the most part obliquely or politely. The most beautiful account is the letter of January 16, 1786, to his cousin Lady Hesketh:

> You do not ask me, my dear, for an explanation of what I could mean by *anguish of mind,* and by *the perpetual interruptions* that I mentioned. Because you *do not* ask, and because your reason for not asking consists of a delicacy and tenderness peculiar to yourself, for that very cause I will tell you. A wish so suppressed is more irresistible than many wishes plainly uttered. Know then that in the year 73 the same scene that was acted at St. Albans, opened upon me again at Olney, only covered with a still deeper shade of melancholy, and ordained to be of much longer duration. I was suddenly reduced from my wonted rate of understanding to an almost childish imbecility. . . . I could return a rational answer even to a

difficult question, but a question was necessary, or I never spoke at all. . . . I believed that every body hated me, and that Mrs. Unwin hated me most of all; was convinced that all my food was poisoned, together with ten thousand megrims of the same stamp. . . .

It will be thirteen years in little more than a week, since this malady seized me. Methinks I hear you ask,—your affection for me will, I know, make you wish to do so,—Is it removed? I reply, in great measure, but not quite. Occasionally I am much distressed, but that distress becomes continually less frequent, and I think less violent. I find writing, and especially poetry, my best remedy. . . . As soon as I became capable of action, I commenced carpenter, made cupboards, boxes, stools. I grew weary of this in about a twelvemonth, and addressed myself to the making of birdcages. To this employment succeeded that of gardening, which I intermin-gled with that of drawing, but finding that the latter occupation injured my eyes, I renounced it, and commenced poet. I have given you, my dear, a little history in shorthand; I know that it will touch your feelings, but do not let it interest them too much. *In the year when I wrote the Task,* (for it occupied me about a year), *I was very often most supremely unhappy,* and am under God indebted in good part to that work for not having been much worse. You did not know what a clever fellow I am, and how I can turn my hand to any thing.

This is written with extraordinary tact. In *The Madhouse of Lan-guage,* an interesting and stimulating recent book about descriptions of madness and the writings of madmen in eighteenth-century England, Allen Ingram cites a similar letter to John New-ton and claims that

Cowper's emotions are so well in hand that his prose is at times hardly in touch with them at all. The balance and propriety of a grammar and expression . . . suggest not an engulfment by feelings of despair but rather a linguistic endeavour that is at a remove from the reality of the obsession and of the terrible knowledge that lies behind it.[2]

This is to displace the center of gravity of Cowper's prose: it is not with his own emotions that he seeks to remain in touch, but with

2. Routledge, Kegan and Paul, 1991, p. 152.

the feelings of his correspondent. The wonderful achievement of Cowper's letters is the sympathy realized at almost every point with those to whom he writes.

Even in those letters from the last months of his life, in the depths of his irrational misery, he conserves the sense of what the friend to whom he writes will comprehend, as in the following letter to Lady Hesketh of January 22, 1796:

> My thoughts are like loose and dry sand, which the closer it is grasped slips the sooner away. Mr. Johnson [a distant relative] reads to me, but I lose every other sentence through the inevitable wanderings, and experience, as I have these two years, the same shattered mode of thinking on every subject, and on all occasions. If I seem to write with more connexion, it is only because the gaps do not appear.

It is, indeed, only through an effort of sympathy with another that he could deal adequately with his madness in his poetry— particularly in the brief masterpiece of his last year, 1799, the account of a drowning man in *The Castaway*.

> Not long beneath the whelming brine,
>     Expert to swim, he lay;
> Nor soon he felt his strength decline,
>     Or courage die away;
> But waged with death a lasting strife,
> Supported by despair of life.

Nineteen years after Cowper's death, William Blake, fascinated by a passage on religious mania in a book by Spürzheim called *Observations on the Deranged Manifestations of the Mind, or Insanity*, wrote in 1819 on the flyleaf an account of a vision of William Cowper. (I presume that Blake had read *Adelphi*, which had been published three years before.)

> Methodism, &c. 154. Cowper came to me and said: "Oh! that I were insane, always. I will never rest. Cannot you make me truly

insane? I will never rest till I am so. Oh! that in the bosom of God
I was hid. You retain health and yet are mad as any of us all—over
us all—mad as a refuge from unbelief—from Bacon, Newton, and
Locke.

"Mad as a refuge from unbelief"—from what was felt as the
monotonous and unsatisfying rationality of the modern scientific
and philosophic movement.

Blake, like Cowper, found madness an escape, a way of life that
could be chosen with all its terrors. (I use the word "madness" in
the loose meaning it had then—as any extravagant form of alien-
ation either of behavior or of perception.) Blake's madness was a
happier solution than Cowper's, his sanguine temperament was
sustained by indignation. He could identify the enemy: Bacon,
Newton, and Locke—and, above all, Sir Joshua Reynolds, presi-
dent of the Royal Academy.

In the late eighteenth century and early nineteenth centuries,
madness had its attraction as well as its miseries. On June 9, 1796,
the young Charles Lamb wrote to his equally youthful friend,
Samuel Taylor Coleridge, about a brief period when he had been
in an insane asylum.

> I look back upon it at times with a gloomy kind of Envy. For while
> it lasted I had many hours of pure happiness. Dream not Coleridge,
> of having tasted all the grandeur & wildness of Fancy, till you have
> gone mad. All now seems to me vapid; comparatively so . . .

For Lamb, madness brought color and excitement into a drab
existence. Perhaps, too, he remembered a scene from Goethe's
*Werther,* in which a strange young man tells the hero about a time
in which he was as happy as a fish in water, and his mother later
confides that this period of happiness was when he had been held
in chains in a madhouse.

Roy Porter in *Mind Forg'd Manacles: A History of Madness in
England, from the Restoration to the Regency*[3] insists that, for the

3. Harvard University Press, 1987.

Romantics, poetic genius was not to madness near allied, but that genius was basically healthy, and calls as a witness Charles Lamb's essay "The Sanity of True Genius." He does not appreciate the irony in the essay, and, above all, he does not go far enough. For the Romantics, paradoxically, insanity itself was healthy. At the opening of *Aurelia,* his spiritual autobiography, Gerard de Nerval wrote:

> I shall try to transcribe the impressions of a long sickness which took place entirely in the mysteries of my mind—and I do not know why I use the word sickness, for never, as regards myself, have I ever felt in better health.

In a letter of November 9, 1841, to Mme. Alexandre Dumas, Nerval added:

> They only let me out [of the insane asylum] to move definitively among reasonable people when I agreed formally that I had been "sick," which made me lose much of my self-respect and even of my veracity. "Confess, confess," they called to me, as one did in the past to heretics and witches. . . .

It would be cruel to say that madness, always the subject of profound anguish, became fashionable between 1750 and 1850, but there is a grain of truth in the statement. At this time, madness became not simply a mental disability; nor was it only a withdrawal from the distress of everyday life, and a protest against intolerable social conditions or against a debilitating rational philosophy. It had gained a new ideological charge: madness was a source of creative energy.

Several of the finest German writers of the generation from 1770 to 1820 would be considered clinically mad by most standards: the career of Jakob Michael Lenz, the greatest of the *Sturm und Drang* dramatists aside from Goethe (and a close friend of Goethe's), was destroyed by mental illness; Friedrich Hölderlin passed the last decades of his life in an almost total schizophrenia;

Heinrich von Kleist ended his with a suicide pact; and the Romantic poet Clemens Brentano was afflicted with a religious melancholia and depression as great as Cowper's. In these cases and others, the most remarkable creative work was accomplished before the onset of mental illness (unlike the case of the great mad English poets Christopher Smart and John Clare, who did some of their most memorable writing within the walls of an asylum).

Still, for all these writers—and for many of their contemporaries—madness was an ideal as well as an anti-ideal, a state that transcended consciousness, and that escaped the mechanical and blind workings of rationalism, but also a state that could not be controlled and could end with the destruction of the individual mind. Madness, for the Romantic artist, was more than the breakdown of rational thought; it was an alternative, which promised not only different insights but also a different mode of reasoning. As Hölderlin wrote in 1801:

Drum! und spotten des Spotts mag gern frohlockender Wahnsinn,
Wenn er in heiliger Nach: plötzlich die Sänger ergreift.
*(Bread and Wine)*

Indeed! and exultant madness likes to mock mockery
When it suddenly seizes the singers in holy night.

Madness was an unpredictable form of inspiration. It had its own methods of persuasion, a logic of the night and of dreams, in some ways as powerful and as convincing as the logic practiced during the day. Nowhere is this clearer than in the tales of E. T. A. Hoffmann, the German Romantic writer. In his stories, the world of everyday reality coexists with a world of delusion which gives significance to the former: the "real" world has priority but is unintelligible without the irrational and often absurd world of shadows, magic, and paranoia that is always present.

In Hoffmann's last work, *Meister Floh* ("Master Flea"), the young Georg Pepusch falls in love with the beautiful Dortje Elwerdink, the Dutch niece of the flea-trainer—who claims to be

the reincarnation of the scientist Leuwenhoek, buried a hundred years ago in Delft. He also claims that his niece is the Oriental flower princess Gamabel. When Pepusch finds Dortje kissing a military officer, she explains that this is the genie Thetel who had saved her back in Samarkand. Pepusch becomes certain that he knew Dortje in that former life, when he was a thistle who protected the flower princess. The author remarks:

> It was a good thing that [Pepusch] did not communicate this idea to other people: they would have believed him mad and locked him up, although the *idée fixe* of the partially mad is often nothing else than the irony of an existence which precedes the present.

This comic madness of children's fairy tales serves here as the basis for a bitter satire on the Prussian judicial system, one section of which was censored and only discovered in 1906 in the Berlin police archives.

Hoffmann was not more than marginally mad, but in the late eighteenth and early nineteenth centuries, he and many writers tried to enter sympathetically into the mind of the insane, or to create effects which playfully or seriously mimicked insanity, like the comedy of Ludwig Tieck's *The Upside Down World*, which begins with the epilogue ("Ladies and gentlemen, how did you like the play?").

In the literature of previous centuries, madmen are depicted as either serious or comic. Comic madmen are fools and eccentrics: they are congenitally foolish, like Don Adriano de Armado in Shakespeare's *Love's Labour's Lost* or Molière's Harpagon in *The Miser*. Serious madmen, on the other hand, are driven mad: Ophelia loses her mind because of Hamlet's cruelty; King Lear is made insane by his daughters' unnatural ingratitude; Orestes (in Racine's *Andromache*) goes mad after he commits murder when so ordered by the woman he loves, who then turns on him once the deed is done. Great occasions make for great madmen.

In theory, fools and madmen cannot be separated: the Fool in *King Lear* calls Lear a fool, and Hamlet's simulated madness is

mirrored by Polonius's foolish wisdom. In *The Anatomy of Melancholy* (of 1621),[4] Robert Burton affirms a universal madness:

> For indeed who is not a Foole, Melancholy, Mad?—. . . who is not brain-sick? Folly, Melancholy, Madnesse, are but one disease, *Delirium* is a common name to all.

We are all mad because man cannot tell truth from illusion: the senses delude us, there is no certainty except in divine revelation. Nevertheless, Renaissance literary decorum largely obliged writers to distinguish between the tragic hero, who becomes mad through great misfortune or great sin, and the pedants and bumpkins who illustrate the universal inbred folly.

This important but dubious distinction begins to slip away in the Enlightenment. It was now the routine of everyday life that drove men to insanity, and madness of the most tragic sort was revealed in the commonplace. In Goethe's sensational best seller of 1774, Werther may have committed suicide out of thwarted love (and he inspired an astonishing number of suicides among enthusiastic contemporary readers); but it was his inability to make a career at Court and his contempt for the society in which he was forced to live—the monotony of existence, in short—that created the emotional impasse in his life. Thackeray's famous parody reflects the new emotional climate:

> Werther had a love for Charlotte
> Such as words would never utter.
> Would you know how first he met her?
> She was cutting bread and butter.

The intolerable social conditions of everyday life could create an atmosphere of madness. In *The Tutor* (1774) by the *Sturm und Drang* writer Jakob Lenz, a comedy (as Lenz called it on publication) or a tragedy (as he described it in his correspondence), a poor young man, hired to tutor the children of an aristocratic family, gets the young girl pregnant, is forced to take flight, and

4. "Democritus to the Reader" (Oxford University Press/Clarendon Press, 1989), Vol. 1, p. 25.

eventually castrates himself. The play reflects Lenz's feeling of humiliation during his own experience as a tutor. Like Cowper, Lenz refused to adjust to the professional conditions of making a living. A few decades later, the madness portrayed by Wordsworth in *The Thorn, The Ruined Castle,* and *The Idiot Boy* is deeply rooted in the ordinary lives of the poor and the middle class.

The old truism that we are all slightly mad, which we saw in Burton and which runs through sixteenth- and seventeenth-century thought from Montaigne and Shakespeare to Pascal, now changes its meaning. When Valentine, in William Congreve's *Love for Love* of 1695, is, like Hamlet, simulating madness, he says, "I am Truth, and I can teach thy tongue a new trick."[5] It is no longer our innate incapacity to distinguish reality from illusion that makes us mad, but an active and aggressive refusal to acknowledge reality. "But I am Truth, and come to give the World the Lie," says Valentine. The resistance to reality has become not a simple innate imperfection, like original sin, but dynamic and creative. This made an understanding of madness essential to a view of humanity. Around 1780, the German satirist George Christoph Lichtenberg, who was to inspire so much of German Romantic thought, jotted down in his notebooks:

> From the folly of men in Bedlam, it should be possible to determine more about the nature of Man than has been done until now.

The deformation of reality that we call madness was beginning to be understood as an indispensable element of human nature— and not necessarily a perverse one. To some extent, after all, it is only a matter of convention and social pressure whether a person is certified as a lunatic. It is not clear that Cowper, with his conviction of damnation, or Blake, with his visions of angels and the ghost of William Cowper, was any more insane than those people today who believe that no one was gassed at Auschwitz, who think that the Biblical tower of Babel was built to sight intruders from outer space, or who maintain that AIDS is the just vengeance of

5. (Chicago University Press, 1967), Act IV, Scene I, line 488.

God on perverts and drug fiends. Which varieties of madness are to be stigmatized or isolated? The whole of our common culture is shot through with beliefs that are demonstrably irrational.

In the eighteenth century, the normalization of madness, like so much else, was influenced and confirmed by Rousseau. In the first book of the *Confessions*[6] he recounts his adolescent fear of revealing his desires:

> A thousand times, during my apprenticeship and since, I went out with the intention of buying some delicacy. I approach the pastry-shop: I see women at the counter; I already think I can hear them laugh and make fun of the little glutton . . . my desire grows with my shame, and I return in the end like an idiot, eaten up by desire, having enough in my pocket to satisfy it, and not having dared to buy anything.

This is perhaps the first description of the paranoia of everyday life, the terrifying conviction that revealing our secret desires puts us in the power of those who can read our minds. It was the intensity of his desire that made it impossible for Rousseau to buy his pastry: the paranoiac fear that he could not hide his thoughts. The roots of insanity are found in the trivial desires and acts that make up ordinary experience.

It was the mad poets who revealed this most clearly. Their truths caused embarrassment: "It is not," as Rousseau said, "what is criminal which is hard to speak, but what is ridiculous and shameful." In Kleist's *Penthisilea* of 1808 (a drama that Goethe rejected as morbid, and no wonder), the Amazon queen not only kills her lover Achilles in battle, but in a frenzy that transcends consciousness disfigures and eats him alongside her dogs. She comes to her senses, horrified to realize what she has done, yet remembering her delight:

> Like many who hang about the neck of the beloved,
> She spoke the words: she loved him, o so much
> That she could, from love, almost eat him.

6. Vol. 1 (Editions de la Pléiade, 1933), p. 37.

Then afterward she proved what she said, the fool.
  (scene 24, lines 2991–2994)

The greatest of Romantic dramatists, and the only one to write in a Shakespearean style who can be compared to Shakespeare without being diminished, Kleist was the master of embarrassment. I know of no more powerful and moving scene in tragedy than the third act of *The Prince of Homburg,* where the courageous young military hero, faced with a sentence of death, grovels like a terrified dog to beg for his life. It shames everyone on the stage and everyone in the audience.

In almost all these poets (Kleist is perhaps the one exception), insanity takes the form of religious mania. In every case, a protest is registered against the suppression of religious sentiment by the Enlightenment, and we might think we are witnessing the reaction against the French *philosophes,* a reaction which determined the religious revival after the downfall of the Jacobin leaders of the revolutions. Nevertheless, it is significant that for none of these poets did any respectable form of religion provide an inspiration or an adequate "refuge"—to use Blake's word for his madness. In the early career of the London poet Christopher Smart, between 1749 and 1759, we find little beyond some light satirical and didactic verse; his few religious poems are accomplished but not striking. In 1759, however, he suddenly attempted to make people in the street kneel down and pray with him, and this, along with his continual drinking, was the reason given for locking him up in a madhouse. (On his release he tried to sue the people responsible.) Clemens Brentano, the most exquisitely musical of German Romantic poets, returned to Catholicism in 1817: for the next seven years he took down the dictation of a nun who had miraculously received the stigmata of the crucified Christ, and tried to work her vision into a trilogy on the life of Christ; his conversion marked the end of his creative poetic activity.

Neither the blandly conservative established churches on the continent or in England nor even the new popular sects, like the Methodists, were able to fill an intellectual void, even if they could

satisfy some emotional needs. The religious thought, Catholic or Protestant, of the eighteenth and early nineteenth centuries is rarely stimulating: the one grand exception is the terrifying philosophy of Joseph de Maistre, for whom the life of any religious institution depended upon blind obedience to an absolutely arbitrary divine will, just as all civilization rested upon the continuous menace of capital punishment. His philosophy is a form of religious melancholia hardened into dogma, and its emotional power explains its curious fascination for intellectuals like Baudelaire.

De Maistre's great strength was that he could face absurdity without flinching. "The entire human race," he wrote, "comes from one couple. This truth has been denied like all the others. Who cares?" The eighteenth century as a whole, however, was embarrassed by absurdity, including the fundamental and profound absurdities of religion. "I believe in you," Voltaire once said, looking at a splendid sunrise, "but as for your son and *Madame sa mère,* that's something different." *Credo, quia absurdum:* "I believe, because it is absurd"—this is one of the oldest expressions of the Christian faith. "Absurd" here meant impossible, illogical, unjustifiable, and incomprehensible. It did not, until the eighteenth century, mean ridiculous, even comic. Perhaps not since the late Roman Empire, at the time of Lucretius, had the mysteries of religion seemed unworthy of serious consideration by most members of the governing classes. The Enlightenment condemned religious enthusiasm as appropriate only for the uneducated and the great unwashed, and tried to strip dogma of all the traditional mysteries, paradoxes, and foolishness. The result was an anodyne deism widespread among cultivated people throughout Europe and England; and David Hume at the end of his life made a devastating argument that the difference between deism and atheism was largely one of verbal emphasis.

Since the new philosophy of the Encyclopedists had removed the life-giving madness from religious thought and from religion, it is understandable that the only original and vital religious poetry between 1760 and 1840 should have been written by poets considered genuinely mad by their contemporaries: Smart, Blake, and

Mad Poets

Hölderlin. Smart's masterpiece is *A Song to David,* and it has a rapid succession of images and a rhythmic swing that carry the reader with increasing excitement along its eighty-six six-line stanzas. Published after Smart's release from the asylum, it made some critics conclude that Smart was as mad as ever: the most sympathetic critic found a "great rapture" and called it "a fine piece of ruins."[7] The most personal of Smart's works, *Jubilate Agno* ("Rejoice in the Lamb"), was so eccentric that it was not considered publishable until 1940. Written in imitation of Old Testament prose poetry (above all the Psalms and the Prophets), it combines Smart's own life with mystical and occult writing and the Bible. In the following lines the cryptic names Shephatiah and Ithream refer to two of the sons of King David:

> Let Shephatiah rejoice with the little Owl, which is the wingged Cat.
> *For I am possessed of a cat, surpassing in beauty, from whom I take occasion to bless Almighty God.*
>
> Let Ithream rejoice with the great Owl, who understandeth that which he professes.
> *For I pray God for the professors of the University of Cambridge to attend and amend.*[8]

Later in this work, the poet gives a striking description of his method:

> For my talent is to give an impression upon words by PUNCHING, that when the reader casts his eyes upon 'em, he takes up the image from the mould which I have made.

This punching[9] was not to eighteenth-century taste, and not until our century has Smart been given his due.

---

7. Quoted in Smart, *Poetical Works,* Vol. 2, Walsh and Williamson, eds. (Oxford University Press, 1983), p. 100.

8. Smart, Vol. 1, Fragment B, lines 68–69, edited by Williamson (Oxford University Press, 1980), p. 23.

9. Smart, Vol. 1, Fragment B, p. 69. Line 404: "punching" is in a larger script in the manuscript; I have added capitals. Williamson writes, "the metaphor is from type foundry."

The more Smart's poetry and religion reflect his madness, the more acceptable they are to readers in our time. It is hard to admire the more sober versification of the Psalms, in which "The Lord is my shepherd, I shall not want" becomes

The shepherd Christ from heav'n arrived
My flesh and spirit feeds
I shall not therefore be depriv'd
Of all my nature needs.

Madness clearly helped Smart to find an original voice.

William Blake invented his own religion by turning Christianity satirically on its head; Satan is the Messiah, and Evil is Eternal Delight. In his Prophetic Books he created his own Pantheon. Although Blake as an illustrator was appreciated in his lifetime and later, and the *Songs of Innocence and Experience* were read throughout the nineteenth century, the Prophetic Books, like Smart's poetry, had to wait for the twentieth century for republication (or, indeed, publication).

Friedrich Hölderlin used the Greek pantheon, not as a traditional poetic decoration, but as a serious representation of natural universal forces. As we read his hymns and his elegies, we become disturbingly aware that he accepted the existence of the ancient gods. Many of his greatest poems, written between 1797 and 1805, were brought to light only in the twentieth century.

Hölderlin's most moving elegy, *Bread and Wine,* is also his most explicit work. Direct contact with divine forces, experienced by mankind in classical Greece, is now lost: the Gods have abandoned us. (We ought to be reminded of the once-famous vision from Jean Paul's novel of 1797, *Siebenkäs,* in which Christ descends again upon earth to tell the weeping multitudes that there is no God and that they have no Father.)

But my friend, we come too late. Indeed the Gods live
But over our heads above in another world.
They act endlessly there, and they seem to have little regard
Whether we live, so much do they consider us.

Since not always can a weak vessel contain them.
Only at times can mankind endure divine fullness.
Henceforth, dreaming of them is life. Nevertheless, going astray
Helps, like sleep, and need and night make strong
Until enough heroes, nurtured in the bronze cradle,
Their hearts, as in the past, similar in force to the heavenly ones,
Arise in thunder. However, I think it often
Better to sleep, than to be as I am without companions,
Thus to wait; and what to do meanwhile and to say
I do not know, and for what purpose are there poets in a lean
    time.
But they, you say, are like the wine god's holy priests
Who roamed from land to land in the holy night.
    (*Bread and Wine*, Stanza 7 [of 9])

In the final stanza Hölderlin explicitly confounds Christ with the wine god Dionysus. The Gods have permanently withdrawn from the world: only at night, in sleep and madness, can we find them again. The poet's madness is his passport to a lost world.

None of this—not the poetry of Blake, Hölderlin, Smart, Lenz, nor Cowper—has much in common with the conservative religious revival of the early nineteenth century, when Wordsworth and Coleridge at last became uncomplaining members of the Church of England, and Chateaubriand in 1802 published the enormously influential and beautiful *Genius of Christianity* (a book wickedly described by Sénancour as a treatment of Christianity in *troubadour* style—that is, something like Ye Olde Frensshe Caffé, and Chateaubriand's friends roared with laughter when they read aloud the chapter on virginity to each other). By contrast, the work of Blake, Hölderlin, and Lenz is a reaction against the contemporary teachings of the churches, both Catholic and Protestant, which preached an intolerably repressive sexual morality and often a passive submission to social injustice.

It is understandable that most of these poets would not be fully appreciated or even completely published until the twentieth century. Nineteenth-century religion could not absorb either Hölderlin's mystic paganism or Blake's radical sexual morality.

Indeed, a passage in Blake's *Marriage of Heaven and Hell* of 1793 parallels the work of a contemporary lunatic, the Marquis de Sade:

> the weak were caught by the strong, and with a grinning aspect, first coupled with, and then devour'd, by plucking off first one limb and then another, till the body was left a helpless trunk. This after grinning and kissing it with seeming fondness, they devour'd too; and here and there I saw one savourily picking the flesh off his own tail. As the stench terribly annoy'd us both, we went into the mill, and I in my hand brought the skeleton of a body, which in the mill was Aristotle's Analytics.
>
> So the Angel said: "Thy phantasy has imposed upon me and thou oughtest to be ashamed."
>
> I answer'd: "We impose on one another, and it is but lost time to converse with you whose works are only Analytics."

The nineteenth century did not like to face Blake's combination of sexuality and religion; I must confess that the passage concerns monkeys, but the reference to Aristotle transforms the whole into an attack on conservative theology. Many of the religious aspirations of the late eighteenth century were partially suppressed: they continued to exist under cover, and to resurface only from time to time. The twentieth century's reevaluation of the poets once dismissed as mad is a proof of their vitality.

There was, of course, a political side to their poems: rebellion is particularly open in the work of Lenz, Blake, and Hölderlin. In fact, the first full appearance of Hölderlin's madness coincides with the arrest of hundreds of students in Germany for sympathizing with the principles of the French Revolution. A letter from a friend (Sinclair) to Hölderlin's mother tries to reassure her that the madness is only faked in order to avoid arrest for treason, and it is clear from police reports that only Hölderlin's mad behavior (he went about the streets shouting, "I am not a Jacobin") saved him from trial. One of Hölderlin's friends, Böhendorff, wrote at this time in his diary: "It is astonishing how many have recently gone mad." If Hölderlin's madness was, at least in part, only put on, he must have found it impossible to shake off. On the other hand, Blake was never placed in an asylum—he had made a professional success

in a small way as an engraver—but he was put on trial for treason and narrowly escaped; he was defended by a friend of William Cowper.

Even Cowper's apparently uncritical acceptance of the Calvinistic evangelical faith is given an odd turn by his madness. A letter of May 10, 1780, to his friend, the pastor John Newton, makes it clear how odd, and how conscious he was of the oddity:

> That a Calvinist in principle, should know himself to have been Elected, and yet believe that he is lost, is indeed a Riddle, and so obscure that it Sounds like a Solecism in terms, and may well bring the assertor of it under the Suspicion of Insanity. But it is not so, and it will not be found so.
>
> I am trusted with the terrible Secret Myself but not with the power to Communicate it to any purpose. In order to gain credit to such a Relation, it would be necessary that I should be able to produce proof that I received it from above, but that power will never be given Me. In what Manner or by whom the denoüement will be made hereafter, I know not. But that it will be made is certain. In the mean time I carry a load no Shoulders Could Sustain, unless underpropped as mine are, by a heart Singularly & preternaturally hardened.

To many contemporary observers, the most intolerable aspect of evangelical Christians was their conviction that they were members of a small band of the Elect, chosen by God for salvation and Heaven, while the rest of the world is predeterminedly and irrevocably damned. Nothing was more resented than the way they considered themselves "a chosen and separate people, living in a land of atheists and voluptuaries," as Sydney Smith observed. Cowper stands this on its head and his madness acts as a criticism of Calvinism: he knows that he is one of the elect, and God has revealed to him personally that he will be forever damned. It is, of course, God who has hardened his heart.

This returns us once again, rightly, to the misery and anguish of madness, in spite of the moments that it sometimes brought of ecstatic delight. For all of these poets, insanity was a solution, involuntary and voluntary, of the difficulties of reconciling a poetic

sensibility and a religious vision with the lack of an independent income and the exigencies of making a living.

The most tragic case was perhaps that of Lenz, whose works embody the sharpest social criticism and whose poetic career lasted only five years before his madness overwhelmed him and embarrassed his friends. It was difficult to help him. A kind-hearted pastor and doctor, Jean Frédéric Oberlin, tried for several months; he kept him from bathing in an icy river in the dead of winter, or from tearing off the bandages from his wounded foot. Finally Oberlin sent him away with friends to Strasbourg and wrote in his diary:

> Some will say we should never have taken him in; others, that we shouldn't have kept him so long; a third group—we should never have sent him away.

We cannot judge someone like Lenz, Oberlin observed, because we lack the ability to represent faithfully the totality of his case:

> Often a tone, a glance that cannot be described, hides something that signifies more than every action that could previously be set down.

The diary of Pastor Oberlin came into the hands of the young Georg Büchner, who was to achieve the greatest dramatic representation of madness with *Woyzeck* in 1836. He first wrote a short novel on Lenz's madness, using Oberlin's diary but inventing many details in an attempt to enter sympathetically into Lenz's mind. At the end of Büchner's account Lenz returns to Strasbourg:

> It was shadowy, the closer they got to Strasbourg, on high a full moon, all distant objects dark, only the mountain nearby drew a sharp line, the earth was like a golden goblet, over which the moon poured its foaming waves of gold. Lenz stared peacefully out, no presentiments, no pressure: only there grew an obscure anguish in him, the more the objects lost themselves in the darkness. They had to put up at an inn: there he made further attempts to lay hands on himself, but was watched too sharply. On the following

morning, by gloomy rainy weather, they reached Strasbourg. He seemed quite reasonable, spoke with people; he did everything the way others did, but there was a horrible emptiness in him, he felt no more anguish, no desire: his being was a necessary burden to him—in this way he went on living.

# Approaches to Criticism

# The Ruins of Walter Benjamin

*German and English Baroque*
*Drama, Romantic Aesthetics, and*
*Symbolist Theory of Language*

*But Marlow was not typical (if his propensity to spin yarns be*
*excepted), and to him the meaning of an episode was not inside like*
*a kernel but outside, enveloping the tale which brought it out only*
*as a glow brings out a haze, in the likeness of one of these misty halos*
*that sometimes are made visible by the spectral illumination of*
*moonshine.*

—Joseph Conrad, *Heart of Darkness*

The reputation of the German philosopher-critic Walter
Benjamin is now secure; paradoxically it has been given
its firm basis by the disputes among those who believe
they have a claim upon him, and by the widely differing
interpretations of his work. The history of the dispersal
of his papers and their posthumous publication has been
determined by these conflicting and disparate claims.

Just before his death in 1940, some of his man-
uscripts were confiscated by the Gestapo: these have
now turned up in East Germany. Many others were pre-
served through the war at the Bibliothèque Nationale
by the surrealist author Georges Bataille. Benjamin's

---

Originally written in 1977 as a review of Walter Benjamin, *The Origin of*
*German Tragic Drama*, trans., John Osborne.

great friend Gershom Scholem, professor of Jewish mysticism in Jerusalem, had many copies; most of the rest came from Theodor Wiesengrund Adorno, one of the founders of the idiosyncratic version of Marxism called the Frankfurt School. Scholem openly disapproves of the Marxist influence on Benjamin; Marxists in turn generally discount, or attempt to ignore, the theological elements always present in his work.

His publisher in the West is the fashionable and respectable left-wing firm of Suhrkamp. The East Germans publish another edition, and accuse the Western editors of denaturing Benjamin's late Marxist thought. The two editions show little divergence.

Benjamin's work has been less an influential force than a quarry: he has been pillaged but not imitated. He provided what seemed most original in Marshall McLuhan's theories and in André Malraux's writing on art. The structuralists—whoever they were (no one answers to that name any more)—have claimed him as their own, but then so have mystics, neo-idealists, liberals, and followers of Bertolt Brecht. Frank Kermode has called him the greatest critic of the century, but Kermode's own work has remained relatively untouched by Benjamin's methods. Benjamin's study of what might be called the post-history or the afterlife of works of literature has spurred the recent interest in the "history of reception" among younger critics in Germany—principally Hans Robert Jauss—but they cannot be said to share his philosophy. Only the late Peter Szondi, the most distinguished German literary critic since Benjamin's death, has shown a genuine affinity for Benjamin's thought. Most academic work pays him a brief homage, lists his work in the bibliography, and otherwise ignores him.

Plundered without acknowledgment, appropriated without confrontation—his work has met with a degree of misunderstanding that would no doubt have seemed suitable to Benjamin himself, who was thoroughly aware of its esoteric nature. This esoteric quality adds to the work's prestige, protects its aura.

But if Benjamin's reputation is secure, access to his work still remains difficult. A full assessment is impossible while publication remains incomplete. The large essay on Goethe commissioned and

rejected by the Moscow Encyclopedia is still unprinted. Most important of all, the book on which Benjamin was working for more than twelve years before his death in 1940, *Paris, the Capital of the Nineteenth Century,* has been doled out piecemeal by the German publishers, and most of it has yet to see the light of print. The collected edition of Suhrkamp has reserved this for the last.

For those who are interested in Benjamin and who do not read German, the situation is gloomy. A small selection called *Illuminations* has been available for some time in America, with an introduction by Hannah Arendt. Of the major achievements of Benjamin, it contains only "The Work of Art in the Age of Mechanical Reproduction," the introduction to his translation of Baudelaire, and the essay on the stories of Leskov; from his final, unfinished book, there is a chapter of the section on Baudelaire in the injudicious revision that Benjamin made to satisfy Adorno and his colleagues at the Institute for Social Research (although parts of the original version had already appeared posthumously in Germany before the American selection). A translation of both the original and revised versions of the Baudelaire essays has been issued by New Left Books in Great Britain, but there seems to be no plan for similar publication here.

The most important of Benjamin's literary essays, that on Goethe's *Elective Affinities,* was omitted by Hannah Arendt on the questionable grounds that the polemic in it against Friedrich Gundolf's biography of Goethe would have required too many explanatory notes, since Gundolf is unknown in English-speaking countries. This essay on the *Elective Affinities,* however, may be found in a larger, two-volume French selection, disfigured by a translation of exceptional ugliness and opacity (such admittedly difficult terms to render as *Einfühlung* [empathy] and *Sachgehalt* [material content] appear barbarously as *Intropathie* and *teneur chosale*).

The largest gap has been filled for the English reader—but not for the American: the one book after his doctoral thesis that Benjamin finished, *The Origin of German Tragic Drama (Trauerspiel),* on German baroque drama. New Left Books has finally

issued a translation of this work in England after many years of announcement and postponement. The holders of the American rights are sitting on them, and appear to have no intention of making the British translation of this work available here. However, rumors rise from time to time of a new selection which will excerpt from the baroque drama book only the "Epistemo-Critical Prologue" *(Erkenntniskritische Vorrede)*.

This preface is composed with a density so unrelenting that the author himself suggested it should be read at the end of the book instead of the beginning: it sketches a theory of criticism as part of a theory of knowledge, and attempts a reformulation of so many of the fundamental problems of epistemology that Benjamin gaily characterized it in a letter to his friend Gershom Scholem as "an immeasurable *chutzpah.*" I cannot imagine why a publisher would suppose this preface to be more interesting to the average reader than the rest of the work, which deals not only with the German baroque drama but extensively with Romantic symbolism, Greek tragedy, the Spanish baroque theater, Shakespeare (above all, the figure of Hamlet), the nature of allegory, and the emblematic concept of melancholy during the Counter Reformation. This book makes more explicit than any other work by Benjamin his critical principles and his idiosyncratic views of art, language, and history.

*The goal I had proposed to myself is not yet fully realized, but finally I am very close. It is to be considered as the principal critic of German literature. The difficulty is that, for more than fifty years, literary criticism in Germany has no longer been considered as a serious genre. To make oneself a place in criticism means, basically, to recreate it as a genre. . . .*

—Walter Benjamin to Gershom Scholem, Paris,
   January 20, 1930 (WRITTEN IN FRENCH), *Briefe* II, p. 505.

Benjamin's training was in philosophy, his work in literary criticism. Yet his essays are not often purely literary, or purely philosophical. They map out an important area between the two. The major essays exhibit both criticism and a philosophy of criticism. This tactic was, for Benjamin, a heritage from early Romantic Ger-

man thought. George Steiner was right to affirm that Benjamin never abandoned the principles of Friedrich Schlegel and Novalis that he expounded in his first thesis, "The German Romantic Concept of Art Criticism."[1]

Criticism was central to Schlegel's view of art—at least, the art of his contemporaries. In a well-known opposition that he derived basically from Schiller, he defined modern Romantic art as self-conscious and critical, in contrast to the naïve, immediate, and natural classical art of antiquity. This polarity was eventually to receive strange treatment at Schlegel's hands, including an expansion of Romantic art to include even the plays of Sophocles; but it placed the critical act at the center of the work of art. In 1798 Schlegel introduced the book reviews of the *Athenäum* (which he edited for two years with his brother) by declaring: "Great works of art criticize themselves. The work of criticism is therefore superfluous unless it is itself a work of art as independent of the work it criticizes as that work is independent of the material that went into it." The critical essays of Benjamin aim at this status and this independence.

Placing criticism at the heart of literature (or, for that matter, music and the visual arts) was an inevitable step for the early Romantic generation in Germany, those poets and writers whose youth had coincided with the French Revolution. Their exaltation of the critical process was necessary to their rejection of earlier standards, to their invention of "modernism."

As early as 1770, Herder and Goethe had insisted that a new art should not be judged by rules derived from antiquity; each civilization, each folk, each nation created its own standards. For Schlegel and Novalis this had become true for each artist and even each work of art. It is only from within a work that one could derive the principles by which it was to be judged. Criticism was, therefore, immanent in the work itself. Essentially this was, with

---

1. *TLS*, October 25, 1974, p.1198. Review of *Gesammelte Schriften*, Volume I. At the opening of his thesis on Schlegel and Novalis, Benjamin claims that a Messianic vision of history lies at the heart of their criticism, but he does not mention this further. The same thing may be said of his own criticism.

one stroke, to turn criticism from an act of judgment into an act of understanding. Although the theoretical problems it provoked are not to be underestimated, this new approach guaranteed both the individuality of the artist and the integrity of the work. But by making works of art incommensurable one with another, it also seemed to destroy the possibility of a history of art.

Benjamin was, in fact, to deny the existence of the history of art for this reason, as well as on other and more complex grounds. He had no taste for Hegel's attempt to restore history to Romantic aesthetics by envisaging the relations among the arts as a historical process, from the supremacy of sculpture in the antique world to the ascendance of music in the Romantic period, and finally to the eventual disappearance of all the arts—or rather their absorption into philosophy. Hegel's system of aesthetics fell into ruins almost within a few years of its erection, but something like his more general conception of history reappeared much later in art history, in 1901, with a book to which Benjamin ascribed the greatest influence on his thought: Alois Riegl's *Late Roman Industrial Art*.

Riegl drew the final consequences from early Romantic aesthetics and from what has been called Hegelian "expressionism" —the view that at any point in history all social institutions and all human activity as well as art, philosophy, and religion are expressions of a certain state in the development of history. Riegl saw that if the criteria for understanding any given style or period in the development of art were to be drawn from within the style itself, then the concept of decadence was not tenable. Each style was an expression of its period, an answer to its needs, a realization of its will. His book was a justification and a validation of what had seemed the least attractive artistic period in Western history—the Western European art of the fourth to the eighth centuries A.D.—a period which deliberately rejected both the serene beauty of classical art and the lively energy of the unclassical, Hellenistic style. Riegl claimed an expressive value not only for the products of the high arts of painting, architecture, and sculpture, but also for the industrial artifacts and the decorative motifs of the age.

The derivation of Benjamin's work on seventeenth-century German drama from Riegl's *Late Roman Industrial Art* is evident; Benjamin himself acknowledged it as his inspiration. Like the art of the fourth to the eighth centuries, German baroque tragedies were generally considered either a decadent form, a weak and imperfect attempt to imitate classical Greek tragedy, or an immature and unsuccessful attempt to move toward a more modern ideal. In Benjamin's reinterpretation of these works, a surprising and perhaps unconscious adaptation of Riegl may be observed. Where Riegl elucidated the significance of industrial forms (buckles, earrings, spoons, etc.) and the abstract decorative patterns in the late Roman period, Benjamin turned his attention to the structure of figures of speech in German dramatic poetry of the seventeenth century, the use of double titles, the insertion of mottoes into dialogue, and the expressive values in syntactical forms. As long ago as the early 1920s, in fact, Benjamin was studying what Roman Jakobson has since called "the poetry of grammar."

*The Origin of German Trauerspiel*[2] (or *Tragic Drama*) was intended as Benjamin's *Habilitations* thesis, as the work that would entitle him to a teaching position in a German university. It was turned down by the members of the faculty at the University of Frankfurt, who declared they could not understand a word of it. No doubt. If they had understood it, they would have turned it down anyway. In his work, Benjamin mounted a sustained attack on almost all the forms of criticism and literary study that were practiced in the university—and that are still practiced today.

This put an end to any of Benjamin's hopes for an academic career. It was, moreover, only one of many such incidents. Benjamin regularly and emphatically marked his critical distance from those who otherwise would have, if not given him aid, at least stood out of his way. He estranged the only other group in Germany that could have helped him to a university position, the avant-garde group around Stefan George, by attacking—in his

---

2. I use *Trauerspiel* throughout for the title instead of *Tragedy*. Since Benjamin carefully distinguished between the classical Tragedy and the baroque *Trauerspiel*, it avoids confusion if one keeps the German (as does the translator John Osborne throughout, except in the title).

study of the *Elective Affinities*—the biography of Goethe written by one of their members, Gundolf.

Later, in the 1930s, after he had become a Marxist, Benjamin deliberately offended the orthodox communists by his rejection of orthodox communist criticism and his public defense of literary movements then being suppressed in Russia. His attacks on liberal center-left figures like Tucholsky may have made access to some of the literary reviews more difficult for him. Finally, he insisted upon defending the virtues of the traditional philological methods so that not only did his friends of the Frankfurt School, now transferred to the New School for Social Research in New York, refuse to publish the original versions of his Baudelaire essays at a crucial moment in his career, but they were to prevent publication for more than twenty-five years after his death.

Hannah Arendt, in her sympathetic essay, puts such mishaps down to monumental bad luck or to bungling on Benjamin's part. It is difficult to believe, however, that these successive moves were not necessary to Benjamin's program, to his conception of the work he felt obliged to carry out. Each attack of Benjamin was a strategic move; no doubt he hoped not to have to pay too high a price for each, not to suffer so great a loss. He must, however, have envisaged the possible consequences, realized that the chances of getting the book on the German baroque drama through the examiners were minimal. It is worth examining the operation of Benjamin's strategy, his successive attempts to define his own methods against those practiced by his contemporaries (and still practiced today). By the ruin of his career he ensured the permanence of his work.

"*M. Mallarmé, ne pleurez-vous jamais en vers?*"
"*Ni ne me mouche.*"

"*Mr. Mallarmé, do you never weep in verse?*"
"*Nor blow my nose.*"

The trail of Benjamin's misadventures begins with his first impor-

tant published work, the essay on Goethe's novella *Elective Affinities*. It contains an extended polemic against the general practice of biographical criticism, with Gundolf's biography of Goethe chosen as the exemplary enemy. This long essay by Benjamin (which Hugo von Hofmannsthal, who published it, called "simply incomparable . . . it has made an epoch in my life") proclaims, in an esoteric fashion, his continuation of early Romantic criticism. A study of Goethe's *Wilhelm Meister* had opened Friedrich Schlegel's career as a Romantic critic, and it was the first attempt at giving a critical essay the status of a work of art as independent as the work it criticized. Like Schlegel, Benjamin also claimed to draw all that can be said of the *Elective Affinities* from an examination of the work alone.

This declaration of purism and the sustained polemic against Gundolf was an attempt not to remove Goethe's work from history, but to find the proper relation of the work to the life from which it came and—a point of equal importance to Benjamin— to which it was going. For Benjamin, the significance of the work is not exhausted by the meaning given to it by the author and his contemporaries, and is often not even adequately realized by them. The work is "timeless" in that it is not limited to the moment of its appearance. It transcends history, but this transcendence is only revealed by its projection through history. The transcendence is double: on the one hand the work gradually reveals a meaning accessible without a knowledge of the time in which it arose, and on the other it preserves for posterity some aspect of that time. A symphony of Haydn is meaningful and moving even to those who know little or nothing of Haydn's contemporaries and of his age, and yet it appears to embody that age for us today. The work detaches itself both from the life that produced it and from the specific cultural milieu within which it was conceived; nevertheless, it keeps a sense of that past life as an effect of distance from us. Commentary and criticism are Benjamin's names for the two ways of approaching this double nature of literature. Commentary deals with the sense of the past life evoked by the work; criticism with the way the work detaches itself from that life. Commentary is philological in its method: criticism is philosophical.

They are interdependent: without commentary, criticism is self-indulgent revery; without criticism, commentary is frivolous information.

In his essays on Proust, Kafka, and Baudelaire, we find that Benjamin never hesitates to refer from the literary work to the life and back again, but always with a tact that is a sign of his respect for the dignity and integrity of both life and work. Tracing the development of a work in the writer's life was as fascinating to Benjamin as to a professional biographer. What he protested in Gundolf was a form of interpretation which diminishes and restricts the meaning of the work by viewing it as a direct product of the author's life. Unlike an act, a work does not draw its immediate meaning from the life—if it did, the *Elective Affinities* would be unintelligible to a reader ignorant of Goethe's biography. The work is to be understood first of all in a more objective literary, historical, and even philosophical tradition. Underlying Gundolf's approach, Benjamin felt, was a process of sentimental mythmaking, which turned the life of Goethe into a work of art in order to place it into a correspondence with the novella.

Supporting the myth is a tenacious fallacy, which distorts the life even more than the work, the gratuitous hypothesis that what is most profound, most moving in a work must have a corresponding emotional experience of equal power in the author's life. For Benjamin, this inevitably and disastrously misrepresented the imaginative process. The artist transforms his experience, but the experience is not simply a source of emotions and motifs that the artist must accept, nor does the experience impose itself on the work. The artist does not sing his emotions, but actively seeks for "occasions" to make into song. By too simply identifying life and art, the biographer has failed to notice the most essential relationship: the artist shapes his life and his experience to make his art possible.

In Benjamin's essay on Proust, this relationship is given its full weight. A few sentences of Benjamin's mosaic style show the importance he attached to it:

The doctors were powerless in the face of this malady [asthma]; not so the writer, who very systematically placed it in his service. To begin with the most external aspect, he was a perfect stage director of his sickness. . . . This asthma became part of his art—if indeed his art did not create it. Proust's syntax rhythmically and step by step reproduces his fear of suffocating. And his ironic, philosophical, didactic reflections invariably are the deep breath with which he shakes off the weight of memories. On a larger scale, however, the threatening, suffocating crisis was death, which he was constantly aware of, most of all while he was writing. . . .[3]

Work and life here interpret each other literally and metaphorically, and the work is seen more as creating the experiment than as helplessly dependent on it. Proust's life, unsentimentalized, retains its dignity, and his art is left free to seek meanings beyond the restricted range of the author's own biography, as the metaphorical cast of Benjamin's style avoids constraint.[4]

The refusal of Benjamin to allow a privileged status to the meaning the work may have had for the author is based both on his idiosyncratic view of history and on his philosophy of language. From the beginning, his criticism was a protest against historicism, the view that the past must be viewed as far as possible through the eyes of the past. The theory that the critic's job is to reconstruct what was in the author's mind at the moment of writing is only a limited and dubious form of historicism—dubious because it reaches most often behind the text for what is essentially unknowable and unverifiable. Basic to Benjamin's philosophy of language was an emphasis on the functions of language other than that of communication—functions that were aesthetic and, above all, contemplative: the biographical interpretation reduces the sig-

---

3. "The Image of Proust," in *Illuminations*, Harry Zohn, trans. (Schocken Books, 1969), pp. 213–214.

4. In an excellent new book, *Walter Benjamin—Der Intellektuelle als Kritiker*, Bernd Witte has pointed out that Benjamin's criticism of Goethe's *Elective Affinities* is a transformation of the metaphors of the original. By working with the elements of the work itself, Benjamin appears to impose his reinterpretation from within. (I did not come upon Witte's book until this review was almost finished, and I regret not being able to give it detailed consideration.)

nificance of the literary work to that of voluntary or involuntary communication. Benjamin's philosophy of history and of language is best treated in connection with his next misadventure, the thesis rejected by the University of Frankfurt on German baroque drama.

*In Shakespeare's historical plays, there is throughout a conflict of the poetic and the unpoetic. The common people appear witty and unruly—when the great appear stiff and melancholy, etc. Low life is generally opposed to high— often tragically, often as parody, often for the sake of the contrast. History, what history meant to the poet, was represented in these plays. History dissolved in speech. Exactly the opposite of real history, and nevertheless history as it should be—prophetic and synchronic.*
—Novalis, *Fragments and Studies of 1799–1800.*

When Benjamin wrote *The Origin of German Trauerspiel,* between 1919 and 1925, there was already a new interest in Germany in the once-despised literary art of the German seventeenth century. This was in part owing to a revaluation of baroque art strongly influenced by Wölfflin's publications before the turn of the century. In addition, the rediscovery, or the invention, of the literary baroque of Germany was stimulated by expressionism, just as the expressionist painters of the *Blaue Reiter* had made El Greco's cause their own: the exaggeration and the violence of the expressionist poetry and drama of such writers as Georg Trakl and Franz Werfel stimulated an interest (which Benjamin qualified as largely sentimental) in similar manifestations in the works of the seventeenth century. Both styles juxtaposed neologisms and archaisms, delighted in extravagance.

The scholarly treatment of seventeenth-century German literary style before Benjamin remained largely hostile, particularly in its view of the drama, generally condemned as a mistaken, barbarous, and pedantic imitation of Greek tragedy. The plays themselves, by such writers as Andreas Gryphius, Martin Opitz, and Daniel Casper von Lohenstein, had largely been neglected, were seldom read, and almost never produced. The tentatively positive assessments of these works (by Herbert Cysarz, for example) considered

them as primitive but necessary first steps to the classical drama of Goethe and Schiller. It was Benjamin's task to rehabilitate this style for its own sake, to give its own reason for being, and to justify its existence.

In this, as we have seen, he explicitly followed the example of Riegl's rehabilitation of late Roman art: common to both projects was the choice of a period whose art violated the fundamental classical canons of aesthetics, an art that was—to most eyes—neither beautiful nor vital, but awkward and lifeless. If expressionism reinforced Benjamin's project, Riegl's had been helped and no doubt partly inspired by impressionism and post-impressionism. These changes of taste, fashion, or sensibility may account for the urge to rewrite history but not for the grander project of profoundly altering our conception of the nature of history itself. In this, Benjamin was more radical than Riegl; he explicitly set out to demonstrate a thesis that Riegl had only hinted at, and had held largely in reserve in the back of his mind: that there is no such thing as an independent history of art.

In a curriculum vitae, Benjamin claimed that just as Benedetto Croce had opened a path to the particular concrete work of art by smashing the concept of genre, so his book was intended to clear the way to the work by smashing the doctrine of the independent field of art. As he wrote to a friend while working on the *Trauerspiel* book:

What occupies me is how works of art are related to historical life. On this point what seems to me certain is that there is no such thing as a history of art. . . . The explorations of the current history of art always end up only as a history of material or history of form, for which works of art serve only as examples, almost as models: of a history of works themselves there is absolutely no question. . . .

Works of art are, in this respect, like philosophical systems, and the so-called "history" of philosophy is either an uninteresting history of dogmas, or a history of problems, in which case it threatens to lose contact with the temporal extension and to change into timeless, intensive *interpretation*. The specific historicity of works of art is of a similar kind, which opens not into the history of art

but only into interpretation. In the interpretation there arise connections between works of art which are timeless and yet not without historical importance. The same forces which in the revealed world (that is, in history) become explosive and temporally extensive show themselves in the world of silence as intensive.[5]

Here, with Benjamin's idiosyncratic theological terminology, is a formulation of his task; to relate the work to history while respecting its essential function of stepping out of the historical time and space in which it was produced. The achievement of Benjamin was to have recognized and exploited this tension, to have developed a way of interpreting the historical significance of a work that does not question its supra-historical integrity.

In *The Origin of German Trauerspiel,* paradoxically, he does this by resurrecting the concept of genre which he praised Croce for smashing, but in a very different sense. Terms like "tragedy" were not, for Benjamin, either a means of classifying various individual works, or a set of norms by which they could be judged. He states his position in a form so provocative that it was evidently designed to make the hackles of the academic world rise:

> For these ideas [of "tragedy" and "comedy"] are not at all embodiments of rules; they are themselves entities [or structures], at the very least equal in substance and reality to any and every drama, without being in any way commensurable. They therefore make no claim to embrace a number of given works of literature on the basis of some feature or other common to them. For even if there were no such thing as the pure tragedy or the pure comedy which can be named after them, these ideas can endure.[6]

This appears a straightforward affirmation of Platonic realism, but Benjamin's position, as I shall try to make clear, was a much stranger one.

*The Origin of German Trauerspiel* is a relatively short book of a little over 200 pages, divided into two parts. The first deals spe-

5. Letter to Christian Florens Rang, December 9, 1923. *Briefe* I, pp. 321–322.

6. *The Origin of German Tragic Drama,* p. 44 (slightly altered—I have preferred to translate *Inbegriff* as "embodiment" instead of "sum total." I have altered the translation of most of the quotations from Benjamin in this chapter).

cifically with the *Trauerspiel,* the second with the technique of allegory, intimately related to the drama of the seventeenth century. The *Trauerspiel* is marked off from classical tragedy; the efforts of contemporary baroque theorists to base their discussions on Aristotle are shown as factitious and misleading, an attempt to give dignity and tradition to radically new work. Benjamin distinguishes tragedy from *Trauerspiel* as two totally distinct genres:

> Historical life, as it was conceived at that time, is the content, the real object [of the *Trauerspiel*]. In this it is different from tragedy. For the object of the latter is not history, but myth, and the tragic stature of the *dramatis personae* does not derive from rank—the absolute monarchy—but from the pre-historic epoch of their existence—the past age of heroes. (p. 62)

Tragedy and *Trauerspiel* are, as genres, bound to time: neither one is possible outside the era in which it originated.

For the seventeenth-century German poet, history was the fall of kings. Benjamin traces in the *Trauerspiel* the relation of the plays to contemporary theories of sovereignty ("the sovereign represents history. He holds the course of history in his hand like a scepter," p. 65), as well as to the theological outlook of the German seventeenth century, in particular to the devaluation of everyday life in the Lutheran opposition to the Counter Reformation (most of the German playwrights were Lutheran). As he writes,

> The relationship of Lutheranism to the everyday had always been antinomic. The rigorous morality of its teaching in respect of civic conduct stood in sharp contrast to its renunciation of "good works." By denying the latter any special miraculous spiritual effect, making the soul dependent on grace through faith, and making the secular-political sphere a testing ground for a life which was only indirectly religious, being intended for the demonstration of civic virtues, it did, it is true, instill into the people a strict sense of obedience to duty, but in its great men it produced melancholy. (p. 138)

From this melancholy, foreign to Greek tragedy, springs the grief, the *Trauer* of the *Trauerspiel.*

Politics and theology are reflected in the psychology of the plays:

> The antithesis between the power of the ruler and his capacity to rule led to a feature peculiar to the *Trauerspiel* which apparently comes from the nature of the genre but which can be illuminated only against the background of the theory of sovereignty. This is the indecisiveness of the tyrant. The prince, who is responsible for making the decision to proclaim the state of emergency, reveals, at the first opportunity, that he is almost incapable of making a decision. Just as compositions with restful lighting are virtually unknown in mannerist painting, so it is that the theatrical figures of this epoch always appear in the harsh light of their changing resolve. What is conspicuous about them is not so much the sovereignty evident in the stoic turns of phrase, as the sheer arbitrariness of a constantly shifting emotional storm in which the figures of Lohenstein especially sway about like torn and flapping banners. (pp. 70–71)

Benjamin follows this with a series of extraordinary examples of vacillations drawn from the plays, moments of crisis in which the hero hesitates in an agony of indecision. In Lohenstein's *Sophonisbe* the hero, about to send Sophonisbe poison to save her from imprisonment by the Romans, cries: "Alas, what terrors weigh upon my tortured heart! Away! Be gone! But no! Stay! Come back! Yes, go! It must be done at last" (p. 71n). Politics and theology together are implicated in the *Trauerspiel*'s conception of history as catastrophe.

> The enduring fascination of the downfall of the tyrant is rooted in the conflict between the impotence and depravity of his person, on the one hand, and, on the other, the extent to which the age was convinced of the sacrosanct powers of his role. It was therefore quite impossible to derive an easy moral satisfaction . . . from the tyrant's end. For if the tyrant falls, not simply in his own name, as an individual, but as a ruler and in the name of mankind and history then his fall is played out as a judgment, and the subject too feels himself implicated in the sentence. (p. 72)

The limits of the genre are revealed by the tyrant-drama and the martyr-drama:

> In the baroque the tyrant and the martyr are the Janus-head of the monarch. They are the necessary extreme coinings of the princely essence. (p. 69)

The image is that of the royal medal, and the martyr and tyrant imply each other, are the reverse images of the same form.

Benjamin's ideas, conveyed by a deliberately discontinuous mosaic of quotation, observation, and metaphor, are difficult to summarize—or even to translate.[7] What was, as far as I know, without precedent at that time, except for Georg Lukács's analysis of the nineteenth-century novel, was Benjamin's representation of a genre historically—treating the political, theological, and social aspects of the drama as formal elements of the work, examining them exactly as he did the figures of speech, the verse forms, and the grammatical structure of the style. In this way Benjamin avoided both the falsifications of the usual historical approach which reduces and simplifies the work to signifying something outside itself, and the limitations of formalism, which has blinded itself to some of the most characteristic and representative elements of art.

*I will! and once more fill a kingdom's throne.*
*Spain, I'll new mould thee: I will have a chair*
*Made all of dead men's bones; and the ascents*
*Shall be the heads of Spaniards set in ranks:*
*I will have Philip's head, Hurtenzo's head,*
*Mendoza's head, thy mother's head, and this—*
*This head, that is so cross, I'll have't.*
*The scene wants actors; I'll fetch more and clothe it*
*In rich cothurnal pomp; a tragedy*
*Ought to be grave: graves this shall beautify.*

—Thomas Dekker, *Lust's Domination, or the Lascivious Queen*, Act V, scene 5

7. The present translation by John Osborne is, paradoxically, good—it was made with a real sensitivity to Benjamin's thought and style, and it contains major errors, many of them disastrous.

By representing the *Trauerspiel* through its relations to the politics, religion, and philosophy of the society in which it was produced, Benjamin made his work applicable to the contemporary Spanish baroque, and the late Elizabethan and Jacobean dramas. In an early draft of his preface, in fact, Benjamin doubts whether the German *Trauerspiel* can be adequately described without reference to the drama of Shakespeare and Calderon (the English and Spanish *Trauerspiel* we might call them). The power of Benjamin's method may be indicated briefly by extending his observations on theatrical conventions of time, above all the use of illusion and stage properties.

Theatrical conventions are generally treated as something that the contemporary audience—and we, today, as well—must accept blindly and unquestioningly; the conventions are simply given, and we surrender to them. In a brilliant essay[8] Christopher Ricks protests against the slackness of this view and insists that a convention must be justified, its probability vindicated by the dramatist each time, and that the vindication must come from plot and character. Against his opponents Ricks wins easily, but he stops midway in his considerations of convention. A convention is indeed not simply given, but has its own *raison d'être:* the dramatist uses or abuses the convention. Ricks interprets the use, Benjamin goes one step further to interpret the convention itself.

There is an extreme form of *Trauerspiel,* in which probability has little relevance: the so-called Tragedy of Fate, in which the action moves mechanically and inexorably toward the catastrophe. In this kind of play—for Benjamin the supreme examples are by Calderón—psychological motivation is often deliberately abandoned. Calderón's "whole mastery lies in the extreme exactitude with which, in a play like the Herod-drama, the violent passion is elevated out of the psychological motivation of the action which the modern reader looks for" (p. 133). This lack of motivation is

---

8. "The Tragedies of Webster, Tourneur and Middleton: Symbols, Imagery and Convention" in *English Drama to 1710,* Christopher Ricks, ed. (Sphere Books Limited, 1971).

a sign of man's total subjection to powers which he cannot control or influence, and it brings with it the fatal role of the stage property—the inorganic object which inexorably involves the characters in their doom.

Unmentioned here by Benjamin but clearly relevant is *Othello*, the only great example of the Tragedy of Fate in English. The stage property is the handkerchief, and the psychological motivation that Ricks demands is emphatically refused to Iago:

> *Othello:* Will you, I pray, demand that demy-Divell,
> Why he hath thus ensnar'd my Soule and Body.
> *Iago:* Demand me nothing: what you know, you know:

This lack of motivation disconcerts not only critics but Iago himself, who says earlier that he hates the Moor because of a rumor that "twixt my sheets / He's done my Office. I know not if't be true, / But I, for mere suspition in that kinde, / Will do, as if for Surety." Neither he nor Shakespeare seems to believe it much, and no one else ever has either.[9]

In 1692 the critic Thomas Rymer, in a famous attack on *Othello*, made the infamous suggestion that Othello's jealousy would have been better grounded had the handkerchief been a garter. Ricks replies that this:

> ignores the fact that from one point of view such an item as a garter would be too incriminating, might hint a frame-up. The great thing, the fatal thing, about the handkerchief is precisely that it is a trifle.[10]

Ricks does not appreciate his own insight in the last sentence, because he is, for the moment, too concerned with propriety of motivation—from that point of view Rymer is, after all, surely

---

9. The silence of Iago after the crime is a convention, too, going back to Prince Hieronimo's words in *The Spanish Tragedy* after the final murders: "But never shalt thou force me to reveale / The thing which I have vowed inviolate," after which he bites out his tongue. It signifies the irrelevance of motivation against the power of fate.

10. Ricks, op. cit., p. 349.

right, a garter would be more convincing. But it would not be a trifle.

Benjamin's method, extended to Jacobean drama, tells us, as Ricks cannot, why the garter will not do—it would have too much of the life of Desdemona about it, it is not sufficiently neutral, dead. Benjamin is not concerned, like the scholars that Ricks attacks, with merely confirming the existence of a convention, or, like Ricks, only with its use: he wants to force out its meaning.

He therefore enables us to discover something in *Othello* that Ricks does not: that the blindness of Othello's passion, jealousy, is expressed, not motivated, by something as insignificant as the handkerchief. The disparity between the cause of his jealousy and its fury is essential. As Benjamin writes about the German Tragedy of Fate:

> For once human life has sunk into the merely natural, even the life of apparently dead objects secures power over it. The effectiveness of the object where guilt has been incurred is a sign of the approach of death. The passionate stirrings of natural life in man —in a word, passion itself—bring the fatal property into action. It is nothing other than the seismographic needle which registers its vibrations. (p. 132)

For Benjamin, the stage property in the Tragedy of Fate, like the absence or presence of psychological motivation, was not merely a convention given to the baroque dramatist, which he could use or abuse: it came to him with ideological strings attached. It had, in short, an inherent expressive function.

The breaking of stage illusion so essential to baroque style was another such convention with an expressive value. It can be understood only in a critical approach as wide as Benjamin's that reinterprets the past from the perspective of a much later period. Put the following remarks of Ricks against Benjamin's treatment of illusion:

> The scene in *Othello* (Act 4 scene 1) in which the credulous Othello is snared by Iago into overhearing (and misconstruing) a con-

versation between Iago and Cassio about Bianca . . . is no more convincing, no less stagey than [a similar scene in *The White Devil* by Webster]; the particular convention presents such difficulties, is so intractable, that even Shakespeare here fails to master it. . . .[11]

"Stagey" is the exact and necessary word; Ricks mistakenly proffers it as a reproach. Benjamin relates the breaking of illusion, the staginess of the *Trauerspiel,* to the effort to express the "play" character of life itself, which has lost its ultimate seriousness in the despair of Counter-Reformation theology.

> In the drama the play element was demonstratively emphasized, and transcendence was allowed its final word only in the worldly disguise of a play within a play. The technique is not always obvious as when the stage itself is set up on the stage, or the auditorium is extended onto the stage area. (p. 82)

The scene in *Othello* is such a play within a play, staged by Iago for Othello, who becomes a member of the audience, the only one, in fact, to misunderstand what is being played.

This explicit reference to the stage that Benjamin remarks in the German *Trauerspiel,* moreover, occurs at the moment of crisis of every one of Shakespeare's major tragedies. King Lear, cast out by his daughters into the storm, stages a mock trial with the footstool as Goneril; Cleopatra, preparing for suicide, does so in order not to be dragged in triumph to Rome and see herself played on the stage by a boy; at the death of his wife before his final disaster, Macbeth compares life to a poor player that struts and frets his hour upon the stage; and, perhaps most movingly, Coriolanus, about to order the sack of Rome, sees his wife and mother come to plead with him and says hopelessly:

> Like a dull actor now, I have forgot my part,
> And I am out, even to a full Disgrace. . . .

11. Ricks, op. cit., p. 309.

The staginess of these references[12] is allegorical: they turn the stage itself into an emblem of illusion. Nowhere is this made more emphatic than in *Richard II*. Forced to abdicate, Richard calls for a looking glass, and begins to quote Marlowe's *Faustus:*

> Was this Face the Face
> That every day under his household roof
> Did keep ten thousand men? Was this the Face
> That, like the Sun, did make beholders wink?
> Is this the Face that fac'd so many follies
> And was at last outfac'd by Bolingbroke?

(each phrase approaching more and more closely to the famous lines on Helen "Is this the face that launch'd a thousand ships?"). This reference to the stage at the climax of the tragedy is not a poet's game, an irrelevant frivolity. Richard with his looking glass, like Hamlet with the skull of Yorick, or Lear judging the footstool, is a figure of allegory, frozen for a moment into an emblematic stiffness. "The shadow of your Sorrow," Bolingbroke says when Richard smashes the looking glass, "hath destroyed the shadow of your Face." The references to the stage, the looking glass, the death's head, are all emblems of illusion and premonitions of death. This is why the catastrophe in Jacobean drama arrives so often as a play within a play, a game of chess, or even a dance.

As Benjamin says, the allegorical technique is central to the view that life is an illusion which, when dissipated, reveals nothing. The essential characteristic of seventeenth-century allegory (the only kind with which Benjamin is basically concerned) is discontinuity, an unresolvable discrepancy between a visual sign or image and its

---

12. See also, among many other examples from other dramatists, the final scene of Middleton's *The Changeling.*

> Almero: I'll be your pander now; rehearse again
> Your scene of lust, that you may be perfect
> When you shall come to act it to the black audience,
> Where howls and gnashings shall be music to you.
> Clip your adulteress freely, tis the pilot
> Will guide you to the *mare mortuum*
> Where you shall sink to fathoms bottomless.

meaning, "a dualism of signification and reality" (p. 194). Allegories are never understood easily and naturally, but decoded: they require effort, which takes time, so sign and meaning are never simultaneous, never fused.

When John Donne, in the famous lines of "A Valediction: forbidding mourning," compares the departing lover and his love that stays behind to "stiff twin compasses" (i.e., the two legs of a drawing compass)—

> Thy soule the fixt foot, makes no show
> To move, but doth, if the other doe.
>
> And though it in the center sit,
> Yet when the other far doth roam,
> It leanes, and hearkens after it,
> And growes erect, as that comes home.

—the discrepancy between image and meaning is audacious. The inanimate scientific sign of the compass arrests and stiffens the vital meaning and reveals the kinship of such an emblematic figure with the fatal stage property that seems to have a life of its own and brings death. The dead image of the compass controls the living souls of which it is the sign, and the poem, indeed, starts with a scene of death:

> As virtuous men passe mildly away,
>   And whisper to their soules, to goe,
> Whilest some of their sad friends doe say
>   The breath goes now, and some say, no:
>
> So let us melt, and make no noise. . . .

an image both of death and of the act of love which changes—imperceptibly—to the image of absence and love figured by the compass.

Benjamin was by no means the first critic to find allegorical elements in baroque drama, but he was, I think, the first to insist on their importance for the works as a whole, not merely for the occasional detail or character; he did not conceive allegory merely as a survival of an archaic technique within a more developed style.

He was also a pioneer—as George Steiner has remarked[13]—in the study of sixteenth- and seventeenth-century emblem books, and the way that their figures appear in the drama. Other English examples of such emblems abound, and it is easy to add to Benjamin's German ones. The Duke in *The Traitor* by James Shirley dies with a series of images drawn from the emblem books on his lips:

> For thee, inhuman murderer, expect
> My blood shall fly to heaven, and there inflam'd,
> Hang a prodigious meteor all thy life,
> And when by some as bloody hand as thine
> Thy soul is ebbing forth, it shall descend
> In flaming drops upon thee: oh, I faint!—
> Thou flattering world, farewell! let princes gather
> My dust into a glass, and learn to spend
> Their hour of state, that's all they have; for when
> That's out, time never turns the glass agen.

This magnificent collection of bric-a-brac—meteor, burning shower of blood, hourglass—all familiar from emblem books, illustrates what Benjamin called the arbitrary grouping of elements within the allegory. He wrote:

> It is perfectly clear that this fragmentation in the graphic aspects is a principle of the allegorical approach. In the baroque, especially, the allegorical personification can be seen to give way in favor of the emblems, which mostly offer themselves to view in desolate, sorrowful dispersal. . . . It is as something incomplete and imperfect that the objects stare out from the allegorical structure. (p. 186)

"In allegory the observer is confronted with the pallor of death, the 'Hippocratic countenance' of history as a petrified, primordial landscape," as Benjamin writes (p. 166). Earlier, he observes that the *Trauerspiel* gives us "the transposition of the originally temporal data into a figurative spatial form" (p. 81)—as the Duke's dying speech in *The Traitor* freezes the movement of the sovereign's life into the image of the hourglass.

13. *TLS,* October 25, 1974, p. 1198.

The allegorical structures of the baroque age are better represented by the German *Trauerspiel* than by its more successful relatives in Spain and England—just because of their greater artistic success: the vitality of Spanish baroque drama comes from its playful brilliance, that of the English from the fusion of comedy with *Trauerspiel*. The elemental power of Shakespeare, as Benjamin says, rendered the equally important allegorical character of the plays almost unrecognizable for Romantic critics. Precisely because such artistic power was denied it, the German *Trauerspiel* can reveal the beauty of the genre and of the allegorical structure that underlies it.

For allegory is not just an artistic technique but also, as Benjamin points out, a corrective to art. By its discontinuity of image and meaning it rejects the false appearance of artistic unity, the fusion of meaning in the symbol, and presents itself as a fragment, a ruin. The German *Trauerspiel*, too, is just such a ruin. It has been eroded by time. The critical action of time is a well-worn cliché: it is time that separates the masterpieces from the second-rate, the great artist from the small fry. For Benjamin, time had a different function: the passage of time not only decided the success of a work, but—more importantly—separated the essential from the inessential in it, distinguished between the elements which were immediately appealing to contemporaries and those which had a more lasting interest. That is why the post-history of a work, the tradition it created, is as indispensable to the critic as its pre-history, its sources and the tradition it came from.

*The Origin of German Trauerspiel* has an esoteric secret, nowhere stated directly although implied at many points and inescapable from a close reading. Benjamin believed that every work of art in order to retain its essential nature had to become a ruin. This could—and generally does—happen in its history, but it is a potential of all works and discoverable to the critic. Every authentic work of literature, for Benjamin, was a metaphorical embodiment of philosophical ideas. Every critical reading should move toward that moment when the work appears to exist for the sake of the philosophical truth within it: it no longer exists for itself,

and it therefore loses its charms. It reaches the condition of the *inexpressive*. As a ruin, the *Trauerspiel* is an allegory of art in general.

The business of the critic, for Benjamin, is not to resuscitate the dead, or to reconstitute the original which now stands before us fragmented, but to understand the work as a ruin, and in so doing paradoxically to awaken the beauty present in it as a ruin. But to achieve this Benjamin had to invent a methodology for criticism, based on an idiosyncratic and esoteric philosophy of language, and a radical theory of knowledge and history.

*Eine klassische Schrift muss nie ganz verstanden werden können. Aber die, welche gebildet sind und sich bilden, müssen immer mehr draus lernen wollen.*

—Friedrich Schlegel, Lyceum Fragment, number 20

*A classical text must never be completely understandable. But those who are educated and who continue to educate themselves must always wish to learn more from it.*

*The Origin of German Trauerspiel* is an esoteric book. That is surely the immediate reason why first the Department of Germanic Studies and then the Department of Philosophy of Art of the University of Frankfurt rejected this study of seventeenth-century dramatists when it was presented to them as a thesis. The publishers of the English translation have enhanced Benjamin's esotericism by omitting all page numbers from the table of contents, as well as by printing the six separate sections of the book's two parts with no indication of where one stops and the next one starts. The esotericism is deeply rooted in Benjamin's style: even where the book is easy to read—by no means necessarily where it is best— the argument is not made explicit, and the connection between ideas is only suggested, never emphasized.

This is what makes his work resist summary and paraphrase, or even quotation, unless one wrenches his sentences as brutally from their contexts as he tore his quotations from theirs. The difficulty of reading his mosaic of quotations and commentary, which de-

mands a pause for reflection after each sentence, is characteristic of his era, an age of great esoteric literature. The *Trauerspiel* book was finished in 1925; 1921 is the date of Joyce's *Ulysses*, 1922 of Eliot's *The Waste Land* and Rilke's *Sonnets to Orpheus*, while Yeats's *A Vision* appeared in 1926. *The origin of German Trauerspiel* is a masterly work in that tradition.

The esoteric had a more general value for Benjamin: it revealed something about literature in general. Esoteric journalism is a contradiction in terms: literature, however, is permitted to baffle us. Even more, we might say that all literature which lasts, which remains literature and has not become a document, is baffling.

This well-known phenomenon is generally sentimentalized by saying—about simple lyric poems, for example—that they express the inexpressible, or that every great work has a mysterious quality that can never be reached by analysis but only felt by instinct. Such evasions are unnecessary. The mystery arises because literature invokes aspects of language other than that of communication.[14]

Language cannot be reduced to communication even if its other functions sometimes take second place. Among them is an expressive function: swearing to oneself without the benefit of an audience. There is the sheer pleasure in nonsense syllables that children develop early and that adults never lose. And there is the magic formula and the sacred text.

A sacred text can never be simply described as communication except by metaphor. There are questions necessary to communication that we are forbidden to ask of a text whose sacred character we accept: is the speaker mistaken? is he sincere?—or indeed any question designed to test the validity of what is said by an appeal to experience. The sacred text is characterized, in short, by its autonomy. Its meaning is independent of all human contingency; the divine is not contingent.

Since the sixteenth century, if not before, some of the forbidden questions have been asked of Scripture; it has been considered

---

14. This does not mean that communication is ever completely absent: even when its force is at its lowest point in literature, we find substituted for it a mimicry of its procedures.

subject to contingency, losing its sacred character. It has become literature, which is not sacred, but which has always tended to usurp the place of religion. Literature—at least ever since Homer—has appropriated and exploited the functions of a sacred text. For an essential part of our experience of them, the texts of literature demand to be taken as objective, as given for contemplation, for meditation, incantation, for a form of understanding that evades intention, author's as well as reader's. Literature aspires not so much to attain as to return to the condition of music, which is, in Romantic mythology, the original form of speech.

These noncommunicative aspects of language exist in everyday usage (the slogan, for example, works partly like a magic formula), but they are either hidden by the overwhelming needs of communication or pushed aside as reprehensibly primitive. A work of literature, however, not only preserves them but would lose all its power without them. That is what Valéry meant by saying that a work of literature lasts just so long as it is able to appear other than as its author conceived it.

The illusion of autonomy enables the work to operate effectively: it stops the reader from taking it simply as a form of communication and so allows the other aspects of language to press forward. The autonomy is an illusion, of course, because a work of literature is subject to history, created by an author, its words and even its form comprehensible only if one starts from a specific culture (even if, in the end, the work is not restricted to that culture). The illusion can neither be simply dispelled nor maintained.

No critic saw this as clearly as Benjamin. The formalist critic respects the autonomy of the work, but rejects whole areas of meaning and thereby impoverishes the form itself. The biographical and historical critic denies the autonomy and freezes the work into a fixed mold of interpretation, limiting its range of meaning as constrictingly as the formalist.

The difficulty, the esoteric quality of Benjamin's writing, arises from his attempt to give full weight to both sides of the dual nature of literature. The insights of critics often come in spite of their systems. In Benjamin's case, I believe, his success is directly related

to his radical methodology, a compound of early Romantic aesthetics, Symbolist theory, and much that is wholly new. It is worth examining this system above all in order to see briefly how it applies to criticism in our own day.

Benjamin's sporadic attacks on academic criticism in all its forms are phrased with an intransigence that was to cost him any chance for a position in a German university.[15] It was essential for him decisively to cut off what he was doing from the procedures of most of his contemporaries—and most of ours as well. His arguments have not lost their immediacy.

Where Benjamin's convictions depart most trenchantly from those of other critics is, first, in his attack on what he called "inductive" methods of analysis—that is, his preference for studying the extreme, the exceptional in place of the average, the normative, in the belief that the extremes give the most accurate picture of a style; second, in his insistence on the autonomy of the work of art as opposed to the autonomy of "literature" or "art"; and, above all, in his affirmation that words are not signs, that they only degenerate into signs (that is, into things that arbitrarily stand for something other than themselves—necessary substitutes for what they refer to): or, in idealist terminology, that words degenerate from Ideas into concepts.

This latter point is the most radical, the one in which Benjamin opposes himself to most forms of contemporary philosophy, linguistics, and criticism. The word, for Benjamin, was not a substitute for something else; it had a value of its own, and was the name of an Idea.

In spite of his explicit appeal to the authority of Plato and the implicit references to Kantian terminology, Benjamin's use of "Idea" is in large part original. It derives most immediately from the aesthetics of the early Romantics, above all, that of Schlegel and Novalis. The word names an Idea, the work of art is a meta-

---

15. Benjamin's intransigence was reserved for critics. On the other hand, he wrote about such contemporaries as Hofmannsthal, Gide, Valéry, Brecht, Kraus, and Rilke with open respect and admiration, although he differed radically from all of these both philosophically and politically. His taste in contemporary literature was very sure.

phor for an Idea. A quotation from the notebooks of Novalis clarifies the notion of "Idea" that Benjamin was drawing upon (in what follows, "novel" [*Roman*] is to be understood as any work of art of some substance—for example, a play by Shakespeare was called a *Roman* around 1800 by these young German critics):

> The novel, as such, contains no defined result—it is not the picture or the factual reality of a *proposition (nicht Bild und Faktum eines Satzes)*. It is the graphic carrying-out—the realization—of an Idea. But an Idea cannot be seized by a proposition. An Idea is *an infinite series* of propositions—an *irrational quantity—untranslatable* (musical)—incommensurable. (Should not all irrationality be relative?) What can be set down, however, is the law of its development [*Ausführung,* i.e., the rule for deriving the infinite series]—and a novel should be criticized from this standpoint.[16]

The distinction between concept and Idea is partially derived from Kant and is the one still employed by Benjamin: a concept may be defined by a simple sentence, or proposition, an Idea cannot.

This makes an Idea much grander than a concept (which is why I have conserved its initial capital) but not, according to Novalis, vaguer. It is precise and definable, but not as a sign—that is, not as a simple relationship between two sets of words in which the definition may be substituted for the original expression. The definition of an Idea is not an exhaustible process.

Novalis uses the infinite series as a metaphor for the process of describing the Idea. Benjamin accepts the distinction between concept and Idea, and like Novalis he, too, draws philosophy and art together. His description of Ideas, however, is not that of Novalis, and he substitutes very different metaphors: configuration and constellation.

> . . . the representation of Ideas takes place through the medium of empirical reality. For Ideas are not represented in themselves, but

---

16. Novalis, *Schriften,* Kluckhorn and Samuel, eds., (1960), vol. 2, p. 570. Benjamin's doctoral thesis on the concept of the criticism of art of the early German Romantics was written from 1917 to 1919 and based on the fragments of Schlegel and Novalis. This fragment of Novalis was first published in 1901, and Benjamin must therefore have known it.

solely and exclusively as an arrangement of real, concrete elements in the concepts. And indeed as the configuration of these elements. . . . The staff of concepts which serves as the representation of an Idea realizes it as such a configuration. . . . Ideas are to things as constellations are to stars. This means, in the first place, that they are neither their concepts nor their laws. . . . (p. 34, translation altered)

The distinction in Benjamin between concept and Idea may be roughly summarized: the concept defines a class of phenomena, the Idea determines the relation of the phenomena in the different classes to each other. Tragedy as a concept defines a certain number of plays: Tragedy as an Idea figures the relation of these plays to history in the widest sense.

Here we come to the root of Benjamin's attack on the academic history of literature: its reliance on classification. "Tragedy," for example, *as a concept* is ordinarily defined by "induction," that is, taking a large number of examples and then analyzing what they have in common. This blurs more than it reveals. When one puts modern

plays by Holz or Halbe alongside dramas by Aeschylus or Euripides, without so much as asking whether the tragic is a form which can be realized at all at the present time, or whether it is not a historically limited form, then, as far as the tragic is concerned, the effect of such widely divergent material is not one of an overarching conception, but of sheer incongruity. When facts are amassed in this way . . . , the less obvious original qualities are soon obscured by the chaos of more immediately appealing modern ones. (p. 39, translation altered)

So defined, the concept of tragedy gives not the general, but the average: it is therefore incapable of aiding us to assess the significance either of the norm itself or of the most characteristic divergences from the norm. Induction can at best help us to discern the outlines of an Idea, but not to validate it. Indeed, Benjamin's distinction between *Trauerspiel* and tragedy depends

on his refusal to fit the German baroque drama into a generalized concept of tragedy; in Benjamin's method of describing a genre, no example can be admitted without questioning its right to be there, and this destroys the basis for simple inductive or statistical definitions.

Benjamin's ponderous idealist terminology (to which I am probably as allergic as the next man) provokes two fundamental questions to which Benjamin gives by no means the traditional idealist answers—his solutions are indeed already in many ways close to materialism. The questions are: how are Ideas to be known? and how are they to be described?

Benjamin starts by denying any form of immediate intuition or perception, mystical or otherwise, of Ideas. They are not to be found as data, as given in the phenomenal world. They are given in language—but in language seen as extending far beyond its function of communication. In Benjamin's own oracular terms:

> The Idea is something linguistic, it is that very moment in the essence of any word in which it becomes a symbol. In empirical understanding, in which the word has disintegrated, it possesses, in addition to its more or less hidden, symbolic aspect, an obvious, profane meaning. It is the task of the philosopher to restore, *by representation,* the primacy of the symbolic character of the word. . . . (p. 36, translation altered, my italics)

In what follows this—the theory of the word as "name"—we find the principal locus for Benjamin's interest in the Kabbala and in mysticism; in spite of his refusal of mystical forms of perception, he found much that was congenial to him in mystical writings, particularly those of the seventeenth century. Nevertheless, the little that Benjamin found in the Kabbala was only what he had already been looking for, and we may say that the words I have set in relief—"by representation"—introduce a new and very different emphasis into mystical theory. The symbolic aspect of the word

has not been perceived until its representation has been constructed.[17]

To understand what Benjamin meant by "representation" we must see that his philosophy of language does not derive directly from any mystical source whatever but from Mallarmé and from the linguist and critic Wilhelm von Humboldt.[18] For Humboldt, writing around 1800 at the great moment when comparative linguistics first came into its own, language was less a means of expressing ideas than of discovering them. It was an independent system, a separate world different from the objective world of reality and the subjective world of consciousness: only through language, in fact, do we realize that the subjective and objective worlds are one. On the origin of language (a question discussed by almost every writer of the eighteenth century) Humboldt claimed that language could not come into being element by element but must exist all at once: the use of one word implies the whole system, the structure of the language of which it is only a part.

Benjamin's attack upon the arbitrary sign-character of language is already explicit in Humboldt:

> A word is indeed a sign insofar as it is used to signify a thing or a concept, but in the way it is formed and acts it is a particular and independent being—an individual.

Even more in Benjamin's style, we find Humboldt writing:

> A word reveals itself as an individual with a nature of its own which bears a resemblance to a work of art insofar as it makes possible an idea beyond all Nature with a form borrowed from Nature.

---

17. It is this emphasis on representation that distinguishes Benjamin's philosophy of language from Heidegger's; it was elaborated before Heidegger had published any of his major works. Benjamin unfortunately never wrote his projected demolition of Heidegger, whose work he once characterized as a model of how not to do it.

18. Humboldt's anticipation of many aspects of modern linguistics has been celebrated by Chomsky. In one of his *curricula vitae* Benjamin avowed that his interest in the philosophy of language started with a reading of Humboldt, and continued with Mallarmé.

And finally a point that Benjamin was to appropriate in his essay on translation:

> To say '*ippos,* equus and horse is not to say thoroughly and completely the same thing.[19]

Benjamin's version of this is more developed:

> The words *Brot* and *pain* [bread] "intend" the same object, but the modes of this intention are not the same. It is owing to these modes that the word *Brot* means something different to a German than the word *pain* to a Frenchman, that for them these words are not interchangeable, that in the end they strive to exclude each other.[20]

By "mode of intention" Benjamin means something more than "connotation": the words *Brot* and *pain* have a range of significance in French and German culture which, when followed to its limits, to the extreme, will mirror the whole civilization and history governed by their languages. That total range of significance, *represented objectively,* and as a structure of its most distant relationships, is the Idea in Benjamin's sense.[21]

The objectivity of the representation, guaranteed by the nature of language, which is a system independent of our subjective intentions, is preserved only by invoking those aspects of language that transcend its use as a tool for communication—its poetic and contemplative functions, and even the ways in which it can transform itself into a sacred text or become petrified as a magic formula.

For Benjamin, the failure to consider these aspects and the attempts to deny their existence and their power account for the weakness of most contemporary criticism and philosophy. It is communication—language used for an individual purpose, the

19. All the quotations of Humboldt are from the end of his essay "Latium und Hellas." I have used here (with some changes) the translation by Marianne Cowan on p. 248 of *Humanist Without Portfolio* (Wayne State University Press, 1963).

20. "The Task of the Translator," in *Illuminations,* Harry Zohn, trans. (Harcourt Brace Jovanovich, 1968; Schocken Books, 1969), p. 74.

21. Peter Szondi in "L'Herméneutique de Schleiermacher" (*Poésie et poétique de l'idéalisme allemand,* Editions de Minuit, 1975) defines Idea "in Benjamin's sense" as "the figure of the unity of the diverse semantic nuances of a word." That gets rid of the mysticism, but also of the required objectivity.

Ideas reduced to concepts—which is subjective. Language is not arbitrary, present at the moment of speaking without reason or justification, but given by tradition and history; it is the repository of experience, including the experience that no one will ever have again. Benjamin had thoroughly absorbed the criticism of Kant by Hamann, the eighteenth-century philosopher of the *Sturm und Drang* who attacked Kant's "pure reason" as an unwitting attempt to get behind language. Hamann demonstrated that the ideas of philosophy were embedded in language: even Descartes's project of starting afresh, provisionally wiping away all of experience and reconstructing it, entailed the absurdity of doing away with language, which cannot be separated from experience and tradition.

The objectivity of language, its independence, its momentum, was perhaps stated best by Friedrich Schlegel, when he said that words generally understood each other better than the people who used them. The exhibition of this independence, or, better, its symbolic reconstruction *in* art and *through* history is the critic's job.

---

*Verbindet die Extreme, so habt ihr die wahre Mitte.*

—Friedrich Schlegel, *Ideen*, no. 74

*Unite the extremes, then you have the true mean.*

Benjamin's attack upon the contemporary practice of criticism was deeply rooted in an attempt to reformulate the relations of literature, philosophy, language, and history. In this he anticipated many of the solutions that were to be offered years later, and even answered in advance the objections that are now put forth against positions similar to his. It is evident that Idea, in his sense, undefinable in any simple way but representable, is allied to the theory of "open concepts" that has recently developed[22] as well as to

22. See particularly Morris Weitz, "Genre and Style," from *Perspectives in Education, Religion and the Arts,* vol. 3 of *Contemporary Philosophic Thought* (State University of New York Press, 1970), in which concepts of period, style, and some genre concepts are considered as "open," i.e., perpetually debatable.

Wittgenstein's concept of meaning as a "family," in which the various meanings of a word are conceived as a loose assemblage. Arthur O. Lovejoy, for example, in his influential essay of 1948, "On the Discrimination of Romanticism," called attention to the existence of such a family: the word "romantic" is used with a variety of meanings, some so far apart as to appear to exclude each other.

Against theories of this kind, however, Benjamin posits the coherence of relationships among the various meanings of a word.[23] He retains the openness but insists that the relationships are neither loose nor inchoate. They form a pattern—a configuration—which it is the business of the critic to reconstruct. The configuration of "romantic," for example, when applied to landscape, starts in the eighteenth century with the meaning of "picturesque"; by the early nineteenth century it indicates the landscape painting of artists to whom the "picturesque" is anathema—John Constable, Caspar David Friedrich, and many others. To trace the historical pattern of this radical change of meaning in its relation to European culture as a whole is to represent the "romantic" as an Idea in Benjamin's terms, to investigate two of its extremes.

Applied to terms of period style—like "baroque," "romantic," "classic"—Benjamin's philosophy of language and history presupposes the coherence of the period, assumes that the critic may work with the arts, sciences, theology, and politics of a given age and with the assurance he will not find himself with disparate, unrelated strands that he cannot weave together.

The method of weaving, however, is crucial: when, for example, the art historian John Shearman recently related some aspects of sixteenth-century music to his etiolated version of "mannerist" style in painting, the result was not encouraging (particularly as the same tendencies in music could be found centuries before and after).[24] Benjamin had a word for such strategies which his trans-

23. The mechanism of these relationships was to be demonstrated many years later by William Empson in *The Structure of Complex Words*.

24. John Shearman, *Mannerism* (Penguin, 1967).

lator renders excellently as "analogy-mongering." Benjamin's method requires the exploration of the most contradictory aspects of a period, an investigation of extremes, not the limitation of the research to the normative aspects. It is not as concepts "which make the similar identical" that Benjamin advised employing terms like "Renaissance" or "baroque," but as Ideas.[25] "When an Idea takes up a sequence of historical formulations, it does not do so in order to construct a unity out of them, let alone to abstract something common to them all" (p. 46, translation altered).

The most visible and distinguished attacks today on the coherence of period styles come from Sir Ernst Gombrich, who sees the specter of Hegelianism wherever a unified stylistic field-theory rears its head. Gombrich's critical intelligence is powerful, his imagination limited: armed with the blinkered positivism of his friend Sir Karl Popper, he has made out a formidable case against Hegelian historical theory without ever being able to account for its seductions. The trouble with getting rid of these ideas of period and style, as many besides Gombrich have proposed, is that they slink back disguised even from the author and out of his control: a reviewer of Gombrich's recent biography of Aby Warburg commented acidly that for someone so opposed to Hegelian theories of style, Gombrich used the expression "period-flavor" surprisingly often. In any case, Benjamin does not attempt to construct a unity out of his picture of the seventeenth century in *The Origin of German Trauerspiel,* and Gombrich's arguments against theories of period style are harmless if applied to Benjamin's work.

An alternative to coherence is the loosely organized "family" of meanings, the treatment of a period that allows the different tendencies to jostle each other uncomprehendingly in an attempt

---

25. He accepted with strong reservations the positivistic arguments of Konrad Burdach against treating terms like "Renaissance" or "Humanism" as if they were living individuals with a life of their own: they were, according to Burdach, only convenient fictions, abstract concepts invented "as a consequence of our innate need for systematization" which help us "to come to grips with an infinite series of varied spiritual manifestations and widely differing personalities." While Benjamin, however, agreed on the danger of personifying general concepts, he commented that Burdach's "arguments constitute a private mental reservation, not a methodological defence" (*Origin*, pp. 40–41).

to give the illusion of vitality that comes from disorder. The emphasis on variety often arrives at a radical distortion of reality in the interests of the critic's convenience. If, to follow a recent suggestion, we treat late eighteenth-century style in music as a loosely organized set of procedures, and abandon the idea of coherence, one crucially important phenomenon remains unexplained and generally unexamined: when one of the stylistic procedures (like treatment of melody) is radically altered, it creates a complementary alteration in at least some of the others (harmonic structure, phrase, rhythm).[26] Nor could a composer like Mozart or Clementi borrow Haydn's technique of thematic fragmentation without being influenced by his large structures and his harmonic rhythm.

In short, these procedures are not independent and not a genuine collection, not a "family" with the loose acceptance of incoherence that that implies. A period style, like baroque, or even a personal style, like Clementi's, is not a collection of procedures and tendencies, but *the interrelationships of these procedures*. Each time we try to discover these interrelationships, we are postulating a configuration which is the object of our research. It is evident that Benjamin's methodology, or some variant of it, is essential in historical criticism.

It is also evident that the interrelationships among stylistic procedures are best discovered when one of the procedures is used in particularly outrageous fashion, provoking a reaction in others. That is why the extreme case gives more information than the average. At any rate, the average cannot give one the range of a style—only the extremes can do that, and they alone can endow the average with its true sense. We may say that the extremes give the outline of the style, and the average gives its center of gravity. A middle-point has no significance until we know what it stands between.

---

26. An inordinately short recapitulation section in a sonata movement by Haydn after 1770, for example, implies a development section in which part of the second half of the exposition reappears very exceptionally in the tonic.

In his picture of seventeenth-century German drama, Benjamin explores the opposing aspects of the figures of the tyrant and the martyr in the plays, the contrast between legal, bureaucratic terminology and pastoral style, the transformation of the *Trauerspiel* both into opera and the later marionette parodies of the plays. This is Benjamin's synthesis of extremes, a dialectical method, but not a Hegelian one. It does not resolve the contradictions in a false unity but represents their relationship as part of a much larger, total pattern.

The technique of representation is derived from Symbolism: Benjamin arranges his extraordinary quotations in an order that seems both to isolate them—to allow for a moment, with a shock, their alien nature to appear unmediated—and to resonate with their context, by forcing the reader to reassess their meaning.

Even his own sentences in their discontinuous arrangement and their aphoristic density seem like quotations. This procedure was defined for poetry by Mallarmé—or, better, evoked by him. From it Benjamin created a poetry of philology.

Here, in Mallarmés' dense prose (next to which Benjamin's style has the limpidity of John Dryden's), is his formulation of Symbolist technique and its relation to a philosophy of language:

> Parler n'a trait à la réalité des choses que commercialement: en littérature, cela se contente d'y faire une allusion ou de distraire leur qualité qu'incorporera quelque idée.
>
> A cette condition s'élance le chant, qu'une joie allégée.
>
> Cette visée, je la dis Transposition—Structure, une autre.
>
> L'oeuvre pure implique la disparition élocutoire du poète, qui cède l'initiative aux mots, par le heurt de leur inégalité mobilisés; ils s'allument de reflets réciproques comme une virtuelle traînée de feux sur des pierreries, remplaçant la respiration perceptible en l'ancien souffle lyrique ou la direction personnelle enthousiaste de la phrase.

> Speaking only refers commercially to the reality of things: in literature, it is sufficient to make an allusion to them or to abstract their quality which will be embodied by some idea.
>
> On this condition, the song bounds forth, a joy unburdened.

> This aim I call Transposition—another I call Structure.
>
> The pure work implies the elocutory disappearance of the poet: he yields the initiative to the words, mobilized by the shock of their disparity; they light up with reciprocal reflections like a virtual trail of fire on precious stones: replacing the perceptible respiration of the old lyric afflatus or the enthusiastic personal direction of the sentence.[27]

The direct reference of ordinary everyday language attempts to seize reality "commercially," that is, to possess it. Literature transposes it, turns it into structure, by indirection. The pure work of literature is based not on the poet's voice but on the nature of language, considered objectively. The idea must appear to arise solely from the juxtaposition of words as they reflect each other—this implies that more than one facet of the meaning of each word is used to create these reflections. The minute attentiveness to words replaces the coercive rhythm of older poetic styles or the coercive direction of a personal style. The independent initiative of the words is ensured by systematically weakening the linear movement, the flow of the sentence, traditionally cultivated in literary style. The Symbolist poet renounces communication for presentation.

If the words are to exhibit their multifaceted meaning, they must seem to be isolated within the text. By this isolation, they become names. In Mallarmé's words:

> Je dis: une fleur! et, hors de l'oubli où ma voix relègue aucun contour, en tant que quelque chose d'autre que les calices sus, musicalement se lève, idée même et suave, l'absente de tous bouquets.
>
> . . .
>
> Le vers qui de plusieurs vocables refait un mot total, neuf, étranger à la langue et comme incantatoire, achève cet isolement de la parole: niant, d'un trait souverain, le hasard demeuré aux termes malgré l'artifice de leur retrempe alternée en le sens et la sonorité, et vous cause cette surprise de n'avoir ouï jamais tel fragment ordi-

27. Stéphane Mallarmé, "Crise de vers," in *Oeuvres Complètes* (Edition de la Pléiade), p. 366.

naire d'élocution, en même temps que la réminiscence de l'objet nommé baigne dans une neuve atmosphère.

I say: A flower! and out of the oblivion where my voice consigns a certain contour, as something other than the known calyxes, rises musically—itself an idea and sweet—the flower absent from all bouquets. . . .

The verse which, from several terms, remakes a word—total, new, strange to the language and like an incantation—accomplishes this isolation of the word: denying with a sovereign gesture the inessential that remains in the terms in spite of the artifice of retempering them by dipping them alternately into sense and sonority, it causes you that surprise which comes from never having heard this particular ordinary fragment of elocution, at the same time that the reminiscence of the object named bathes in a novel atmosphere.[28]

Benjamin's distinction between symbolic and profane meaning comes directly from Mallarmé's contrast of poetic and everyday language, and the technique of Symbolist poetry gave him his method of representing the Ideas—justly, as Symbolist theory asserts the independence of language and its emancipation from communication, and it is in language so emancipated that Benjamin placed the Ideas.

He was the last great Symbolist critic—and the first, too, in a way—certainly the first to apply the poetic theory to historical criticism. As Mallarmé treats words, Benjamin treats ideas: he names them, juxtaposes them, and lets them reflect one off the other. Renouncing directed argument, he relies upon the ideas through language to produce their own cross-meanings: his arrangements are material for contemplation, they force the reader himself to draw the meaning from the resonances of the ideas, from the perspectives created by the order of sentences.

Like Mallarmé's poetry, Benjamin's criticism is allusive, not coercive: it does not impose its interpretation on literature, but takes the form of a meditation on the texts that are quoted. Where

28. Ibid., p. 368.

it goes beyond Symbolism is in the more modern surrealist use of shock. This is particularly evident in his later essays on Baudelaire, inspired by Baudelaire's own fascination with the technique of shock, the yoking-together of incongruities. In Benjamin's "synthesis of extremes," however, the effect of shock is already a latent power, and the Symbolist procedure of allowing language to speak for itself, of "giving the initiative to the words," does the rest. The extremes are juxtaposed with little or no mediating comment, and the Idea arises in the silence between them.

*L'armature intellectuelle du poème se dissimule et a lieu—tient—dans l'espace qui isole les strophes et parmi le blanc du papier; significatif silence qui'il n'est pas moins beau de composer que les vers.*

—Mallarmé, *Le "Livre"*

*The intellectual armature of the poem conceals itself, and takes place—stands —in the space that isolates the stanzas and amidst the white of the paper; significant silence that is no less beautiful to compose than verse.*

A final assessment of Benjamin's Marxist period from his "conversion" in the late 1920s until his death must await publication of a large part of the material—in particular the Goethe essay written for the Moscow Encyclopedia but refused, like the *Trauerspiel* book, and the mass of notes for his last book, *Paris, the Capital of the Nineteenth Century*. His new allegiance to a more openly activist philosophy made for an improvement, even a purification, of his style. With the partial disappearance of the idealist terminology went some of the mannerism: the writing is less visibly worked over. The long essay on Leskov, "The Storyteller," which contains a historical theory of narration, is perhaps the most accessible and the most beautiful of his works.

When the evidence is in, however, I doubt if we shall find that Benjamin had considerably altered his old opinions. In the 1930s he turned openly to the sociology of literature and language, above all in his essays on Brecht and in "The Work of Art in the Age of

Mechanical Reproduction," but this interest had been implicit in his early work. He never, as Lukács did, retracted or betrayed his earlier insights, and he never ceased to get himself into trouble with those who could have helped and protected him.

The talk he gave at a communist congress in 1934, "The Author as Producer,"[29] was such an open provocation. It was tactless and imprudent to tell a group of communist writers that they ought not to judge a work by its *Tendenz*, by its ideological content, that there was no sense in writing bourgeois novels with communist ideals. His obvious interest in avant-garde art would have found a welcome response in the breasts of the many surrealist artists then in the party, but most of them had learned to temper their surrealist enthusiasm by 1934. Benjamin's efforts to champion Brecht also had a certain bravado, as Brecht was not in the best odor in Moscow. What must have been especially outrageous to the French communists was Benjamin's praise of the interesting experimental movement in Russia which tried to abolish the distinction between reader and writer, and allowed the workers to write their own newspaper: this would have taken some of the press out of state control, and the movement was under heavy attack in Stalinist Russia.

Shortly afterward the movement was suppressed, and then Benjamin repeated his praise of it in "The Work of Art in the Age of Mechanical Reproduction." This was evidently going too far, and Adorno and his friends who published it cut out the offending phrases.

"The Work of Art in the Age of Mechanical Reproduction" is the most influential of Benjamin's writings: it proposes the theory of the *aura*, the traces of history that guarantee the authenticity and uniqueness, the autonomy, in fact, of the traditional work of art. In this essay Benjamin envisages the possibility that art and culture as we know them will disappear, that they will be destroyed by the technology of the new mass arts; he thought that the shock

---

29. This text will appear in a new selection of Benjamin's writings to be published by Harcourt Brace Jovanovich next year [1978].

of information relayed by the newspapers was killing the sense of the wisdom conveyed by the oral tradition of the storyteller.

Benjamin was a lover of rare books, with a splendid collection of children's books. He was tied emotionally in many ways to the old forms of culture. He knew, however, how much the conception of the single, isolated work of art, authentic and unrepeatable, owed to religion, which gave it its sacred radiance, and then later, in a secularized form, how much it owed to a system of private property which gave it its value. He knew the dependence of culture upon a world and a society that he felt—with the intensity of an alien Jew in Paris in the 1930s—to be unjust and even indecent.

It may be that Benjamin exaggerated, and certainly he misstated, the complicity of art and culture in the injustice of history. In any case, he could not bring himself to condemn the possible —and even, he hoped, eventual—disappearance of the society he knew, although he understood that much of what he considered art would disappear with it—not only by the destruction of objects, but by the death of the *aura,* the sense of art which was already losing its power.

He was perhaps the only critic who would neither rejoice at the prospect of the death of art nor—in spite of the deep nostalgia his essay expresses—allow himself to mourn its passing. His dispassionate tone is aristocratic. Perhaps to understand the tragic irony of this famous essay we should need to have the text of the unpublished discussion in which Benjamin, according to Scholem,[30] defended *in Marxist terms* the thesis that art is meant for connoisseurs of art.

In the end, it was probably this aristocratic manner that made the difficulty between Benjamin and the editors of the *Zeitschrift für Sozial Forschung,* the one review where, by 1938, Benjamin could still place a substantial essay. The refusal to publish some of his finest work, the three essays on Baudelaire now grouped together as *Das Paris des Second Empire bei Baudelaire,* delayed their appearance until the years 1967–1971.

30. *On Jews and Judaism in Crisis* (Schocken Books, 1976), p. 221.

The ostensible reason for the rejection, as expounded in Adorno's letters, was Benjamin's faulty Marxism, his pragmatic placing of details from the "superstructure" directly against traits drawn from the "substructure" without the mediation of theory. For example, Benjamin set the stanzas of Baudelaire's "The Rag-picker's Wine" directly alongside a description of the wine tax, without comment. Adorno objected to his "open-eyed wonder in the presentation of the facts" as un-Marxist. There is no doubt, as Habermas has said, that Adorno was the better Marxist of the two—although he, too, was peculiar enough in his own way; what upset him was what he called Benjamin's "ascetic" withholding of theory.

This "asceticism" was central to Benjamin's philosophy. He seized on Adorno's phrase about his "open-eyed wonder":

> When you speak of "open-eyed wonder in the presentation of facts," you characterize the true philological attitude. . . . Philology is the close inspection of a text, moving forward by details, that fixes the reader's attention magically onto it. . . .
>
> In your Kierkegaard criticism you say that this wonder gives "the deepest insight into the relation of dialectic, myth and image". . . . This ought to read: "the wonder should be a prominent *object* of such an insight". . . .
>
> If you think back on other works of mine, you will find that a criticism of the philological attitude has been close to me for a long time—and is at its core identical with my criticism of myth. At times this criticism provokes the philological activity itself. It presses, to use the language of the *Elective Affinities,* towards a display of the material content in which the truth content is historically enfolded.[31]

Benjamin was unregenerate. Necessarily so, as what he called philology was at the heart of his style. Philology is the "display of the material content" of a work of literature, the elucidation, element by element, of its historical significance. Theory, however, could only be presented indirectly, unless it was doctrine—that is,

31. Letter to Adorno, December 9, 1938.

unless it was sanctified by tradition, given the authority of "historical codification," as Benjamin put it.[32]

The form of indirect presentation—that, in fact, of Symbolist poetry—Benjamin called the "tractatus." In it the appearance of a mathematical demonstration, of a rigorously ordered chain of reasoning, had to be abandoned.

> Presentation as detour—that is the methodical character of the tractatus. Renunciation of the uninterrupted course of intention is its principal mark of distinction. Perseveringly thought begins always afresh, ceremoniously it goes back to the thing itself. This unremitting respiration is the most characteristic existential form of contemplation. (p. 28, my translation)

This is the rhythm of Benjamin's style. Basically, this respiration was his innocent idea of dialectic. Between every sentence there is a moment of silence; as he said, he deliberately renounced the use of all those stylistic equivalents of the manual gestures and the directed glance by which we normally carry over from one sentence to the next when we speak, and which the writer can mimic by rhythm and syntax. This renunciation accounts for Adorno's confusion: he thought that Benjamin was implying a causal connection between the facts of social and economic history and the lines of Baudelaire juxtaposed to them. No such connection exists in Benjamin's text. Adorno had not heard the silences.

*Die wahre Aesthetik ist die* Kabbala.

—Friedrich Schlegel, *Literary Notebooks 1797–1801*, Fragment 1989

*The true aesthetic is the* Kabbala.

The Romanticism of the end of the eighteenth century—of Novalis, Schlegel, Blake, Wordsworth, Coleridge, Sénancour, Chateaubriand—is often presented as a religious revival. That is to stand things on their heads. It was a profoundly secularizing movement, an attempt to appropriate what was left of a moribund religious culture and to reinstate it in secular form, most often to

32. *The Origin of German Tragic Drama*, p. 27.

replace religion with art. The fact that by 1810 many of these figures had lost their revolutionary fervor and fled into the arms of the Church meant only a temporary setback: the task was larger than one had initially imagined. It has continued. Most of the institutional aspects of religion had already become secularized by the American and French revolutions: the pretense at transcendence within the Church after that time has largely been fraudulent. What had remained almost untouched were the mystical strains in religious thought. It was to the preservation of these mystical elements, giving them a secular form, that Blake, Novalis, and the others addressed themselves, sometimes inventing new mythologies to liberate mysticism from its religious mold, sometimes merely giving it an aesthetic expression that made it once again available.

In this return to early Romantic philosophy and criticism, Walter Benjamin continued that tradition—he was its greatest representative in our century along with Yeats and André Breton. The preservation of mystical forms of thought meant for him not their resurrection but their transformation—just as, in the seventeenth century, allegorical technique preserved the pagan deities by transforming them into emblematic fragments, presenting them as ruins. Philology, the painstaking study of the fragmentary documents of the past, was an act of transforming memory, of translation.

Benjamin held on to the doctrine of the autonomy of the work of art, because it was only by this autonomy that the work could assume an authority that was once the prerogative of the sacred image or text. The doctrine has been misunderstood: it does not imply that a text does not refer outside itself, or, even more absurdly, that it is intelligible without a knowledge of the universe that surrounds it. It merely guarantees that no elucidation of the text—not even the author's own exegesis—can ever attach itself permanently to it, or pretend to be an integral or necessary condition of experiencing it (except perhaps for the elucidation of the explicit, public sense of the words in it). No critical theory whatever has a valid and lasting claim upon the work. This autonomy

requires that one return to the work itself, and that the interpretation is never in any way a substitute for it, or even, more modestly, its necessary accompaniment.

This doctrine appears hard to some critics. They have labored diligently and long on some work, and they believe that in some sense it is now theirs, that they have earned it honestly like the squatter who has worked a piece of land for many years. That was why Benjamin claimed that knowledge was possession, something one had, but truth was not, and the work belonged to the realm of truth: this means above all that no critical reading can get a permanent hold upon it. The interpretation remains forever and necessarily outside the work. To take a recent example, an interpretation none the less absurd for having been sanctioned by an offhand remark of the author himself: no amount of critical work will ever succeed in turning *The Waste Land* into a work that *says* it is about a private grouse of the author. As long as it survives, a philosophical or sociological interpretation of it will remain as cogent as a biographical one—more so, in my opinion.

The autonomy of a work has recently been attacked by many critics, but with the greatest distinction and the most considerable panache by Harold Bloom. In a recent book, he has proclaimed:

> Few notions are more difficult to dispel than the "commonsensical" one that a poetic text is self-contained, that it has an ascertainable meaning or meanings without reference to other poetic texts. Something in nearly every reader wants to say: "*Here* is a poem and *there* is a meaning, and I am reasonably certain that the two can be brought together." Unfortunately, poems are not things but only words that refer to other words, and *those* words refer to still other words, and so on, into the densely overpopulated world of literary language.[33]

Bloom is incontrovertible as far as he is willing to go, but he makes a disastrous slip which reveals the cloven hoof of the professional. It may be found in the words "literary language": it is into the *whole* of language that each work is absorbed. Bloom refuses to

33. *Poetry and Repression* (Yale University Press, 1976), pp. 2–3.

isolate the poem, but insists on isolating the literary tradition; he would evidently like to claim that before a poem reaches the larger context of culture as a whole, it must first be integrated into the literary tradition. But although the initial movement of a poem is within a purely literary tradition, long before it can find a secure place in even a part of that tradition it has spilled over into ordinary language. This does not make the teaching of literature any easier.

Bloom himself bears witness to what he refuses to recognize: the self-contained meaning of the poem. As he says, few notions are indeed more difficult to dispel. It is by such a meaning that a poem is supposed to work, it is essential to its function, it is what it has been made for—which is why ordinary and extraordinary readers everywhere find it so hard to give up the idea. In absolute terms, of course, the idea is absurd, but no one holds it on those terms.

For Bloom, "words . . . refer to other words, and *those* words refer to still other words," as indeed they do, but that seems a limited view. In Bloom's systematic criticism a poem by Wordsworth refers above all to a poem by Milton, transforms and overcomes it. But a poem refers beyond words to the totality of the culture that produced it, and as it moves through time it reveals the capacity to refer to the future as well.

In denying autonomy to the work, Bloom has to find another independent object for study. He relocates autonomy in the "literary language" and he thereby blocks the access of the work of literature to the rest of life. The "literary language" or "literature" itself is a fiction if there ever was one, unless it is an Idea in Benjamin's sense. Bloom treats literature as if it exists in the real world, the world of phenomena, and so it does—in the university. Bloom is today in this country the most powerful force in literary graduate studies: rightly so, as his systematic criticism is both eminently fascinating and easily teachable.

Benjamin cannot be taught. His criticism imposes nothing. His metaphors for the most part glance at and then fall back from the work of literature: when they appear to be absorbed into it, it is only because they are derived directly from it. His interpretations

do not give meaning to, but strip meaning from, the work, allowing the inessential to drop off and the work to appear in its own light. He does not place the work historically but reveals its integrity: history in his account finds its way to the work. As he himself said, he appeared to be writing cultural history, but it was not meant as such: the beauty and the distinction of his achievement came about because it was conceived as philosophical criticism.

### *Postscript, 1998*

Since this essay appeared in 1977, our knowledge of Benjamin's work has grown considerably. The unfinished *Arcades Project,* the ambitious book on nineteenth-century Paris, has been published, along with a large number of shorter works. The complete edition of his writings in German has few gaps left to fill. Very little was available in English in 1977, but by now most of the important texts have been translated, some of them several times. The first of a very generous four-volume selection in English of his writings has recently appeared (Harvard University Press), which will eventually include the *Arcades Project.*

I have left this account of his rejected doctoral thesis stand, however, as I think it needs to be considered apart from his later development. The thesis is a critical statement and demonstration of method which ought not to be colored by Benjamin's later thought, which is idiosyncratic in a different way. *The Origin of German Trauerspiel* is a valid and provocative criticism of most of the contemporary approaches to literature, all of which are still practiced today in some form or other, and it proposes a new view of style and periodisation which escapes many of the traps normally met with in these studies. On reading it, I regretted that I had been unaware of it when writing a book on the period of Haydn, Mozart, and Beethoven, as it would have helped me formulate my initial ideas less tentatively. In many ways, it is the most useful of his books for other critics, and perhaps the least dangerous (in spite of the avowed imitation and disastrous deformation of his method by Theodore Wiesengrund Adorno in *The Philosophy of Modern*

*Music*). It is for this reason that I devoted the first part of my account largely to showing the application of Benjamin's stylistics to a field that he touched on only in passing, Elizabethan and Jacobean tragedy. The poetic and philosophic resonance of Benjamin's succeeding work have obscured the practical value of his rejected dissertation. This practical side has its limits, as I tried to show—it is difficult to use Benjamin's method for academic teaching. This difficulty still seems to me an advantage. That criticism can be any easier is an illusion.

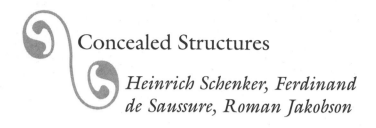

# Concealed Structures

## *Heinrich Schenker, Ferdinand de Saussure, Roman Jakobson*

*It is equally fatal intellectually to have a system and to have none. One must decide to combine both.*

—Friedrich Schlegel

Heinrich Schenker claimed that if you did not hear music according to his system, you could not be said to hear it at all. Moreover, his system was not elaborated with much consideration for more traditional ways of looking at, or listening to, music. He swept away as trivial and insignificant not only such notions as "modulation" and "sequence" but even "melody," the common man's way of recognizing and appreciating music.[1] Schenker's contempt for the layman is exceeded only by his contempt for all previous theoretical work before his own except that of Karl Philipp Emanuel Bach.

---

Originally written in 1971 as a review of Heinrich Schenker, *Five Graphic Music Analyses* (with Introduction and Glossary by Felix Salzer); *La Poétique, la Mémoire;* and Roman Jakobson and Lawrence G. Jones, *Shakespeare's Verbal Art in "Th'Expence of Spirit."*

1. This point is somewhat obscured by Schenker's occasional use of the term "melody" to describe the linear working out of his deep structure. But in his article on sonata form, he insists that the layman's and the theoretician's general conception of melody, theme, and motive only serve to hide the true musical process.

Schenker was the musical heir of the great Romantic literary critics of the early nineteenth century, like Friedrich von Schlegel, who conceived the task of the critic as being to convey the unity of the work of art. At the time of his death in Vienna in 1935 at the age of seventy-eight, he was ignored by most of the world of music except for a small group of distinguished pupils and admirers. Before Schenker, the analysis of a musical work was largely an articulation of its parts. Even today the most common method is still to identify the succession of themes and to note which ones appear more than once. A more technical analysis may articulate the harmonic scheme, listing the different keys to which the music moves and their relation to the main key of the piece (the tonic).

Schenker tried instead to show not how the piece may be divided up, but how it held together. A beginning was made toward this end in music criticism as early as E. T. A. Hoffmann, who observed how a work of Beethoven seemed to derive from a single motif, and traced this technique of composition back to Haydn and Mozart. For later nineteenth- and twentieth-century critics, however, analysis of motifs became only a new way of atomizing a work of music, and matters remained at this relatively primitive level until Schenker revived Romantic aesthetics and combined it with an anticipation of certain aspects of structuralism.

Schenker's analyses contain the most important and illuminating observations made in this century about the music written before 1700 and 1880. Until now only the earliest and weakest of his books, a treatise on harmony, was available in English. A translation of the central theoretical work, *Der Freie Satz*, has never been published, nor are there any English versions of his analyses of Beethoven's Third, Fifth, and Ninth Symphonies and the last piano sonatas.

For this reason two recent publications are welcome: the *Five Graphic Music Analyses* [published in 1969] and, in *Music Forum*, Vol. II, a discussion of the Saraband of Bach's C Major Cello Suite, one of the essays (and by no means the most significant one) from

the volumes called *Der Meisterwerk in der Musik*.[2] The *Five Graphic Music Analyses* is particularly important, although—since the book contains almost no text at all—it can hardly be said to make a beginning with the task of translating Schenker into English. These reductions of music by Bach, Haydn, and Chopin to skeletal graphs are Schenker's last works.

In his excellent Introduction Felix Salzer maintains that, although Schenker was a specialist in eighteenth- and nineteenth-century music, his theory has much to contribute to the understanding of other periods as well. Schenker, however, was no mere specialist in these two centuries, but a firm believer that musical art of any consequence was confined to that period, when a developed and sophisticated form of tonality was the basis of music.

His book on Beethoven's Ninth Symphony was dedicated to "Brahms, the last great master of German music." "German" was an unnecessary qualification for Schenker, who considered the ability to sustain musical expression a proof of membership in the German race, even if one had foreign blood in one's veins. Chopin, whom Schenker used to illustrate his theories almost as often as Beethoven, would, I presume, be an honorary German. This is like Schlegel's "They say that the Germans are the greatest people in the world for their sense of art and scientific spirit: no doubt, but there are very few Germans."

That the music after Brahms did not fit Schenker's theories was only a proof to him of its inferiority. Stravinsky and Reger are both easily disposed of in this way and outside tonality was the outer darkness into which the degenerate composer was forever consigned.[3]

In Schenkerian analysis, every work of music is reduced to a simple line which is a step-by-step descent to the central or tonic

2. *Music Forum*, II, also contains Lewis Lockwood's essay on the manuscript of Beethoven's Cello Sonata, in its intelligence and sympathy the most illuminating description of Beethoven's method of revising and sketching I have read. This was certainly the most important musicological contribution to the Beethoven year.

3. This is not an argument against Salzer's adaptation of Schenkerian analytical methods to medieval and contemporary music, and his work merits independent consideration.

note, and under each note of the line the harmonic functions are indicated by a bass. This line always outlines one of the intervals of the tonic triad (third, fifth, or octave). (In C Major, for example, the line may descend from E to C or from G to C; the octave descent C to C is rarely encountered.)

The fundamental line constitutes, for Schenker, the structure of every tonal work at the deepest level, and music that cannot be reduced to this structure must be judged incoherent and, indeed, ungrammatical. The "idea" of each work is not, emphatically, this fundamental line, but the elaboration of the line into the rich and individual superstructure that we actually hear. It is implied by all of Schenker's writings that only genius can arrive at a musical work that is both grammatical and interesting; and within the terms set by Schenker himself, this is an inescapable conclusion.

What Schenker did was to extend the idea of dissonance from the individual moment to the level of the piece as a whole. Dissonance is simply an interval that requires resolution into a consonance, and the only consonances accepted in Western music since the fifteenth century are the intervals of the basic triad (third, perfect fifth, and octave) and the inversion of the third, or the sixth.[4] All other intervals are, by convention, dissonant, and demand to be resolved into one of the consonances.

This concept was already extended in the eighteenth century when the chord and not the interval became the basis of harmonic thought. Dissonance now implied resolution into a triad, and the final resolution of every work of music was, of course, into the tonic triad.

The basis of Schenker's system is that every note of a piece, whatever its immediate function, is considered as dissonant to the notes of this final, tonic cadence (except, naturally, for the notes of the cadence itself). Each note has therefore ultimately to be resolved into the tonic triad. An unresolved note is considered as in suspense, the tension it creates lasting until its resolving note

---

4. The ambiguous historical role of the fourth may illuminate this: theoretically it fluctuated between consonance and dissonance with theorists unable to decide; practically, it was a dissonance after 1400 except when it functioned as an inversion of the fifth.

finally appears in a context that emphatically displays its role in the large plan. The context is defined by the harmonic significance at each point of the basic line.

What is most striking about Schenker's analytical system is his insistence that both listener and composer—consciously or unconsciously—have a sense of tonal forces that overrides the immediate, small-scale event and allows them to hear "at a distance" so to speak. For example, the basic phrase *(Ursatz)* underlying the whole of Chopin's Etude in F Major, opus 10, no. 8, is:

*F. CHOPIN ETUDE IN F MAJOR, OP. 10, NO. 8*   Hintergrund und Mittelgrund

Resolution at a distance would require enormous space to illustrate properly, and the shortest example will have to suffice. Mea-

sures 10 to 15 of the original are represented in the most complex of the series of Schenker's analytic graphs by:

We can see here not only all the notes of the original resolved into the basic phrase (or its octave doublings), but also the relation of the high G of measure 11 to the high A that occurs four measures later. This is a relationship that a pianist with a sense of line naturally sets in relief, and is a direct part of musical experience. The large-scale resolutions take place according to the strict rules of counterpoint derived from the practice of J. S. Bach.

Schenker assumed that the contrapuntal technique of voice-leading (in which each note is part of an independent vocal or instrumental "horizontal" line in addition to combining into a simultaneous harmony with other notes) was valid not only on the level of the single phrase but underlay the general harmonic structure as well. He found that he could connect what he considered the basic notes at the points of structural importance, and that they formed a series of lines that conformed to the tradition of voice-leading as it had been elaborated in the fifteenth and sixteenth centuries, and systematized in the eighteenth.

These lines constitute the most complex of Schenker's analytic graphs, the *Urlinie Tafel*. These in turn can be reduced in a series of stages to the simple cadential phrase outlining the tonic

triad. This latter phrase is not to be understood as the structure
of the work being analyzed, but as the structure of the tonal lan-
guage.

In other words, for Schenker every tonal work is the elaboration
of a simple cadence. Historically this point has much to be said for
it (although Schenker's way of thinking was preeminently anti-
historical). The cadence is the determining element in Western
music, at least from Gregorian chant until the early twentieth cen-
tury. Not only classical tonality but the medieval modes are defined
by the cadence, and the basic impulsive force of both Renaissance
and Baroque music—the harmonic sequence—is generally a repe-
tition of cadential formulas. The cadence is a framing device, and
it isolates and defines a piece of Western music as the frame defines
a Western painting. Unlike much of the music of Africa and Asia
—and much of what is being written today from John Cage to
rock—a work of European music from the twelfth to the twentieth
centuries is conceived as a determinate isolated event, and the
cadence fixes each performance in time.

If a work is essentially a cadence magnificently expanded, then
it may be seen as a delaying action, or, in Schenker's own terms,
a tension sustained until the final resolution. What was original in
Schenker's approach was his insistence that the means of sustaining
the tension be intimately related in all details to the simple cadence
which defines the work. In this way, he was able to explain that
sense of unity and integrity of the great works of eighteenth- and
nineteenth-century music. A quartet of Mozart holds all its most
violent and dramatic contrasts in one characteristic whole, while a
quartet by Dittersdorf—with much more uniform material and
texture—falls into a series of separate sections, jolly and tuneful as
they may be.

It is a waste of time to ask if this unity that we seem to perceive
really exists, or if the composer knew that he created this unity,
whether or not he was able to put his awareness into words. These
are not, of course, answerable questions even if the composer is
on hand to incriminate himself. The unity of a work of art is
the oldest critical dogma that we have, and every piece of music

demands a perception of its unity in the absolute sense that that is precisely what listening to it means. That is, the unity is neither an attribute of the work nor a subjective impression of the listener. It is a condition of understanding: the work reveals its significance to those who listen as if even its discontinuities correspond to hold it together.

Some sort of symmetrical correspondence between detail and large structure is therefore integral to all Western art, and Schenker locates the basic correspondence in music between those tonal forces that enable a listener without perfect pitch to realize that the original key has returned and the rules of counterpoint that govern the individual phrase. Bach did conceive a saraband as an immense, single phrase, and Haydn could, indeed, think musically at a much longer range than any of his contemporaries except Mozart.

The reduction of a Chopin Etude to a simple contrapuntal graph that often resembles nothing so much as a phrase of Bach is not surprising when we remember how much Chopin revered Bach and how much he depended on him for his conceptions of harmony and form. Schenker considered tonality as God-given and established for all eternity (so much the worse for those heathen on other continents beyond the pale of revelation), but this should not obscure his discovery of how sensitive the greatest composers were to the implications of their musical language.

The limitation of Schenker's approach is as evident as its cogency (although most musicians are capable of appreciating only one or the other, and discussion is blindly partisan). The most crippling omission is the rhythmic aspect: harmony and melody can be entirely reduced, convincingly, if at times somewhat speciously, to the simpler lines of the *Urlinie,* but rhythm plays not only a subordinate role but often none at all. This falsifies the musical thought of all the works with which Schenker dealt, most evidently those of Beethoven.

Resulting logically from the neglect of rhythm is the total disregard of proportions. Schoenberg once looked at Schenker's graph of the *Eroica,* and said, "But where are my favorite passages?

Ah, there they are, in those tiny notes."[5] It is not merely that one note of Schenker's basic line may last one second and another a full minute in the complete piece, but that Schenker often minimizes the salient features of a work. This implies that there are important forces in musical composition that Schenker takes no account of, and they may often supersede the aspects of music with which he is concerned.

Basically these limitations arise because his thought—his way of looking at music—was ruthlessly linear, and while this may be an understandable and fitting mode for an age that saw the development of the twelve-tone technique and the serial music that Schenker so hated, it radically distorts the music of any period, including Schenker's own. His neglect of rhythm, too, has only accentuated the nonsensical separation in theory of the elements of music, as if a tonal melody could exist without a rhythmic contour.

These limitations, however, would not account for the extraordinary distaste that his work often provokes, chiefly among musicologists, and for the absurd disregard of his achievements that still lames critical writing on music. Nor would his manner of writing, brutally and repulsively arrogant, and his insistent German chauvinism explain why work of that importance should have remained relatively unknown and ignored except by an unhappy few during Schenker's lifetime, and should continue to excite hostility during the more than thirty years since his death in 1935.

It is hard to take offense at Schenker's suggestion that a new Beethoven would have to appear among the Germans just as Nature places elephants and crocodiles only where they will find the conditions to sustain life. Absurdities like this have been excised from the more recent edition of *Der Freie Satz,* and Schenker's disciples tend to gloss over, and even dismiss, these aspects of his thought, but a true Schenkerite ought to insist that

---

5. Schoenberg had a great admiration for Schenker's work, and he was one of the few to appreciate it during Schenker's lifetime, in spite of his inevitable disagreement with many of its aspects. Schoenberg's music, indeed, develops on its surface many of the relationships that Schenker was later to read under the skin of classical works.

Schenker's work hangs together as an organic whole. The paranoiac style of Schenker's essays along with his insistence that his theory was a form of monotheism does reflect an essential characteristic of his ideas.

Schenker's method is the uncovering of a hidden and secret form underlying the explicit one. He does not deny that the explicit forms exist (sonata form, rondo form, ternary form are almost as real for him as they were for d'Indy); he denies their importance. The implicit form is the only one that brings salvation, and it alone reveals the way the music was composed. The explicit form was imposed almost as an afterthought.

This absolute rejection of the explicit in favor of the implicit is a classic method of interpretation: the Marxian analysis of ideology, the Freudian theory of dreams and slips of the tongue, and the structuralist doctrine of myths. For Marx (in the *18* Brumaire, for example) the ideology of the different political parties was a mask for their allegiance to a particular class; for Freud, and for Lévi-Strauss, the dream or the myth is a disguise for an irresolvable and unacknowledgeable tension. In each case, the explicit meaning is generally false, and only the implicit meaning systematically revealed is given any weight. The initial reaction to each of these systems was one of rejection by the academic establishment: the Marxian dialectic met as much resistance from orthodox economists as psychoanalysis from the medical profession, and Lévi-Strauss is regarded by many of his fellow anthropologists as something between a charlatan and a poet.

The style of religious paranoia that occasionally appears in all these movements is both an answer to this ostracism and a provocation of it. Their organization into quasi-conspiratorial sects[6] is related to the rejection of explicit meaning, and, in every case, this rejection is presented as a scandal. The scandal may be political,

6. Structuralism is the great mandarin conspiracy of the 1960s, and no other recent intellectual movement has so insisted upon the need for an hermetic vocabulary and a set of sacred texts (Mallarmé, Sade, and Lévi-Strauss). A counterrevolutionary movement is rising, however, and it is now becoming fashionable in Paris and New York to claim proudly to be unable to understand *Tel Quel*.

sexual, or purely intellectual, but it is always construed as an ethical attack on a conspiracy of silence. The explicit meaning which is to be cast out is conceived not only as mistaken or trivial, but as having been deliberately designed to mislead. The symbols of a dream are there to hide what they unconsciously betray, as ideology is intended not to enlighten but to conceal. For Schenker, all musical theory before his own was a deliberate conspiracy between mediocrity and non-Germanic musicians to betray the great tradition of music from 1700 to 1850 by concentrating only upon the superficial, explicit aspects of the great German classics. Even the works themselves, indeed, are conceived not as revelations, but as concealments of the underlying structure.

In Schenker's analyses, this creates a difficulty when moving from the implicit to the explicit.[7] He tried to cover the difficulty with an interesting and provocative theory of "improvisation," but the awkwardness is always present. Schenker continued to use old-fashioned concepts like "first theme," "counter statement," and "bridge passage" in writing about sonatas, and even accepts these terms with all their nineteenth-century crudity. What remains unclear, however, is the transition from Schenker's graph to the music itself with its admitted tunes, modulations, and so forth.

The transition from implicit to explicit always presents this difficulty, which is naturally less obvious when going in the other direction. It is easy enough to see the implicit meaning hidden within the exterior shell once the methodology has been learned, harder to decide why the inner sense should have taken just this outer form.

It should be emphasized that it is neither the truth nor the importance of Schenker's deep structure that is in question but its *status*—its nature and its relation to the work as a whole. What does a Schenkerian graph represent? We cannot call it the form of a piece because it omits too many major forces of musical impor-

7. He was, himself, aware of this, and his article on sonata form begins amusingly, "To bring the general into line with the particular is one of the most difficult tasks in human experience."

tance. We cannot even call it an adequate representation of the purely linear element of the form unless we are willing to claim that this is not essentially affected by proportion and rhythm. Nor is it, as Schenker claimed, a method of composition, although it plays a definite role in this process.

This ambiguity is a stumbling block found in any artistic analysis that takes the form of a hidden pattern, and yet it is hard to conceive of an analytic approach that could remain interesting while claiming that the meanings it uncovers are less significant than the explicit ones that have been evident all along. Such humility would appear to be self-defeating. The problem becomes clearer when we leave the isolatable world of music for literature, composed in a medium that connects at every point with a language used for everyday speech.

⌁

Ferdinand de Saussure, even while giving the lectures at the University of Geneva which are the foundation of structural linguistics, spent many years investigating the possibility of hidden anagrams in Latin poetry. When he died in 1912, he left ninety-nine notebooks filled with his speculations, but never published anything on the subject. (He was also never able to bring himself to publish—or, indeed, even to write—the great *Course in General Linguistics* on which his immense reputation rests. It is a compilation of students' notes.)

The notebooks have been largely withheld from publication, perhaps because their character is as embarrassing as it is fascinating and provocative. A few selected passages of a general nature were published in essays by Jean Starobinski in 1954 in the *Mercure de France,* in *Tel Quel* No. 37, and in the *Festschrift* volume of 1967 for Roman Jakobson.[8] In *Change* No. 6, which appeared a few months ago, Starobinski has edited Saussure's analysis of lines 1–52 and 1184–1189 of Lucretius's *De Rerum Natura.*

8. Saussure's published correspondence with Antoine Meillet largely treats of these anagrams.

The origin of Saussure's researches was an investigation into the phonetic structure of that early, primitive, and mysterious form of Latin verse called Saturnian. He became convinced that there was a regular repetition, a coupling, in fact, of the phonetic elements. Alliteration (the repetition of an initial sound) and rhyme (the repetition of a final sound) were only particular cases of a more general phenomenon, in which the interior syllables also had a function. His attempts to work out a regular law for these couplings in Saturnian verse proved unfruitful, but they suggested to him that the basis for them was a proper name (a number of the fragments of Saturnian verse that have come down to us are commemorative and taken from the sepulchral epitaphs of the Scipios).

From the proper name it was only a step to the idea of any word, its phonetic elements isolated, freely distributed and combined, providing the basis for verse, and Saussure turned to a study of Virgil, only to find the same couplings and the same musical suggestion of a hidden word influencing and even determining the phonetic structure of any given series of lines. This seemed to Saussure, as to anyone else, a deplorably and absurdly burdensome method of writing poetry, but the hypothesis explained the intricate phonetic symmetries that are a regular characteristic of poetry, and even—though less markedly—of prose.

The assumption that Saussure made was that the manifold phonetic symmetries of a passage in verse, including those not required by the rules of versification, were not determined at random by the sense, but combined into an ordered unity. This would correspond to the feeling shared by many readers of poetry that each part of a poem, closely read, has a specific and individual phonetic character of its own. This individuality of sound is the source of the most direct, most immediately sensuous pleasure that verse can give.

Saussure made the further assumption, a natural if more dubious step, that the unity obtained by the combination of the dominant assonances within a short passage had itself a clearly definable meaning—in other words, that the various syllables made up a

word. This word was his "anagram," a term with which he was eventually dissatisfied, substituting, in turn, "paragram," "hypogram," "logogram," "paramorph," and "anophony"; the last named best expressed Saussure's insistence that the game was played not with writing but with sound.

In all of his speculations on this subject, he relied principally on his ear, and his analyses constantly stress the setting-in-relief of his phonetic couplings by the accent of the verse and the stress of meaning within the line. He made it a condition not only that the different phonetic elements of his theme words should appear clearly emphasized within a very few lines, but that these lines should contain a definite model of the theme words in the form of a short phrase that began and ended as the word did. For example, *Āëriae prīmum vŏlucrēs tē* is one model, or mannequin, as Saussure called it, for *Aphrodite*.

The analyses are fascinating to read because of this sensitivity: they represent the spontaneous reactions of a reader of poetry systematized and rationalized almost to a point of insanity. Almost—because at every point Saussure stopped to ask himself whether the whole investigation was not a magnificent delusion like the hunt for a Baconian cypher in Shakespeare.

In the first fifty-two lines of Lucretius's poem, which contains the invocation to Venus, Saussure finds that the phonetic emphases combine to form the syllables of the Greek word *A-phro-di-te*. This is striking enough to shake any doubts of Saussure's approach. Lucretius was a poet so steeped in Greek verse that it is more than probable that the composition of his invocation to Venus was accompanied by innumerable souvenirs of Greek verses to Aphrodite, echoes of lines and phrases remembered and half-remembered.

It is also reasonable that a poet should be almost pathologically sensitive to the suggestiveness of the purely phonetic aspect of words. The inherent improbability of Saussure's theory begins for a moment to evaporate. In fact, if we accept Saussure's analysis of Lucretius, we do not even have to ask whether the poet was conscious of his use of an underlying theme word; an unconscious

intent is as natural and as credible in this case as a planned strategy.

Nevertheless, Saussure felt impelled to ask just that question: was the anagram a consciously applied technique of Latin verse? At this point, the latent paranoia of his program of research comes to the surface. If Saussure's conjecture is right, the conspiracy of silence on the part of the whole body of classical literature is frightening. Finally, in desperation, Saussure wrote to a contemporary Italian who composed Latin verses, hoping to learn that the tradition of anagrams had been handed down secretly to the present day. We do not know if there was a reply, but Saussure never spoke again of his researches.

To conceal a word phonetically within a set of different words is a legitimate poetic effect; there is a famous example in Valéry's "Cimetière Marin."

La mer, la mer, toujours recommencée
O récompense après une pensée
Qu'un long regard sur le calme des dieux.

The second line literally illustrates the preceding word *recommencée* by hiding it and expanding it over the entire line, like a larger wave that builds itself up and breaks after a moment's tension, broadening the faster and more regular rhythm that preceded it.

Such effects, based on the quality of the individual sounds, are more crucial in French verse, with its relatively uniform syllabic weight, than in English, which relies on the force of the rhythmic accent. They are perhaps even easier to achieve in Latin, with a syntax that permits so much greater freedom in the order of words. Both in French and Latin verse, passages are often emphasized by being constructed out of a specific nexus of sounds, and the importance given to such peculiar refinement is one of the reasons non-French-speaking readers find French poetry so difficult at first to appreciate. One classical scholar has remarked on the intricate patterns of sound that arise in Latin poetry from repeating the phonetic elements of the most expressive word in a passage, so that

the sense of the word seems to radiate phonetically into those that surround it.[9] With this explicit "radiating word" we are not far from Saussure's implicit anagram.

In all of his work on the anagrams, Saussure continued to ask whether his results were due to chance. To this question, and also to the question whether the procedure was intentional or unconscious, no answer could in principle be given, whatever statistics were compiled. Alliteration, assonance, rhyme, rhythmic pattern —any form of phonetic repetition, in general, is part of the essence of poetry. Each system of versification sets up those repetitions which are obligatory (sometimes called canonic), and the others are freely used in subsidiary contrapuntal patterns with the main one. Accent and, sometimes, rhyme are obligatory or canonic in English; assonance and alliteration are subsidiary and, in a sense, free, but they are nonetheless a deeply ingrained part of English poetic tradition. That anagrams may be derived from these subsidiary systems is not surprising; phonetic repetition is not just by chance in a poem.

Or in prose, either, for that matter. Saussure found his anagrams, somewhat unwillingly, even in Latin prose (artistic prose, however, that of Cicero and Julius Caesar). But, as Starobinski pointed out, they may be a part of ordinary speech as well. How often do we not find a word or even an idea suggested by alliteration or rhyme, and allow our thoughts to be guided by sound as well as by sense? Saussure's anagrams grow as much from language itself as from literary technique. The significance of Saussure's ninety-nine notebooks is to show the intimate relationship between poetry and the processes of language and, above all, to demonstrate the power of a phonetic pattern to demand a meaning, the right to exist as a truly functioning part of language. It is difficult to read Saussure without hoping that he will prove to be right.

An ordered structure is a provocation, and we instinctively

9. N. I. Herescu: *La Poésie Latine—Etude des Structures Sonores* (Paris, 1960). The first of Herescu's studies precedes by many years the first publication of any quotation from Saussure's notebooks.

refuse to admit its lack of meaning. What Saussure was claiming was a significance for the structure of language independent of the message it contains. Saussure thought he was investigating not an attribute of language, but an esoteric technique of poetry. Ironically, what he found was an attribute of language which is a necessary condition for the existence of poetry.

We may rephrase Saussure's questions so that neither intention nor chance will muddy the waters. Can the subsidiary, non-canonic techniques of phonetic repetition in a poem have a meaning of their own independent of the explicit poetic discourse? If Saussure's own philosophy of language is right and meaning can only come into existence given an arbitrary convention that unites sound and sense, then the answer must be no. Can the non-canonic repetitions interact with the poetic discourse to form new meanings? That would mean taking the phonetic structure of poetry very seriously indeed. It would also entail defining the relation of implicit to explicit in a work of art.

The explicit, canonic structure of one of Shakespeare's sonnets is fourteen lines of iambic pentameter with a rhyme scheme of three quatrains (each *abab*) and a final couplet. In his pamphlet on Sonnet CXXIX ("Th'expence of Spirit in a waste of shame"). Roman Jakobson (in collaboration with Lawrence G. Jones) has identified a considerable series of subsidiary patterns of a phonetic, syntactic, and semantic nature.

In his literary criticism, Jakobson relies largely on the principle of binary opposition which played so fundamental a role in his systematization of the study of the sound structure of a language. Completing Troubetzkoy's work, he reduced the phonetic structure of any language to twelve and only twelve possible oppositions so that each elementary unit of sound, or phoneme, is analyzed as nasal or non-nasal, consonantal or non-consonantal, and so on. This principle of binary selection is essential to information theory, which conceives the transmission of a message as dependent on a series of successive choices between alternatives.

For this reason, perhaps, he prefers to analyze short poems that divide into four or five parts. He can then contrast the stanzas individually, pitting odd against even, inner against outer, anterior against posterior. The points he considers are of a precise technical nature often brushed aside by critics. The contrast of grammatical and nongrammatical rhymes (rhyme words with the same or different grammatical function) has been treated in English previously only by W. K. Wimsatt, I believe, although the relation of grammatical rhymes to the poetic language was already raised in the section drafted by Jakobson of the Theses of 1929 of the Prague Linguistic Circle. In the Theses, too, we find the principle developed later by Jakobson that the "purely" phonetic patterns in poetry are strongly bound to the semantic structure.

Here is the sonnet as Jakobson and Jones have arranged it for analysis:

I   1 Th'expence of Spirit / in a waste of shame
      2 Is lust in action, / and till action, lust
      3 Is perjurd, murdrous, / blouddy full of blame,
      4 Savage, extreame, rude, / cruel, not to trust,

II   1 Injoyd no sooner / but dispised straight,
      2 Past reason hunted, / and no sooner had
      3 Past reason hated / as a swollowed bayt,
      4 On purpose layd / to make / the taker mad,

III  1 Mad[e] In pursut / and in possession so,
      2 Had, having, and in quest, / to have extreame,
      3 A blisse in proofe / and provd / a[nd] very wo,
      4 Before a joy proposd / behind a dreame,

IV   1 All this the world / well knowes / yet none knowes well,
      2 To shun the heaven / that leads / men to this hell.

What Jakobson calls the "poetry of grammar" is most brilliantly shown in this great "generalizing" sonnet on lust by the remarks he and Jones make on the only two nouns that refer to man: "taker in a swallowed bait that makes the taker mad, and men in the heaven that leads men to this hell":

Both . . . function as direct objects in the last line of the even strophes: II *taker* and IV *men*. In common usage the unmarked agent

of the verb is an animate, primarily of personal gender, and the unmarked goal is an inanimate. But in both cited constructions with transitive verbs the sonnet inverts this nuclear order. Both personal nouns characterize human beings as passive goals of extrinsic, nonhuman and inhuman actions.

It is upon details such as this "grammatical metaphor" (as Jakobson has called it elsewhere) that the authors build their reading of the poem with its "semantic leitmotif" of "tragic predestination." The ability of the grammatical structure of language to assume a poetic life of its own is fundamental to music, which imitates this aspect of language above all.

In their description of the verbal art of the sonnet, the authors are concerned to show the inner correspondences that work against the simple division into three quatrains and final couplet. Most convincing in this respect is the light shed on the central verses in this scheme. Lines 7 and 8 stand out in relief, as they are the only ones without grammatical parallelism, and line 8 is "built of five totally unlike grammatical forms." This partially elucidates the means by which Shakespeare achieves the remarkable change of tempo in the center of the sonnet, with its sudden breadth and complexity of movement.

The prejudice against linguistic criticism of this kind is solidly, and to some extent reasonably, founded on a distaste for learning a new vocabulary, one which is at times unnecessarily technical for one's purposes. But Shakespeare's art consists—at least in large part—in an extraordinary feeling for the very stuff of language in all its aspects, and criticism has need of the tools that Jakobson offers. It is melancholy to read the pious horror (mostly British) at the invasion of an urbane humanistic discipline by the linguistic barbarians. Syntax is as relevant as irony for the understanding of literature, and Jakobson's microscopic examinations come out of a long life's delight in literature, and a breadth of interest unsurpassed since the deaths of Erich Auerbach and Leo Spitzer.

Those of us who cannot read a Slavic tongue must be content with Jakobson's essays on English and French poetry. The most

famous of these is the analysis of Baudelaire's "Les Chats" (done in collaboration with Claude Lévi-Strauss), the most satisfying perhaps the closely reasoned treatment of Baudelaire's "Spleen." Equally important are the theoretical papers, above all the article "Linguistics and Poetics,"[10] in which the largeness of vision is balanced by its clarity. In all this work, social and biographical interpretations are excluded. Jakobson has always insisted that language and literature must be understood as systems in their own terms before their interaction with other systems can be apprehended. It is doubtful whether, as a matter of fact, this is a possible or even desirable goal in all of the purity with which Jakobson has invested it, but it is unquestionably the best practical starting point for criticism.

As appears in one minor aspect of the Shakespearean pamphlet, Jakobson has been considerably influenced by Saussure, and he and Jones tentatively suggest an anagrammatic signature worked into the opening line:

> Th'expence of Spirit in a waste of shame
>    ksp       sp.r              Sha

in addition to a pun on "Will" in the concluding couplet, "All this the world well knowes yet none knowes well, / To shun the heaven that leads men to this hell;" and in support of this suggestion they cite Shakespeare's tendency to equate "will" and "well" in puns. (For a sonnet on lust, they might have added the Elizabethan sense of "will" as "carnal desire.") This is not Jakobson's first use of Saussurian anagrams. He finds anagrams for "Spleen" in all four of Baudelaire's poems with this title, and an anagrammatic influence of the title throughout the poem called "Le Gouffre."

The difficulty—at least in the Shakespeare—is not an inherent improbability, but the lack of coordination with the rest of the analysis. Sonnet CXXIX, written on the most personal of themes— fornication and its bitter aftermath—is "the only one among the

10. In *Style in Language*, T. Sebeok, ed. (Wiley, 1961).

154 sonnets of the 1609 Quarto which contains no personal or corresponding possessive pronouns." Nor is a fornicator even referred to except in a dependent clause as part of a simile and there in a passive role (see remarks on *taker* above), and in the superbly general word *men* in the last line. The entire sonnet is not only "generalizing," but absolutely and even repressively impersonal.

If we accept the anagram and the pun on *Will*, they are—if conscious—sardonic jokes, and—if unconscious—the revenge of suppressed nature.[11] In either case, we are left with a specifically personal meaning which deliberately undercuts the explicitly generalizing form of the sonnet. We need a very superior sort of irony to integrate the two.

The most disappointing part of Jakobson and Jones is the section "Odd Against Even." They list every binary correspondence that comes to hand, and we sometimes have the impression of reading a series of notes left unused after an analysis was written. (There is even an apologetic note in the presentation, when they write, "By the way, the preposition *in* appears only in the odd strophes.") It would be unfair to suggest that much of this detail has an interest more linguistic than literary: poetry rejects no aspect of language. But the presentation of this section does not establish throughout its relevance to Shakespeare's verbal art.

All this would not matter if the significance of the odd-even opposition were acceptable. It is suggested that the odd strophes contain "an intensely abstractive confrontation of the different stages of lust *(before, in action, behind)*, whereas the even strophes are centered upon the metamorphosis itself." I do not believe that a reading of the sonnet bears this out: the heaven and hell of the fourth strophe, for example, are as abstractive a confrontation as anything in the first, although one leads to the other; and the opening line already describes the metamorphosis of "in action" into its aftermath.

---

11. Acrostic signatures (like Villon's) and joking titles (like "Mr. Eliot's Sunday Morning Service") cannot be equated with hidden allusions. The latter stake a claim to greater significance—else why were they hidden?

In fact, the treatment of the three stages of lust is beautifully balanced, and the movement from one to the other is subtly modulated. Jakobson and Jones do not study this movement, so they miss the balance of the opening quatrains, in each of which the first two lines present two states and the last two lines characterize one at length (*before action* in lines 3 and 4, *after* in 7 and 8). They also miss the remarkable backward slide in time of line 10:

Had, having, and in quest, to have extreame,

which is prepared by the retrospective glance of lines 7 and 8, where the third stage is described by its horrified view of the first.

Jakobson has called upon Saussure's authority to justify taking "the elements out of the order in time" in which they are presented in the poem. But to be effective, the correspondences so discovered should not be invalidated by an actual reading in time. A detail found in both the first and third strophes cannot be isolated when it is found in the second as well, and in linking the odd strophes Jakobson and Jones cite as correspondences some features which are pervasive; they bring together: I, *Spirit* (sp.r.t) *in;* III, *In pursuit* (p.rs.t). But they themselves later call attention to the paronomastic chain which unites the odd and even strophes and which pairs *In pursuit* with *Past reason* (the latter occurring twice in the second strophe, both times in the prominent initial position). Their neglect of this pervasive character makes the analysis of the expressive sound structure of the final couplet uncertain as well.

On the other hand, if we eliminate the opposition of odd and even, we can see that the four consonants of *Spirit* dominate the first twelve lines:

1 expence, Spirit, waste
2 lust, lust
3 Is perjurd (sp.r.rd)
4 Savage, extreame (str), trust
5 dispised straight
6 Past reason hunted (p.str.s)
7 Past reason hated,

8 On purpose layd (p.rp.s'. . . .'d),
9 In pursuit (p.rs.t)
10 in quest, to have extreame
11 A blisse in proofe
12 proposd

This concentration is emphasized by the phonetic symmetries of the verses (e.g., the first word of line 7 is *past,* the final word *bayt; pursuit* of line 9 is balanced by *possession;* in line 6 *reason* and *sooner* exchange their three consonants).

In the last two lines, on the other hand, this particular nexus of sounds disappears, and the contrast of sonority is striking. The final couplet has no "p," only one "r" (in *world*) and its three "t"s are all on weak beats and two of them are finals (*yet* and *that*), which further weakens their emphasis. The dominant sounds of the last two lines are the alliterations on "w," "n," "th," "h," the recurrence of "l," "s," and "n" in final position, and the prominent "sh" of. *To shun,* a remarkable concentration of aspirates and soft consonants.

Jakobson and Jones remark on the density of texture in the final couplet[12] but not on its hushed quality and on the almost complete absence of the explosives that pervade the first twelve lines. If one were to construct anagrams, it might justly be said that *Spirit* determines the sonority of the quatrains, and *shame* of the final couplet.

Jakobson and Jones do not convey the richness of meaning in the opening line and the extent to which it announces the tragic theme of the whole sonnet. They note double meanings in the opening line for *shame* (chastity and genitalia) and for *Spirit* (a vital power of both mind and semen), but do not give for the latter the common meaning in Shakespeare's time of the soul, in particular at the moment of death as it leaves the body. This is a sense

---

12. The final couplet is actually less dense than lines like:

Is perjurd, murdrous, bloody full of blame
    ur urd    urd      bl     f.l    bl

Savage, extreme, rude, cruel, not to trust
        kstr    rue    krue      t  tr. st

enlisted by the word *expence* which had for Shakespeare the now obsolete meaning of "loss," as in Sonnet xxx:

> Then can I drowne an eye (un-us'd to flow)
> For precious friends hid in deaths dateless night,
> And weepe afresh loves long since canceld woe,
> And mone th'expence of many a vannisht sight.

"Th'expence of Spirit" is a metaphor for death, which is itself the oldest and most common of all rhetorical images for sexual intercourse. This philological background is a necessary supplement to Jakobson's and Jones's linguistic detail.

Jakobson has held with Empson that "the machinations of ambiguity are among the very roots of poetry," as of any message centered on itself, and Jakobson and Jones remark that Shakespeare's double entendre does not interfere with the firm thematic construction of the sonnet. The double meanings they sketch are, as they say, only a kind of double-talk. But Empson's stand is more powerful and more interesting, and his machinery enables us to integrate ambiguity into the sonnet as a whole instead of presenting it as a suggestive but unessential decoration. He claims that when the poetic context calls up two meanings of a word, it enforces a relation between the two which is understood in the context of the poem.

In "Th'expence of Spirit" this relation is, in fact, the theme of "tragic predestination" that Jakobson and Jones clarify. The grossly physical sense (semen) of *Spirit* is identified with the spiritual (soul) by the degradation of lust. The religious overtones of the last line ("the heaven that leads men to this hell") take this up again: man loses his soul through the expense of *Spirit* and is damned. The paradox of a heaven that leads to hell mirrors the opposition compressed into *Spirit*.

As we have seen from Saussure, a formal pattern must signify something, but to achieve this significance, it needs a context. The context of a poem can only come from a "reading," and many of

Jakobson's and Jones's correspondences do not submit to—or, better, do not acknowledge submission to—their own specific "reading" which is essentially the thematic structure they assess so convincingly.

In other words, there is a hierarchy of significance in all poetry before Mallarmé, and an explicit sense to which all the other interpretations must pay homage. This central, explicit sense is generally not subject to much controversy. It is the meaning established by a reading in time, in a simple linear[13] fashion starting from the beginning. This explicit meaning is the literal reading of Aquinas, and, when summarized, it is the simple thematic structure affirmed by Jakobson.

This is not to claim that nonlinear interpretations and subsidiary, implicit patterns do not exist. On the contrary, their existence and their interaction with the explicit structure is the source of poetic strength, the verbal art of Jakobson's and Jones's title. But the criterion of relevance for these implicit patterns is the possibility of integration into the explicit one.[14]

Unfortunately for critics, some of these patterns will always prove to be irrelevant. In every sonnet, the phonetic structure is partially set in advance and therefore gratuitous. The semantic structure is mapped out to fit the rhyme and the meter. In a line like

Is lust in action, and in action, lust

the ideas are arranged to reveal the balance of the ten syllables and to isolate them: to some extent the content signifies the form and illuminates it, holds it up for inspection. The poet works to make the gratuitous form seem to be determined by the meaning. By definition he cannot completely succeed: if the phonetic structure

13. I do not mean linear in Schenker's sense, which distorts the actual movement in time, but in Saussure's, in which the order from past to future is essential to the comprehension of a message.

14. For this reason, "Les Chats" is a more impressive analysis than "Th'expence of Spirit." The reader can forgive the mass of detail heaped indiscriminately upon him for the sake of the elucidation of the large movement from extrinsic to intrinsic, which dovetails with the progression real to surreal.

seems totally dependent on the meaning, the work ceases to be poetry—that is, it ceases to be a privileged message, protected by its prosody from being confounded with an ordinary statement. The form must remain overdetermined.

The subsidiary, noncanonic phonetic patterns, in harmony with the principal one, are also partially gratuitous, can never completely fulfill the criterion of relevance. Their interaction with the semantic structure can never be complete. Above all, the semantic pattern itself will inevitably reveal the workings of organizing forces that are partially gratuitous: it, too, is set up like the rules of a game. These patterns also demand interpretation and yet cannot be made to yield absolutely to coherence. An analysis will always leave a residue, arabesques of phonetic and semantic patterns that imply a meaning and yet elude interpretation.

This gives art its privileged position. We are not allowed to claim, because of Sonnet CXXIX, that Shakespeare thought sexual intercourse disgusting, immoral, or degrading. This would be like rushing onto the stage to warn Othello that the handkerchief was planted. The sonnet is not a personal communication, however much feeling and experience went into it. The richness of meaning in the sonnet depends on the partial release of language from its normal function of conveying information. A poetic "message" is not tied to a specific receiver, and its direction remains open; in Schlegel's words, "A poem is written for everyone or no one— the poet who writes for someone in particular deserves to go unread." If, however, the significance of the "message" is now tied asymmetrically to the sender, this freedom is equally menaced. A personal message to everyone or to no one is a voice crying in the wilderness, and excites an absurdly misplaced pathos.

This privileged status makes art dangerous: these arbitrary conventions that struggle into significance and that signal to the reader that the message is a fiction allow things to be written that would be otherwise intolerable. The unspeakable may be whistled. A characterization of fornication that has the intimate emotional power of Shakespeare's would have been unthinkable in late sixteenth-century prose, even in a sermon.

Concealed Structures

When the poetic "message" is freed from too intimate a tie with a specific sender or receiver, the latent meanings in the text are released and come alive, and the sonnet is open to the reader to interpret as irresponsibly as he pleases. No control is possible. But if the status of a work of art is threatened by being taken too seriously, it is also endangered by being reduced to "a superior amusement," as T. S. Eliot modestly called poetry. Unless the implicit patterns, the intricate correspondences that Jakobson delights in uncovering take their place within a "reading," they lose the significance that only that framework can give, and, in turn, cease to contribute to that framework. They tend to become facts of language, not of poetry. The analysis of the most complex and various patterns can only impoverish a work if they do not come together, if there is no focus.

Jakobson has, indeed, always insisted that the apparently autonomous phonetic and grammatical structures must be related to the structure of meaning. But the relation he generally proposes is a static one, less dynamic than a simple reading. His implicit correspondences sometimes add emphasis to the thematic structures, or at other times are a decorative counterpoint to the explicit form. Rarely do they substantially affect or alter the explicit reading; we start from the text and move to the discovery of the interior symmetries. What is lacking is the continuous movement back and forth between the whole text and the interior forms, a movement which makes possible the fullness of poetic criticism.

As we read, we create—by imagination, instinct, reason, or whatever—a frame from which the poem takes its meaning. Criticism is only an extension of this process, and is therefore, as Walter Benjamin said, the necessary completion of a work of art. The fundamental critical tradition since the sixteenth century, philology, is the creation of a historical context. It appears inevitable that linguistics, with its new-found power, will replace philology, and Jakobson prefers a context as little tied to history as possible. This releases Jakobson's correspondences from any fixed relation with tradition for the most part, and the new freedom is welcome: not all poetic technique is founded on convention, based on prece-

dent. But the loss of historical significance is not easy to accept. It makes the poetry paradoxically less immediate, less likely to disturb.

Like literature, music can disturb and even shock. It has all the attributes of language except one. It has a grammar, a syntax, accent, tone of voice, syllables, and phonemes; it, too, is formed into sentences, paragraphs, chapters—what it lacks is a vocabulary. Musical phonemes act directly without first being strained through an abstract system of denotation. Music is a mimetic art in so far as it imitates language and language's poor relation, gesture. It may be called pre-verbal but post-lingual. (What rudimentary vocabulary music has is mostly one of gesture, not of language.)

Most accounts of the expressive character of music have been largely attempts to identify the vocabulary; that is why they appear so simpleminded. The expressive force of music rests principally in its grammar. The capacity of the grammatical structure of a language to assume a meaning of its own (described by Jakobson), the power of any ordered pattern to appear significant, to demand interpretation (which fascinated Saussure)—these attributes of language are annexed by music and developed with an intensity unparalleled in any other art. Music is made up in great part of relationships like those that Jakobson analyzes as Shakespeare's verbal art, but the musical structures are far more sophisticated, efficient, and powerful.

The relation between explicit and implicit in music is therefore more difficult to clarify. For example, the distinction between canonic and noncanonic organization necessary for prosody is almost useless in music. Those conventional forms so often taught in music courses are largely a fiction, invented long after the fact. The fugue was a free form for Bach, and Mozart and Haydn never heard of sonata form and certainly had no idea of the standard pattern that has been taught under that name since the middle of the nineteenth century. Schenker was correct in maintaining that (at least since 1600) the most important "rules" of music are simply the rules of counterpoint and the laws of tonality. It is to these rules that Schenker reduces a work of music, ignoring the phrase-

structure—which for most listeners contains the explicit sense of the work, and he turns his principles of organization into a hidden, esoteric form.

This is so because his method takes the form of a gradual reduction of the surface of the music to his basic phrase,[15] and the analysis moves in one direction, away from what is actually heard and toward a form which is more or less the same for every work. It is a method which, for all it reveals, concentrates on a single aspect of the music and, above all, makes it impossible to bring the other aspects into play. The work appears to drain away into the secret form hidden within itself. That is the impasse of every critical method which places the source of vitality in an implicit form.

Criticism cannot do without these implicit forms, inner relationships, hidden significances. But they must be so presented that they not only reflect the work but also reflect back upon it, and at an oblique angle so that they can receive more in return than their own images. Criticism is not the reduction of a work to its individual, interior symmetries, but the continuous movement from explicit to implicit and back again. And it must end where it started—with the surface.

## Postscript, 1998

Since this was written, much more of Schenker's work has been made available in English, including a translation of the basic theoretical treatise, *Der Freie Satz*. Furthermore, this review demands an important correction. Like Edward T. Cone, I have accused Schenker of neglecting rhythm, and this is true only in a very limited sense. *Der Freie Satz,* indeed, contains almost nothing about rhythm, but certain important aspects of rhythm are treated very cogently in the different individual analyses in the volumes of *The Masterwork in Music*. Above all, the varying length of phrases concerned Schenker, and his observations on this are always valuable. It can even be maintained, as Milton Babbitt has done in

---

15. The presentation of the analysis by Schenker as starting with the *Ursatz* and moving to the finished piece does not disguise the principle, which is always that of reduction.

conversation, that Schenker is always about rhythm, as the reso-
lution of dissonance is a major element of rhythm in determining
the weight of accent. Nevertheless, small-scale details of rhythm
are skimped by Schenker, and the absence of any serious consid-
eration of large-scale proportion is distressing.

Alexander Goehr once remarked to me that many of the ele-
ments of form downgraded by Schenker were taken for granted
by his contemporaries: he may be said to have assumed that they
would be perceived. Today's graduate students in music, largely
raised on Schenker, are not so lucky, and the ignorance of tradi-
tional form makes it difficult for them to integrate Schenker's
observations with a broader view of the music.

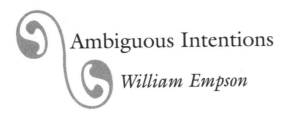

# Ambiguous Intentions

## *William Empson*

William Empson was the finest critic in our century of English literature, but each of his books sparked a vigorous protest and even expressions of outrage. The first and still most famous of his writings is *Seven Types of Ambiguity* (1930), written when he was a twenty-two-year-old undergraduate at Cambridge University, and the story goes that he produced this very substantial book in only two weeks. He never got his degree at Cambridge because his bedmaker discovered contraceptives in his room. (When charged with this offense, Empson explained that he was sleeping with a lady don, and suggested to the disciplinary committee that they would surely prefer that he did not get her pregnant.) For the next decade, he taught English in Japan and China. Returning to England at the beginning of the Second World War, he worked for the BBC as China editor from 1942 to 1946, and then went back to Peking.

Not until 1953 did he find a post teaching literature

Originally written in 1993 as a review of John Haffenden, ed., *William Empson: Essays on Renaissance Literature, Volume One, Donne and the New Philosophy* and John Haffenden, ed., *William Empson: Argufying, Essays on Literature and Culture*.

in England: it took a certain amount of courage, Empson realized, for the University of Sheffield to make the appointment. In an informal speech that Empson gave three years after retiring, on an occasion when he received an honorary degree from Sheffield, he said:

> Listening to that splendid praise given me by the Orator, it struck me that the University also deserved some praise for making the appointment. It was what is called bold; when I was made Professor here, I had actually never done any teaching in England at all.[1]

Empson was knighted in 1979 and died in 1984. Since his death, an attempt has been made not only to keep his books in print but to collect the numerous essays that were scattered throughout the years in many different publications. A volume of *Essays on Shakespeare* came out in 1986 and has been followed this year [1993] after a long delay by the first of two books of *Essays on Renaissance Literature*, this one subtitled *Donne and the New Philosophy*. Between these two volumes, both of which he had planned himself but did not finish, there appeared his study of Marlowe's *Faustus* and also a collection of shorter reviews and articles called *Argufying*, a word that Empson used and may have liked for its provocative inelegance (he preferred the kind of poetry that said something, that argued, and that one could talk back to).

The last two volumes have been edited by his colleague and authorized biographer-to-be, John Haffenden, with prefaces that assume the heavy task of defending every aspect of Empson's thought. This is a friendly thing to do, and Haffenden does it about as well as one could want. I do not think that he realizes, however, that Empson's greatness does not depend so much on his having been right. In fact, even when wrong, which was often enough, he was generally a better critic than his opponents.

The remarkable innovation of the early work of Empson (developed after the first youthful volume in two succeeding books, *Some Versions of Pastoral* and *The Structure of Complex Words*) was a close and detailed examination of the different nuances of meaning

---

1. *Argufying*, p. 641.

that a word could assume, and the way these related meanings acted upon each other: the intensity of the analysis recalled the way that seventeenth-century preachers would torture a text from the Bible in an effort to extract the last drop of significance—this close likeness may appear ironic in view of Empson's bitter hostility to Christianity. It was, in fact, seventeenth-century style that inspired him. A fine if minor poet whose poems will continue to appear in anthologies for years to come, Empson modeled his verse on that of John Donne, and he remained faithful to his love for Donne till the end of his life.

Empson's analytic technique was created for poetry, and he defended it near the opening of *Seven Types of Ambiguity:*

> A first-rate wine-taster may only taste small amounts of wine, for fear of disturbing his palate, and I dare say it would really be unwise for an appreciative critic to use his intelligence too freely. . . . Specialists usually have a strong Trades Union sense, and critics have been too willing to insist that the operation of poetry is something magical, to which only their own method of incantation can be applied, or like the growth of a flower, which it would be folly to allow analysis to destroy by digging up the roots and crushing out the juices into the light of day. Critics, as "barking dogs," on this view, are of two sorts: those who merely relieve themselves against the flower of beauty, and those, less continent, who afterwards scratch it up. I myself, I must confess, aspire to the second of these classes; unexplained beauty arouses an irritation in me, a sense that this would be a good place to scratch; the reasons that make a line of verse likely to give pleasure, I believe, are like the reasons for anything else; one can reason about them; and while it may be true that the roots of beauty ought not to be violated, it seems to me very arrogant of the appreciative critic to think that he could do this, if he chose, by a little scratching.[2]

A brief illustration of the way Empson considered words may perhaps be given most effectively from prose rather than poetry. I use an example that he discussed in the most systematic of his

2. *Seven Types of Ambiguity,* Third ed. (Meridian, 1955) pp. 12–13.

books, *The Structure of Complex Words,* the word *delicate* in a
phrase spoken by a Victorian matron:

> "You can't take Amelia for long walks, Mr. Jones; she's *delicate.*"
> The word has two senses . . . and I suppose the lady to assert a
> connection between them. "Refined girls are sickly" is the asser-
> tion, and this gnomic way of putting it is a way of implying "as
> you ought to know." I choose this case partly to point out that a
> stock equation may be quite temporary; this combination of mean-
> ings in the word seems to be a Victorian one only. You might think
> that the expectation that young ladies will be unfit to walk was
> enough to produce it, and that the expectation merely followed
> from tight-lacing: but the eighteenth-century young ladies also had
> waists, and would agree that long walks were rather vulgar, and yet
> this use of the word would be "out of period" if you were writing
> a pastiche. The reason seems to be that in the eighteenth century
> the older meaning "fastidious" was still knocking about, and even
> the meaning "luxurious, self-indulgent" was not yet sufficiently
> forgotten. . . . Now it is clear that *refined* and *sickly* must be given
> different logical positions in the Victorian use; all refined girls are
> sickly, but not all sickly girls are refined. . . . it is by a tone of moral
> grandeur that the Victorian matron has to put the meaning
> "refined" here into her use of *delicate.*[3]

Later Empson observes:[4]

> It seems fair to say that our two senses of *delicate,* "refined" and
> "sickly," . . . proceed from the two equations "persons devoted to
> pleasure improve their taste but lose their health." The Victorian
> matron . . . would fiercely deny this connection with sensuality; her
> equation of the surviving pair [of senses] was meant to imply that
> the best people ignore the body and its pleasures, preferring chas-
> tity and the consequences of tight stays.

What interests Empson is not so much the poetic resonances of
meaning but rather the possibility of saying something covertly
that could not be put into more direct expression without dis-

3. *The Structure of Complex Words* (Chatto and Windus, 1951), pp. 44–45.
4. *The Structure of Complex Words,* p. 77.

closing aspects of experience which society was unwilling to face head-on. The ambiguity of language reveals our unacknowledged desires and prejudices. For Empson, the role of the poet or the novelist was to uncover these unrecognized tensions and contradictions, to provide his readers with the knowledge of themselves and their culture they did not know they needed.

It is clear from the protests inspired by parts of these early volumes that even Empson's admirers felt that his ingenuity at winkling out possible meanings sometimes went too far: time has not softened the irritation created by his overzealous intelligence.[5] He was accused, not without some justice, of treating the lines of poetry that interested him by simply looking up one of the key words in the large *Oxford English Dictionary*, noting which senses existed at the time the poem had been written, and attempting to read all of these meanings into the poem without regard to their relevance to the central meaning of the passage or of the poem as a whole, and without sufficiently considering which senses of the word were primary and which secondary.

As a matter of fact, however, *The Structure of Complex Words* is perhaps the first systematic attempt to deal with the way primary meaning and secondary associations combine to inflect and even determine the significance of propositions. (In the example quoted above, *sickly* is the primary meaning of *delicate*, but the context pushes a secondary meaning to the fore.) The book even maps out a very elaborate machinery for describing the interaction of the different senses. Nevertheless, many of Empson's analyses of poetry were of individual lines or passages ripped from their contexts, and he seemed to take a virtuoso's delight in bringing up the most far-fetched considerations, many of them at least at first sight very remote from the text he is looking at. The virtuosity is all the more impressive, of course, when it pays off, as in his

5. Some of the irritation must have been engendered by Empson's friendly but unrepentant way of dealing with criticism of his work. A footnote in the second edition of *Seven Types of Ambiguity* begins with a typical offhand impudence: "Critics have disliked the meanness and fussiness of this passage [on Wordsworth], and I wish that I had something wise and reconciling to say after all these years."

remarks on the influence of Charles Darwin and *The Origin of Species* on *Alice in Wonderland.*

An accusation even easier to demonstrate against Empson was his habit of misquoting. It is true that he mostly quoted from memory—he was famous for being able to reel off enormous quantities of verse without referring to the texts, something he found not only useful but necessary when he was teaching in the Far East without access to a library with any English literature. Unfortunately his memory tended to be creative. In a note introducing his selection of Empson's articles *Argufying*, Haffenden writes that "his publisher reported 900 cases of incorrect quotation in the typescript of *The Structure of Complex Words;* that is, 80 percent of all the quotations in the book needed to be corrected before publication." That is a hefty percentage, but the assertion that he deliberately distorted his quotations in order to prove the point he wished to make about them will not stick. (He himself said in answer to this charge that almost any other form of human frailty would have appealed to him more.) No important aspect of his interpretations ever depended on a misquotation.

It may appear surprising that a critic should excite such admiration when so much of his work seems irrelevant, immensely self-indulgent, or just plain wrong. Perhaps we should remember that Samuel Johnson, often considered the greatest literary critic of the eighteenth century, by his own admission never finished a book, but just browsed over some of the pages, and that his judgments of literary value were absurdly prejudiced by his politics. It is manifestly unfair that critics whose work is openly vitiated by the most evident irresponsibility should reach such eminence with ease, while the conscientious worker who does not shirk his professional drudgery must be content with a more lowly rank, his virtue largely unrewarded.

In the latter part of his life after *The Structure of Complex Words,* Empson was embroiled in two controversies: arguments about the

Intentional Fallacy—here his enemies were W. K. Wimsatt and the critics influenced by T. S. Eliot—and about the text of the poetry of John Donne, where he attacked the new edition of Dame Helen Gardner for what he called a neo-Christian viewpoint or an attempt to whitewash the blasphemy that Empson felt was so vital to Donne's early writings before he became a famous preacher. His attacks on his opponents became heated in the last years, although he rarely lost the off-hand, bluff urbanity that character-ized his style. He often wrote like a hearty, old-fashioned country squire from one of Fielding's novels, speaking his mind to his social inferiors: this, too, did not endear him to other scholars.

He tended to nag irritably about the Intentional Fallacy, a crea-tion of Monroe C. Beardsley and W. K. Wimsatt, who claimed that the intention of the author was irrelevant to his achievement—it was not what the author wanted to do that mattered but what he succeeded in doing. Essentially, back in 1946, they were protesting the academic tradition of interpreting a poem or novel only with reference to the author's biography, as if it were a private docu-ment of which the sole interest was what it revealed about the writer's life: at the time this was the fundamental way of teaching literature in the university. A student's interpretation of a text that went beyond the limited horizon of what was thought to be the author's point of view was discouraged. The pendulum of aca-demic fashion then swung the other way: to try to imagine what the text could have meant to the author was no longer acceptable. The author's own view of his work, for example, was not consid-ered privileged; once having written the poem, he was now merely a reader and a critic like anybody else. And it is true that an author's explanation of his work is meant to mislead or to cover up as often as it is to illuminate.

The anti-intentionalist position is sometimes considered a mod-ern fashion, a new-fangled way of looking at literature wickedly invented by the New Critics in the 1940s as a means of preventing people from enjoying novels and poems in the traditional way, that is, with a feeling that they were coming into direct contact with the mind of the author. But the belief that the author is in fact no

better at interpreting his work than anyone else is a very ancient one, explicitly presented by Plato in the *Ion*. I should imagine that both intentionalist and anti-intentionalist views have existed throughout history. An attack on the kind of biographical criticism that the essay on the Intentional Fallacy condemned was made most provocatively at the end of the eighteenth century by a friend of Goethe, Johann Heinrich Merck, and those who believe, as Empson did, that this theory is diabolical, will be glad to know that Goethe used Merck as the model for Mephistopheles in *Faust*. I quote a few passages from Merck's charming dialogue "Reader and Author" not only to show the age and persistence of the controversy, but to shed some light on its confusions:

*Reader:* Before we get further acquainted, tell me: Just who are you and what was your intention in writing this book?

*Author:* I should have thought that would be as unnecessary to know as whether a shopkeeper was Catholic or Lutheran. I am an author, just as a businessman is a businessman and that should be enough to give me the honor of your acquaintance.

*Reader:* But with an author it is very important to know what else he does besides his profession, how and why he became an author, whether he is single or married, a priest or a local tax-collector.

*Author:* That is a new way of judging works of art. Does it have any interest when you see the canal to Bromberg to know that the author is a chief counsellor to the consistory of Berlin?

*Reader:* Of course, a lot depends on outer circumstances, and if I know that the author is a student, I can say to him in advance: Sir, please spare me any scenes of high society, pictures of sophisticated life, and everything that you want to serve up about the secrets of the female heart and affairs of great passion and so on. You have invented all that and not seen it, and as a man who has lived, I can take out of my pocket a sum of experience for daily expense with which I could buy your entire patrimony.

*Author:* I see that you are getting excited as if very important business is going to be transacted between us. Our relationship

> to each other should remain very distant. One of us buys and
> the other sells, and in this case we do not have to audit the
> financial statement on either side. The most insignificant
> tobacconist in Spaa may negotiate his business with Lord Clive
> concerning the Lord's pleasure or convenience and for what
> the Lord did not possess before he made the acquaintance of
> the small shopkeeper. The Lord can gain by the transaction
> and the shopkeeper, too, without one of them paying too
> much or the other becoming rich.[6]

The Author here wishes the relation to the reader to remain impersonal, and for him a book is not a direct communication but a transaction, even a commercial transaction; the Reader, for his part, wants a guarantee of authenticity, an assurance that he is not being cheated by a fake product. Like the Reader, Empson insisted on the authenticity of the text—that is, on the sincerity and the immediacy of its reflections of the world. In a brilliant review of an edition of the poems of the Earl of Rochester, he takes up the famous lyric that begins "Absent from thee I languish still" and quotes the stanza:

> Dear, from thine Arms then let me flie,
> That my Fantastick Mind may prove
> The Torments it deserves to try,
> That tears my fixt Heart from my Love.

He comments on these lines with admiration:

> What saves the poem is the wild claim that his "fantastic mind"
> somehow needs the "torments it deserves to try." One is prepared
> to believe it of him. He is a test case, I think, against some recent
> critics who have said that one ought to ignore biography because
> a poem ought to stand by itself—if one didn't believe Rochester,
> his poems couldn't come off properly.

There is at least the germ of a confusion here. One has, indeed, to take the poems seriously for them to work, but the reader's

6. Johann Heinrich Merck, *Werke* (Insel Verlag, 1968), p. 418.

conviction that they are not superficial paradoxes does not come from a study of Rochester's life—at least, we do not have to study the life for the poems to work. They convince on their own, by their intensity. It is true, however, that our conviction may be reinforced by a study of the life, and if, as everyone agrees, an understanding of the period when the poems were written is helpful to full appreciation, we can hardly avoid dealing with the poet's life.

Arguments between Empson and his sometimes unwilling opponents about the Intentional Fallacy mostly give the impression that neither is listening to the other. The controversy reminds me of the eighteenth-century quarrel between atheists and deists: David Hume shrewdly pointed out that there was no real disagreement, merely a slight shift of emphasis, the deist insisting on the analogy between human intelligence and the apparently rational structure of the laws of Nature that governed the universe, the atheist insisting on the unbridgeable gap between the human mind and the transcendent workings of Nature that made it improper to claim that anything like a human mind was in charge. Similarly, neither Wimsatt nor Empson believed that a work of imaginative literature was a form of personal communication like a telegram asking to be met at Penn Station tomorrow morning, and both of them also knew that a poem or novel mimics communication, pretends to be very like the things we say to each other every day.

A love poem may be like a proposal of marriage, but even if we think that it reflects the author's life and is sincere, it does not engage his responsibility: it does not, like a proposal, derive its meaning by being fixed in time and space. The poem has its action in an indeterminate space, and its time is whenever it is read. Our initial stab at understanding the poem may be to try to imagine someone saying and believing it, but we are not supposed to stop there: it was made for us to put our own feelings to work in it, and even to imagine the feelings of other people remote from us and from the author. The real fallacy is to believe that we have understood the poem once we think we have found out what it

meant to the poet, and the successful poem is the one that leaves biography far behind.

In their controversy both Empson and his opponents made concessions which in the end badly weaken their positions. Anti-intentionalists mostly admit that biography is frequently a useful tool for understanding. On his part, Empson had so broad a view of intentions that it conceded almost everything to the other side: the intentions he liked to consider were largely unconscious ones. He wrote,[7]

> What one can sometimes say, I think, is that the poet was inspired and meant more than he knew, and that the later reader can recognise in his working the growth of ideas which through also working in his contemporary public, and therefore accepted when they accepted his poem, were then obscure or even forbidden.

In practice, Empson interpreted intention to mean everything the author ought to have been unconsciously thinking about if he wished to retain Empson's interest and admiration.

Indeed, Empson liked to think well of the authors whose work he admired. This was at the root of his harsh treatment of John Carey's 1981 biography of John Donne. Carey's image of Donne was that of a hypocrite, an arriviste, and a male chauvinist pig (his image of Empson, incidentally, was of a poet and critic with a "distaste for people," "captious, niggling" and overingenious, whose criticism was a vandal's attack on the more obvious values of English literature). Carey's picture of Donne was not absolutely false. At a time when openly professing controversial opinions could get one thrown in jail, Donne was certainly not always completely frank about his religion or philosophy. He was also ambitious, although his making an unwise marriage showed that there were limits to what he would do for his career. Virtually all men in the early seventeenth century (and most women, too) were male chauvinist pigs, as they still are today except for a few who try hard to be politically correct—and then their swinishness may often

7. In a letter to John Wain, quoted by Haffenden in his introduction to *Argufying*, p. 19.

take another but not very different form. What is untrustworthy about Carey's biography is its fashionable, even chic, debunking and its relentless lack of magnanimity.

The chief bone of contention was Carey's reading of the elegy "To His Mistress Going to Bed." For Carey, this traditional exercise in Renaissance soft porn, in which the poet urges the woman to undress, is an attempt to "insult, humiliate, and punish." For Empson, "it describes the greatest bit of luck in this kind that a male reader can imagine"; furthermore, at the poet's finest moment, "he says he has no claim to deserve such intimacy, except that she has already chosen him by her visit; her previous choice is like the predestination of God." In Empson's discussion of the elegy, two obsessions met and fused: his admiration of Donne and the importance of biographical criticism.

Both Carey and Empson viewed the poem as autobiography, although Empson admitted that "this early poem must be expected to be fantasy," since the woman must be assumed to be aristocratic and the young poet had not yet met any upper-class women. Empson's biographical speculations are much more good-humored and generous than Carey's determinedly nasty ones, but both seem to me beside the point. In a typically wild rush of imagination, Empson decided that the fantasy woman is married (she is called "Madam"—not really a very convincing argument) and that "she has (presumably) come on from a banquet or reception to the humble lodging of the speaker; somehow she has been released, maybe because her husband got drunk." If she is only a fantasy, what are all those conjectures about her life outside the elegy doing? It is true that Empson's reconstructions are sometimes very far-fetched, but he clearly had fun thinking this one up.

It seems pedantic and churlish after that to point out that this elegy is in a long tradition of erotic descriptions of a woman's body, with the finest models of it in French literature of the sixteenth century. Empson generally and rightly did not like being told that his interpretations were fanciful because he was dealing

with an ancient and traditional trope,[8] and it is true that Donne transforms the erotic tradition into a little dramatic scene. Empson, however, was right to protest against some critics that the girl is not a prostitute, but then she is not a married lady, either, or aristocratic, or upper-middle class, or whatever; she is, indeed, well-dressed, but that is only to make the description of the striptease more detailed and give it more class.

I suppose one might reasonably reproach Donne with not giving the woman a full humanity with a rounded personality and economic status, but then that was never considered necessary in pornography, even soft porn—and when it is done, it tends to make the porn more vicious by offering opportunities for psychological sadism. (As a matter of fact, in the act of sex one is not often at the crucial moment concerned about the rounded personality or the class status of the partner, unless one has a fetish about being whipped by a member of an upper or a lower class.) The attempts by both Carey and Empson to imagine the actual situation in which Donne either found or imagined himself are distractions: no one ever read the elegy like that before it was taught at a university in the twentieth century.

Empson wanted Donne to be like himself, an advanced, liberal thinker with an up-to-date knowledge of science and philosophy and a dislike of orthodox Christianity, and he insisted that many of Donne's poems hint at the possibility of life on other planets. This idea was making the rounds at the time, largely through Giordano Bruno, who visited England for a few months and was finally burnt in Rome for heresy, and it did create a theological problem: if salvation and the avoidance of eternal damnation could only be achieved by acknowledging the divinity of Jesus Christ, those who lived on other planets were being penalized unfairly, as

8. He himself understood that when attacking Carey, who called Donne bullying in this elegy because he orders the girl to undress and she does not answer. Empson remarked: "Well, a love poet is seldom answered; Shakespeare cannot even report an answer from his earl, who would not be shy. . . . Lord Byron told the deep blue ocean to keep on rolling, and it did, but no one said he was bullying it." One might say that ordering the ocean around is different from ordering a woman, but that would in fact be beside the point. In neither case is the reader presumed to take the commands as actually given in a real scene.

news of Jesus could not have reached them. In fact, this matter had already been raised about the civilizations on other continents, like the Aztecs and the Incas.

The most admiring of Empson's critics, Frank Kermode, has claimed that he was wrong about Donne's position on these matters of contemporary science, and has given very good reasons for believing that, although Donne knew about the latest cosmological theories, his thinking remained pre-Copernican. It is clear that Kermode is basically right, but I suggest he has been trapped by Empson's insistence that the poets he liked must have passionately believed everything they put into their poems, and that it degraded the poetry to think otherwise. Empson wanted the love poems of Donne to be a subtle form of propaganda against Christianity. He did not think a poem could be serious if the poet did not guarantee the truth of what he had written. This makes the question of belief a much less complex thing than it is—as Empson himself realized as soon as he dealt with a poet like Coleridge whose acknowledged beliefs were antipathetic to Empson, and he was able to show correctly that much more heterodox opinions had found their way into Coleridge's poetry—against the author's intention, most of us would say. It seems to me that Kermode slightly underrates the power and interest of the cosmological theories and theological problems that were current in England and Italy when Donne was young. I think that they do play a larger role in his poetry than Kermode is willing to consider, although not as crude or straightforward a role as Empson would like us to accept. They exist in the poems like the secondary meanings of words to which Empson was so sensitive; they add resonance.[9]

---

9. Along with his harshness, Empson could be very generous to his critics. After Carey had attacked him as a vandal, he called Carey's essay on Marvell "magnificent" (along with an essay by Christopher Ricks). Remarking that Carey's condemnation of paraphrase made criticism impossible, he welcomed what he considered Carey's change of program, adding, "Here he is beside [Christopher] Ricks, both of them galumphing like the new dinosaurs, each of them the weight of ten elephants and yet as agile as kittens." This may have been part generosity, part revenge, since Carey might not have been pleased to be in the company of Ricks, whom he had attacked along with Empson.

I do not want to imply that even Empson's wildest biographical speculations are always as wide of the mark as they may first appear. In a review of an edition of Shakespeare's sonnets,[10] Empson once tried to reconstruct in detail the relations, social and sexual, of Shakespeare with the young Earl of Southampton, whom Empson believed to be the Friend to whom the sonnets were written:

> The years 1592–4 make a dividing line for the drama; the theatres were closed for plague. . . . It was for survival, we need not doubt, that [Shakespeare] wrote the two long poems with dedications to Southampton, the first very awestruck, the second boasting of intimacy. There is a legend that Southampton gave him a large sum for a special purpose, and the new Company would need capital to get started in 1594. . . . Southampton was his only angel, in the modern theatre's sense, and the poems among much else thank an angel.
>
> In 1594 Shakespeare was 30 and Southampton 21. . . . The social ladder was steep, and Shakespeare wanted to write speeches for aristocrats on the stage, so he was keyed up to hear them talk. No wonder he was bowled over by the Earl. He continued to feel wiser; that is why he pretends in many of the Sonnets to be old . . . What a pleasure, at 29, to say: "But I can't be friends with you—why I'm a shambling old man, with no *teeth*"; and how adroit one would feel, when the real meaning was "I know I'm not good enough class." . . .
>
> Mr Seymour-Smith, I think, assumes that anal coition took place, with the Earl as the girl; and this is what Dr Rowse *et al.* feel it urgent to rebut. . . . So far I agree with the majority and Dr Rowse: the Earl was prone enough to women, and what he expected of his poets was flattery. I expect he was practically as virgin as the Queen who served as his model in the affair, though

10. *Shakespeare's Sonnets,* edited by Martin Seymour-Smith. Review published in the *New Statesman,* October 4, 1963, pp. 447–448. This article and many others have not yet been collected; the reviews of Shakespeare and the letters to the editors of different magazines are particularly interesting.

some grudging masturbation may have been an occasional reward. . . .

If the Earl was as much of an angel as was needed, and fun as well, need Shakespeare's praise of him so often have been "bitter irony" as the editor finds? . . .

The editor assumes that the metaphor of feeding, used for pleasure in the beloved, means some gross kind of love. . . . But when Shakespeare speaks of himself as "starving for a look"—across a crowded room, no doubt, when the Earl is giving a grand party, to show that Shakespeare is forgiven—the thought of food is used for something very unsensual. . . . Shakespeare had to pretend an all but unrestrainable desire for the person of the Earl, so that the Earl (as it might be the Queen) could have the pleasure of restraining him.

A modern reader is necessarily misled if he uses the words "snob" or "pansy" about the affair, because it is so far from our experience. In the course of applying for a grant (as we would say), when in dire need, Shakespeare was not upset to find that the formula had become genuine; he had actually worked up a desire for the patron. A man must expect this only to make the routine more exasperating, but it wasn't so bad if one had a Dark Lady in the background. To have the patron take over the lady would at least make it more intimate. But I suspect that the main thing (after the life-saving grant) was to be allowed to come to the parties, every detail there was going to be important for all his working life. The poet might well respond with the generosity which C. S. Lewis found to be the astonishing thing about these love poems: the childish patron had given much more than he realised.

The extravagance of this fascinating but flimsy construction, based on very little evidence, is breathtaking. Every detail may in some way be mistaken. Nevertheless, it raises almost every major point that concerns the mysterious relation depicted in the sonnets: an older man to a younger one, a commoner to an aristocrat, a dramatist to someone of the highest social class, a professional man to a very rich one, a supplicant to a patron, a lover to his rival, a lover to one who rejects him, a poet to a friend who needs to be

flattered. Empson has turned here from the ambiguity of words in his earlier books to an ambiguity of situation—that is, the sonnets are subject to multiple readings, none of which can be easily dismissed.

Empson's account has a deliberate impudence in its assurance; to any right-thinking scholar it is a kind of effrontery. Yet it neglects very little, and calls attention to the complexity of tone and emotion that every one finds in the sonnets but that so many critics wish to reduce and simplify. This almost off-hand review, which Haffenden has not bothered to reprint, is in many respects like the brilliant essay in *Some Versions of Pastoral* on the sonnet "They that have power to hurt and will do none." I remember reading this a number of years ago and feeling that many of the observations were irrelevant; and yet when I turned back to the sonnet afterward, it seemed to have become richer, more coherent, and more moving.

The deliberately disengaged looseness of Empson's style has stimulated most of the indignation of his critics: F. L. Lucas objected to the "vulgarity" of his analysis of a poem by George Herbert, and Carey called the same analysis a "crude rewording" and a "comic paraphrase." There is no doubt that the style was a provocation, an attack on the conventional academic manner. In a letter to Janet Adam Smith, Empson described the reaction of a and of his to the way he wrote:[11]

> I suppose he thinks if a critic says something simply that proves he meant to be ironical. Then he said, "How do you manage to get it as loose as that? Do you dictate it?" I explained I used beer, but that when I saw the stuff in print (I had to admit) it shocked my eye as much as it did his. He was very friendly, you understand. One thing is, I have to read so much Mandarin English Prose now, especially in literary criticism, and am so accustomed to being shocked by its emptiness, that I feel I must do otherwise at all costs.

Empson's manner, and even its occasional use of lower-class slang,

11. Letter quoted by Haffenden in *Argufying*, p. 395, and quoted in a review of the book by David Trotter in *The London Review of Books*, February 4, 1988, p. 6.

is a sort of High Mandarin, and an uningratiating way of looking down on the lower mandarin echelons.

In recent years, literary theorists have felt that Empson anticipated many of their techniques, and have tried to enlist him in their ranks. He himself resisted this takeover—this, in my opinion, is neither here nor there, merely another irrelevant quarrel about intention; but his work does not fit comfortably into the latest forms of theory, in spite of the impression he made on Paul de Man, and in spite of the admiration he now receives from deconstructionists like Christopher Norris, who has written well and interestingly about him.[12] The situation is a little like the one many years ago in Vienna, when the Logical Positivists read Wittgenstein's *Tractatus Logico-Philosophicus,* and thought delightedly that he was one of them; but after they had a meeting, it turned out that they were very far apart indeed. Still, it must be said that the Viennese positivists were not completely wrong about Wittgenstein, and their ideas did really overlap at many points; and the theorists today are not mistaken when they find much of what they are working for in Empson.

Nevertheless, Empson was neither one of the old New Critics, although his analyses of poetry had so much in common with theirs, nor a proto-deconstructionist, even if his insistence on multiple and contradictory significance in literature foreshadows their work. His contradictions always coalesce to form a new and cleanly defined sense, his ambiguities make a covert but definite statement. He was an old-fashioned humanist and a literary historian of culture, the last one of great distinction in our century.

It is through his humanism, or, better, his feeling for humanity, that he could reach extraordinary poetic heights with his quirky,

12. Norris, along with Nigel Mapp, edited an interesting set of essays, *William Empson: The Critical Achievement* (Cambridge University Press, 1993). More important is Paul H. Fry's *William Empson: Prophet Against Sacrifice* (Routledge, 1991); this is a stimulating, if often ungracefully written, study of Empson's moral and religious beliefs and their significance for his criticism.

allusive, disconnected style that darts rapidly from point to point refusing to spell out the connections. His masterpiece seems to me the essay "Milton and Bentley" in *Some Versions of Pastoral,* which examines the objections that the great classical scholar Richard Bentley made to Milton's *Paradise Lost,* and the controversy created by Bentley's often niggling comments; many years in advance of the present interest in studying the critical reception of a work, this essay works toward an understanding of Milton by trying to account sympathetically for his critics.

In the final paragraphs, Empson considers what the poem tells us about the way we look at the past and treats the objections the critics made to Milton's use of classical and pagan imagery in a Christian epic. He begins by identifying his view—and the reader's—with Satan's alien gaze looking back at our first parents Adam and Eve in the Garden of Eden; like the great and guilty figures of history from Caesar to Napoleon they come to us from too far a distance for their original sin to spoil our admiration, even if officially we must deplore their eating of the apple. To the embarrassment of some of Milton's early critics, Bentley above all, Milton introduced his pagan deities directly into the Garden of Eden in order to imply that the pagan landscape had nothing as beautiful or as sacred as the bower of Adam and Eve—admitting prudently, nevertheless, that in fact the classical nymphs and the god Pan were "but feigned," unreal. These are not, however, the commonplace nymphs and satyrs of so much verse from that period. Empson perceived the wonderfully nostalgic tone here of the classical imagery and he comprehended the way this poetic tone affects the sense of Milton's epic:

> We first see Paradise through the eyes of the entering Satan, seated jealously like a cormorant on the Tree of Life. Like him we are made to feel aliens with a larger purpose; our sense of its pathos and perfection seems, as he does, to look down on it from above; the fall has now happened, and we must avoid this sort of thing in our own lives. Like so many characters in history our first parents may be viewed with admiration so long as they do not impose on us their system of values; it has become safe to admit that in spite

of what is now known to be the wickedness of such people they had a perfection which we no longer deserve. Without any reason for it in Milton's official view of the story this feeling is concentrated onto their sexual situation, and the bower where Eve decks their nuptial bed (let not the reader dare think there is any loss of innocence in its pleasures) has the most firmly "pagan" and I think the most beautiful of the comparisons.

> In shadier Bower,
> More sacred and sequestered, though but feigned,
> Pan or Sylvanus never slept, nor Nymph
> Nor Faunus haunted.

[Bentley's sarcastic comment is now quoted:] "*Pan, Sylvanus,* and *Faunus,* savage and beastly Deities, and acknowledg'd *feign'd,* are brought here in Comparison, and their wild Grottos forsooth are Sacred. . . ."

Surely Bentley was right to be surprised at finding Faunus haunting the bower, a ghost crying in the cold of Paradise, and the lusts of Pan sacred even in comparison to Eden. There is a Vergilian quality in the lines, haunting indeed, a pathos not mentioned because it is the whole of the story. I suppose that in Satan determining to destroy the innocent happiness of Eden, for the highest political motives, without hatred, not without tears, we may find some echo of the Elizabethan fulness of life that Milton as a poet abandoned, and as a Puritan helped to destroy.

These lines of Empson's call for a rereading as close and as intense as he brought to bear on his seventeenth-century poets. They deal with the moral pressure that we all feel when we look back at the past, above all at a past that we do not wish completely to acknowledge, just as Milton insisted that his classical deities were *feigned.* He could not renounce them, however, because they represented a view of the world that he needed but did not want to admit fully to his consciousness. This page, overcompressed and laconic—which gives it its force—is the most searching treatment I know of the role of the classical tradition in our civilization; Empson's observations illuminate both the power of classical art, and the nostalgia it can evoke: "the pathos not mentioned because it is the whole of the story." The essay is one of the few that give

an adequate account of the emotional power of the poetry of the time.

I think the source of Empson's success here is that he succeeded in loving Milton, an easy poet to admire but not to like. Even if we are not willing to accept without minor reservations Empson's equation of classical mythology with the Elizabethan fullness of life (both evoke a mythical Golden Age which never existed)—an equation which arises from his hatred of Puritan Christianity—Empson is putting the most magnanimous interpretation on Milton's lines, and his definition of the role of the pagan divinities in late seventeenth-century English culture is profound and essentially right. Empson's achievement here as elsewhere comes from the generosity of spirit which made him consistently a great critic.

# The Journalist Critic as Hero

## George Bernard Shaw

"Who am I that I should be just?" wrote Shaw in reply to a letter to the editor of the *Star* from an aggrieved member of the Globe orchestra which had played Edward German's incidental music to Shakespeare's *Richard III*. Shaw had reviewed the production of Richard Mansfield at the invitation of the *Star*'s dramatic critic, A. B. Walkley. He explained:

> As a matter of fact, I did go to the Globe, not because Walkley wished me to hear "Mr Edward German's fine music, with its *leitmotivs* after Wagner's plan" (ha! ha! ha!), but because a musician only has the right to criticize works like Shakespeare's earlier histories and tragedies. The two Richards, King John, and the last act of Romeo and Juliet depend wholly on the beauty of their music. There is no deep significance, no great subtlety and variety in their numbers; but for splendour of sound, magic of romantic illusion, majesty of emphasis, ardour, elation, reverberation of haunting echoes, and every poetic quality that can waken the heart-stir and the imaginative fire of early manhood, they stand above

Originally written in 1981 as a review of Dan H. Laurence, ed., *Shaw's Music: The Complete Music Criticism in Three Volumes.*

all recorded music. These things cannot be spectated (Walkley signs himself Spectator): they must be heard. It is not enough to see Richard III, you should be able to *whistle* it. (vol. I, pp. 585–587)

This is one of the most splendid shots in Shaw's long campaign of debunking Shakespeare, and it shows him as the greatest master of the paradoxical encomium since the Renaissance.

It is almost always a mistake to write letters to an editor; the unhappy Globe musician had much to complain of in the review, including Shaw's estimate that the orchestra consisted of only twenty-two players. Shaw disposed of his objections with evident relish (March 30, 1889):

> With all the gentleman's ingenuity and exceptional opportunities of knowing Mr German's score, he has succeeded in convincing me of only fifteen mistakes in an entire column of The Star: a result which speaks for itself. . . . If there were really "about thirty" players instead of twentytwo, where were they? . . . True, there may have been not only the trumpets and the solitary trombone "right enough" under the stage, but also a bass clarinet in the scene dock, an English horn in the flies, third and fourth horns in the box office, and a harp on the roof. I can answer only for what I saw and heard: and I can assure Mr German that the Bayreuth device of an invisible orchestra is also inaudible on the floor of the Globe, whatever may be the case upstairs. Besides, I confess I do not feel quite easy concerning the estimate of "about thirty," made by one who is in a position to be exact. It suggests more than twentynine and less than thirty; possibly twentynine and a boy. (vol. I, pp. 593–594)

It is clear that justice is not the aim of such criticism, but Shaw's facetiousness should not obscure the passion behind the cry: "Who am I that I should be just?"

"The fact is," Shaw wrote some time later, "justice is not the critic's business; and there is no more dishonest and insufferable affectation in criticism than that impersonal, abstract, judicially authoritative air. . . ." Long before the five-year period from 1889 to 1894 when he was to do most of his work as a music critic, Shaw was already firm on this point. It appears plainly in a letter he wrote at the age of twenty-seven to Francis Hueffer, the music critic of

*The Times,* defending an article of his on music that Hueffer hesitated to publish:

> But what is it that gives the vitality to the criticism of Berlioz and
> Schumann, both of whom you admire? Is it a conscious [indeci-
> pherable word] calm leading to the conclusion that there is much
> to be said on both sides? . . . For my part, I believe the public likes
> to see a fight, I think they ought to be gratified when there is battle
> to be done in a good cause. . . . I grant you that it is not worthwhile
> to fight, that most things, impartially considered, are as broad as
> they are long, but in this spirit is it not still less worth while to
> publish a journal? and criticism is a mere waste of time.

This would appear to suggest that, for Shaw, the ideal critic was
spoiling for a fight, but it was rather the coupling of his aggressive
temperament with a clear-headed—and *just*—evaluation of how
little the fight was worth, "impartially considered," that made
Shaw a magnificent polemicist. Among polemical writers, W. H.
Auden once wrote, "there are a few who must be ranked very high
by any literary standard and first among such I would place
Hooker, Swift, Sydney Smith and Bernard Shaw."

That is very grand company, but it was not only, or even mainly,
because of his polemical bent, that Shaw became perhaps the great-
est of all music critics. Now that all his journalism on musical sub-
jects (with one important exception, but including more than
125,000 words never before reprinted) is collected in these three
new volumes, the greatness is easy to measure: only E. T. A.
Hoffmann and Berlioz come anywhere near him, and Berlioz did
not write as well.

Shaw's pre-eminence in music criticism (or musical criticism, as
he called it) is only too often explained simply by his being right
where so many others were wrong. In the introduction to this new
edition, the editor, Dan H. Laurence, cites Shaw's colleague and
old enemy, Ernest Newman, who conceded that "time has proved
the rightness of nine contemporary estimates of his out of ten."
It is difficult to give a precise meaning to this specious assessment.
Unless one holds that a work of music has an absolute value for

all eternity independent of historical contingency—something that Shaw himself would have rejected vigorously—it could signify only that Shaw was good at predicting the opinions of the next generation, that he backed the right horses ninety per cent of the time.

That is not a very interesting achievement, nor, in fact, a startlingly high average: most moderately intelligent critics do about as well, since it is generally fairly obvious who the important contemporary composers are early on in their careers. A blindness in these matters is almost always wilful, as in Hanslick's well-known attacks on Wagner, and Shaw's on Brahms: the violence of the attacks, in both cases, is a tacit admission of the stature of the composers. In any case, Shaw's criticisms of Parry, Stanford, Gounod and Saint-Saëns are considerably milder, more gentlemanly, than his notorious assaults on the *German Requiem*. Brahms was the enemy for Shaw, although he always praised the G minor piano quartet highly, perhaps because he heard and liked it early on in life, before Brahms had been invested with an almost mythical status: the figure that had to be destroyed so that the progress of dramatic music from Mozart to Wagner could continue on into the future. (Later, in the last edition of *The Perfect Wagnerite*, Shaw was to claim that "Wagner did not begin a movement: he consummated it," but by then [1930] Shaw had also recognized the virtues of Brahms—he first expressed his repentance with an air of not admitting a thing as he wrote that "such works as his German Requiem endear themselves to us as being musically great fun.")

In any case, being right does not matter very much in music criticism: almost anybody can be right. What counts is the basis for judgment. No doubt, if the ideas that go into the making of an evaluation, the point of view that illuminates it and the reasoning that justifies it are persuasive and lively, the criticism remains valid even when one rejects the final judgment. In his ability to persuade and stimulate, of course, Shaw rose far above his colleagues, but not far enough to be incapable of the most egregious foolishness at times.

His sneer at "the delightful toy symphonies of Stravinsky" makes one wonder what, in 1914, he could have been talking about. His refusal to find anything interesting in the chamber music and the symphonies of Schubert is a far greater blot on his record than the polemics against Brahms, which could be excused as part of his pro-Wagner strategy. And surely nothing could be sillier than his claim that Mozart would have written in free forms like Wagner if only father Leopold had not forced him to write symmetrical sonatas. What redeemed every foolish opinion that Shaw set down (there were not, after all, very many of them) and all of his shortcomings in the comprehension of music (and he did rather better than most musicians) was his extraordinary talent for making anything he wrote consistently entertaining and provocative, and his pragmatic understanding of musical life, of the way concerts were given and operas produced.

The ability to entertain was almost frightening: Yeats had a nightmare vision of Shaw as a sewing-machine that smiled. Shaw's style was urban journalism; it had none of the hand-sewn quality of Yeats's prose or the determined rusticity of the other great members of the Irish renaissance. But if writing, for Shaw, was not a transcendental form of cottage industry, his style was never impersonal, as Yeats had implied. His technique depended perhaps more than anything else on his talent for writing nonsense.

Shaw's nonsense was indispensable to his music criticism: it enabled him to avoid pedantry and yet to slip in unperceived that minimum of technical information necessary to talking about music. The nonsense was perhaps at its most impressive during one week of May 1889 in two articles, the first is called "A Typical Concert":

> ... I remember a tenor who used to mark time by shooting his ears up and down. If you have ever seen a circus clown twitch his ear you know how it makes your flesh creep. Imagine the sensation of looking at a man with his ears pulsating 116 times per minute in a quick movement from one of Verdi's operas. That man permanently injured my nervous system by rehearsing in my presence (unsuccessfully) the arduous part of Ruiz in Il Trovatore. But he

237

was eclipsed by a rival who marked time with his eyes. You know the fancy clock in which an old man with a pistol looks out of a rustic window, glancing from side to side for burglars as the clock ticks. That was how he did it; and never shall I forget the shrinking of my whole nature from his horrible ocular oscillations. Feeling that I should go mad if I ever saw such a thing again, I left the country (he was not an Englishman), and have never revisited it.

Time, the great healer, eventually effaced his detested image from my memory. But on Wednesday afternoon I happened to be at Mr Henry Phillips's concert at St James's Hall, contemplating Mr Frederick King, who was singing *O du mein holder Abendstern*. To confess the truth, I was not minding the song so much as Mr King's fashionable trousers, made according to the new mode in which the tailor measures you round the chest, in order to get the correct width for the knee. I am rather an outsider in these matters, as it is my practice to make a suit of clothes last me six years. The result is that my clothes acquire individuality, and become characteristic of me. The sleeves and legs cease to be mere tailor-made tubes; they take human shape with knees and elbows recognizably mine. When my friends catch sight of one of my suits hanging on a nail, they pull out their penknives and rush forward, exclaiming "Good Heavens! he has done it at last."

However, the musical critic presently prevailed over the clothes philosopher; and I lifted my gaze to Mr King's face as the piano began the six-eight rhythm of the Romance. To my intense horror, he instantly beat time horizontally with his eyes for a whole bar. Unbearable memories crowded upon me. I held on to the back of my seat in a silent struggle with homicidal mania. It was a terrible moment; for my place was within a few yards of Mr King's throat.

I quote this at length in order to make it evident that such passages serve to assert Shaw's personal authority as a critic, and succeed triumphantly. The buffoonery of the article three days later (May 21), entitled "Bizet Italianized," was even greater:

To lovers of poetry the pearl fisher is known as one who "held his breath, and went all naked to the hungry shark." To the patrons of the Opera he is now familiar as an expensively got-up Oriental, with an elaborate ritual conducted in temples not unlike Parisian

newspaper kiosks, the precincts whereof are laid out, regardless of expense, in the manner of a Brussels tea garden. . . . He keeps the hungry shark in order by the prayers of a virgin priestess, who remains veiled and secluded from all human intercourse on a rocky promontory during the oyster season.

The last sentence, one of the finest in all of Shaw's works, depends on the rhythm of the successive clauses to achieve its culminating bathos. There is a controlled acceleration, and the syllabic rhythm goes: 9,9,8,7,8,7. "During the oyster season" may bring one up short, but it has been neatly prepared. Shaw himself attributed his mastery of style both to his experience of public speaking and to a study of Mozart. The symmetrical balance of asymmetrical elements was derived from Mozart.

Praise of his style irritated Shaw: he wrote somewhere that it made him feel like a man who shouted "Fire!" to people who responded by saying "How admirably laconic!" Shaw's supremacy as a music critic may have depended on his ability to write better nonsense than any of his contemporaries except Oscar Wilde, but it would be unfair to the profession and to Shaw to claim that that was the whole story. One might say that Shaw understood as almost no one else before or after the function of musical journalism.

How much attention is paid to music criticism? A review of a concert is read by three groups of people, and I list them in a diminishing order of intensity of concern: first the performers and their agents, who are looking for anything favourable enough to be quoted in publicity releases; then the members of the public present the night before, who wish to have their impressions confirmed and to be assured that they have been at an important event; in last place come those music-lovers who were not there, and who want to decide whether or not they should buy a ticket at the next opportunity. For none of these groups is the accuracy of reporting the center of interest: performers and agents want praise, not justice; the public, both those who were there and those who might come another time, want above all an assessment of

the *prestige* of the occasion and of the performers—and they also want incidentally to be entertained and amused by the critic.

Accuracy of reporting does no harm, and is no doubt even a good thing, but it matters less than one might think. A critic with a tin ear but with a detailed knowledge of the reputation and the status of the performers he is reviewing is both more informative and less misleading than a critic who can hear and report correctly what went on but knows nothing about performer and composer or about the significance of the event. I do not know how accurate Shaw was: anyone who tried to determine that now would be like the art historian who claimed an exactness of resemblance for Domenico Ghirlandaio's portraits. It is obvious, in any case, that we do not still read Shaw's music criticism today because his ear was accurate. His articles remain alive because he had an acute understanding of the nature of the event he was covering, as well as the international reputation of the performers and the music. He grasped the character and the influence of most of the innovations in both composition and styles of performance that appeared during his years of writing for the *Star* and the *World*.

Journalistic criticism is essential to the economy of music. Public concerts take place in order to permit musicians to make a living at what they love best. The fact that the public wants to hear music is really a secondary matter. The public, in fact, has to be persuaded to go to concerts—that is why criticism exists. I do not think that this point is generally understood, but it has been implied in a talk by Peter Pastreich, executive director of the San Francisco Symphony Orchestra:

> Orchestras were *not* brought into existence to furnish music to a public, they were created by musicians (including conductors) so that those musicians could make music. Boards of directors and managements were brought into the picture in order to make it possible for the musicians to earn a living from the making of music. The public is the fortunate beneficiary of all this effort.

The critic informs the public of musical activity; ideally, he communicates professional opinion to a lay audience. The greatest crit-

ics communicate advanced and enlightened professional opinion to the public. The fact that the system functions badly most of the time should be no cause for surprise. Shaw himself was not happy with it. As he said:

> I must beg my readers not to blame me if the progress of the race makes it more and more apparent that the middle class musical critic is the most ridiculous of human institutions.

A journalist critic who does not express an idiosyncratically personal point of view is dull and unreadable; nevertheless, since music criticism is necessary to the community of musicians, purely personal opinions are trivial, however eccentric and amusing. In spite of popular legend, music critics do not make or break reputations: they register them. When E. T. A. Hoffmann wrote his magnificent articles on Beethoven in 1811, Beethoven was already considered the greatest living composer by an elite that ranged from Charles Burney in England and Ludwig Tieck in Berlin to less famous musicians and writers all over Europe: Hoffmann made the opinion available to the public.

Critics have more power over performers than over composers, but performers sometimes survive universally bad notices; on the other hand, they may often disappear permanently after a series of rave reviews. The careers of performers are made directly by agents, managers, and conductors, and indirectly through the respect in which they are held by fellow-musicians.

Neither critic nor public has more than a minor voice in deciding what music will be played: musicians, in spite of all the pressures to which they are sensitive, play what they like to a great extent. Schoenberg, to take the most notorious example, has never been very popular with either the public or with most critics, but he will continue to be performed as long as someone wants to play his music.

In Shaw's long fight for the music of Wagner, a battle which was at the heart of his activity as a music critic, his was not a lone voice crying in the wilderness—although he at times gave that impression. He was, on the contrary, riding the crest of the wave,

as he himself knew: Wagner's popularity was growing in England all the time. "No other music than his," Shaw wrote on May 28, 1887, "can be depended on to draw large audiences to orchestral concerts"; this was probably a slight exaggeration, an attempt to win the battle by pretending that it was already won. Shaw's goal was the production in London of Wagner's operas. When he wrote, *Tristan* had already been produced in Paris and New York but never in London, and *The Ring* had been mounted in London only by an imported German cast and orchestra.

One of Shaw's advantages as a critic, as he himself claimed, was his understanding of the financial operations of the business of music. In 1894, in an article for the *Scottish Musical Monthly*, entitled "How to Become a Musical Critic," he wrote:

> I was enormously helped as a critic by my economical studies and my political practice, which gave me an invaluable comprehension of the commercial conditions to which art is subject. It is an important part of a critic's business to agitate for musical reforms; and unless he knows what the reforms will cost, and whether they are worth that cost, and who will have to pay the bill, and a dozen other cognate matters not usually included in treatises on harmony, he will not make any effective impression on the people with whom the initiative rests—indeed he will not know who they are. . . .

This practical knowledge gave most of Shaw's paradoxes their force, as he observed the comic deflation of artistic ideals within the grubby, badly ventilated world of real concerts and operas.

Shaw made himself the spokesman for an important body of professional musical opinion at war with the management of Covent Garden and with the entrenched academic interests of the conservatories: his eventual victory was a foregone conclusion. The style of his criticism was personal and inimitable, but the ideas were representative and consequently authoritative. His taste was always for innovation: he championed Wagner as unquestioningly as he fought for Ibsen and the Impressionist painters. Shaw was by nature an avant-garde critic, the equivalent in English journalism of Baudelaire and Théophile Thoré in France. This bias enabled

him to see immediately that Mascagni was second-rate, just as Thoré could pick out Renoir and Monet as the most interesting young painters as early as the Salon of 1869.

"Thoré probably looked at Monet and Renoir only because Manet told him to," an art historian once remarked to me. That was Thoré's genius: no other critic listened to Manet. I do not know to whom Shaw listened: probably the members of the Wagner Society. While he had all the right avant-garde ideas about German music, he was singularly inept about the French. Indeed, his only references to Debussy are so idiotic that it gave Ernest Newman the chance, in their famous controversy, to say correctly that "the amateur is writ large over Mr Shaw's latest remarks."

The controversy with Newman is perhaps Shaw's most exemplary piece of music criticism: who else could have written so magnificently about a performance to which, he proudly asserted, he had not gone, and smashed the review of a fellow-critic who knew at least as much about music as he did and who had actually been there? Nothing demonstrates better the fundamental impersonality of Shaw's music criticism.

Newman reviewed the British première of Richard Strauss's *Elektra,* conducted by Thomas Beecham on February 19, 1910, and he wrote in the *Nation:*

> All but the Strauss fanatics will admit that, though he is undoubtedly the greatest living musician, there is a strong strain of foolishness and ugliness in him. . . . Nor do we need to wait for posterity to tell us that much of the music is as abominably ugly as it is noisy. Here a good deal of the talk about complexity is wide of the mark. The real term for it is incoherence, discontinuity of thinking. "The three angles of a triangle are equal to two right angles" sounds absurdly simple, but really represents a good deal of complex cerebral working; so does the G minor fugue of Bach. But "the man in the moon is the daughter of Aunt Martha's tomcat," though it sounds very complex, is incoherent nonsense; and so is a good deal of Elektra.

Shaw had largely abandoned music criticism for more than a dozen years, but his letter to the *Nation* (March 12, 1910) has the rhe-

torical fire developed by years of public speaking in Hyde Park, the technique of being able to work himself up into a passion on almost any subject:

> Sir—May I, as an old critic of music, and as a member of the public who has not yet heard Elektra, make an appeal to Mr Ernest Newman to give us something about that work a little less ridiculous and idiotic than his article in your last issue? I am sorry to use [such] disparaging and apparently uncivil epithets as "ridiculous and idiotic"; but what else am I to call an article which informs us, first, that Strauss does not know the difference between music and "abominable ugliness and noise"; and, second, that he is the greatest living musician of the greatest school of music the world has produced? . . . Newman has no right to say that Elektra is absolutely and objectionably ugly, because it is not ugly to Strauss and his admirers. He has no right to say that it is incoherent nonsense, because such a statement implies that Strauss is mad, and that Hofmannsthal and Mr Beecham, with the artists who are executing the music, and the managers who are producing it, are insulting the public by offering them the antics of a lunatic as serious art. He has no right to imply that he knows more about Strauss's business technically than Strauss himself. These restrictions are no hardship to him; for nobody wants him to say any of these things: they are not criticism; they are not good manners nor good sense; and they take up the space that is available in the Nation for criticism proper; and criticism proper can be as severe as the critic likes to make it. There is no reason why Mr Newman should not say with all possible emphasis—if he is unlucky enough to be able to say truly—that he finds Strauss's music disagreeable and cacophonous; that he is unable to follow its harmonic syntax; that the composer's mannerisms worry him; and that, for his taste, there is too much restless detail, and that the music is overscored (too many notes, as the Emperor said to Mozart).
>
> . . . This lazy petulance which has disgraced English journalism in the forms of anti-Wagnerism, anti-Ibsenism, and, long before that, anti-Handelism (now remembered only by Fielding's contemptuous reference to it in Tom Jones); this infatuated attempt of writers of modest local standing to talk *de haut en bas* to men of European reputation, and to dismiss them as intrusive lunatics,

is an intolerable thing, an exploded thing, a foolish thing, a paro-
chial boorish thing, a thing that should be dropped by all good
critics and discouraged by all good editors as bad form, bad man-
ners, bad sense, bad journalism, bad politics, and bad religion.

"I can stand almost anything from Mr Newman except his posing
as Strauss's governess," Shaw added.

The violence of this rhetoric was intended to provoke Newman,
as it did, but the critical principle behind Shaw's attack is impreg-
nable. The sincerity or the justice of Newman's review is irrelevant
to the purpose of music criticism. Newman's article, above all
because of its tone, was gratuitous. It was essential for the health
of London musical life in 1910 for Strauss's new works to be given
a sympathetic hearing. Many years before (in 1894), Shaw had
insisted that the way composers of European reputation were
treated "petulantly . . . as intrusive and ignorant pretenders" was
one of the greatest weaknesses of academic music criticism in the
professional reviews.

Newman rejoined valiantly by pointing to Shaw's attacks on
Shakespeare, remarkable for an outrageously provocative tone
which made Newman's criticism of *Elektra* look relatively mild.
"Unless my memory is greatly at fault, he once called Shakespeare
an idiot," Newman wrote, and this inspired Shaw to retort with
the most important statement of critical method he ever set down.

> Now for Mr Newman's final plea, with its implicit compliment to
> myself which I quite appreciate. That plea is that he did to Strauss
> only as I did to Shakespeare. Proud as I am to be Mr Newman's
> exemplar, the cases are not alike. If the day should ever dawn in
> England on a Strauss made into an idol; on an outrageous attri-
> bution to him of omniscience and infallibility; on a universal respect
> for his reputation accompanied by an ignorance of his work so gross
> that the most grotesque mutilations and travesties of his scores will
> pass without protest as faithful performances of them; on essays
> written to show how Clytemnestra was redeemed by her sweet
> womanly love for Egisthus, and Elektra a model of filial piety to all
> middle-class daughters; on a generation of young musicians taught
> that they must copy all Strauss's progressions and rhythms and

instrumentation, and all the rest of it if they wished to do high-class work; in short, on all the follies of Bardolatry transferred to Strauss, then I shall give Mr Newman leave to say his worst of Strauss, were it only for Strauss's own sake. But that day has not yet dawned. The current humbug is all the other way. The geese are in full cackle to prove that Strauss is one of themselves instead of the greatest living composer. I made war on the duffers who idolized Shakespear. Mr Newman took the side of the duffers who are trying to persuade the public that Strauss is an impostor making an offensive noise with an orchestra of marrow-bones and cleavers. It is not enough to say that I scoffed, and therefore I have no right to complain of other people scoffing. Any fool can scoff. The serious matter is which side you scoff at. Scoffing at pretentious dufferdom is a public duty; scoffing at an advancing torchbearer is a deadly sin.

The editor of the *Nation* put in his two cents worth by adding in a postscript that Mr Shaw appeared to think he could distinguish "duffers" from "torchbearers." He could, indeed, and what is interesting is that Newman largely agreed with him. They both knew how the sheep were to be separated from the goats. What was at issue was the politics of criticism, not the correctness of the evaluation.

Shaw was not uncritical about Strauss, but he did not write about him *de haut en bas* as Newman did. Shaw's only previous treatment of Strauss was perhaps the most brilliant page he ever wrote on music: it is unfortunately not included in the new collection. It is to be found in Shaw's answer to Max Nordau, a German doctor who had written a book called *Degeneration,* claiming that all modern artists, including Wagner, Ibsen, Tolstoy, Rossetti and the Impressionists, were pathologically sick. Shaw's long reply, written in 1895 for an American anarchist paper, was called "A Degenerate's View of Nordau": it was republished in 1908 with the less amusing title *The Sanity of Art,* and for the reedition Shaw added a long footnote to explain why a new composer "of the First order," Strauss, was being attacked.

Shaw could see the frequent banality of Strauss's melodies as

well as Newman, but he expressed it more gracefully, wittily and profoundly when he wrote that "Strauss lives on the verge of a barcarolle and seldom resists a nursery tune for long." He ascribed most of the resistance to Strauss to his continuous use of unresolved dissonance and concluded

> that the disagreeable effect which an unaccustomed discord produces on people who cannot divine its resolution is to blame for most of the nonsense now written about Strauss. Strauss's technical procedure involves a profusion of such shocks. But the disagreeable effect will not last. There is no longer a single discord used by Wagner of which the resolution is not already as much a platitude as the resolution of the simple sevenths of Mozart and Meyerbeer. Strauss not only goes from discord to discord, leaving the implied resolutions to be inferred by people who never heard them before, but actually makes a feature of unresolved discords, just as Wagner made a feature of unprepared ones. Men who were reconciled quite late in life to compositions beginning with dominant thirteenths *fortissimo* find themselves disquieted now by compositions ending with unresolved tonic sevenths.
>
> I think this phase of protest will soon pass. I think so because I find myself able to follow Strauss's harmonic procedure; to divine the destination of his most discordant passing phrases (it is too late now to talk of mere "passing notes"); and to tolerate his most offhand ellipses and most unceremonious omissions of final concords, with enjoyment, though my musical endowment is none of the acutest. In twenty years the complaints about his music will be as unintelligible as the similar complaints about Handel, Mozart, Beethoven, and Wagner in the past.

Shaw's remark about "passing phrases" in Strauss is astonishingly acute: it is a beautiful way to characterize the essential innovation of Strauss's music, in which not merely a chord can be dissonant, but whole phrases are conceived as unresolved in relation to the basic harmony. Shaw finishes by apologizing with unbecoming modesty for the old-fashioned "technical jargon" he used: he must have realized it was radically up to date. It was rare for Shaw to use any technical expressions in his criticism.

Debussy, in middle life, said about himself as a young man that he was "Wagnerian to the point of forgetting the elementary principles of civility." Shaw was like that, too, but when he went to Bayreuth, he wrote a series of devastating articles on the bad singing, the unimaginative production and general stodginess of the management. Some of these articles, reprinted for the first time in this new collection, appeared in the *Pal Mall Budget* during August, 1894. Towards the opening of the first of these, Shaw made a bold-faced apology for his humour:

> Like Kundry in Parsifal, I am the victim of an impulse to laugh at inappropriate moments. In the enchanted garden scene of that work, when the piccolo gives a derisive shriek, and the lady points, by a descent of a diminished double octave from B natural above the stave to a C sharp below it, the enormity of her confession, "Ich lachte" ("I laughed"), I always feel inclined to say "Don't take on about it, *gnädige Frau:* so have I, often, at equally unsuitable crises." In fact, I am worse than Kundry, for I never feel the slightest remorse for my misconduct, if misconduct it be to laugh at Wagner in Bayreuth and to uphold him everywhere else.

Here is perhaps the secret of Shaw's superiority: he laughed at Wagner at Bayreuth and upheld him everywhere else. That was the true principle of avant-garde criticism while the avant-garde still existed.

It remains only to emphasize that Shaw knew a great deal about music—much more than he let on and perhaps a little less than he thought he did (to paraphrase Oliver Strunk about a well-known American composer). His mother supported the family by singing and teaching music, and from childhood music was always an important part of Shaw's life. He taught himself to play the piano, beginning ambitiously with Mozart's *Don Giovanni*. He ended up with the most exhaustive understanding of opera, Italian as well as German. He knew when a few bars had been cut, a passage altered or a number transposed. His knowledge of the instrumental repertoire was less extensive, but still remarkable. He could complain only half-facetiously of being

asked to listen to the intellectualities, profundities, theatrical fits and starts, and wayward caprices of self-conscious genius which make up those features of the middle period Beethovenism of which we all have to speak so very seriously when I much prefer these beautiful, simple, straightforward, unpretentious, perfectly intelligible posthumous quartets.

(But this, of course, was a good avant-garde position, not far from Wagner's.) Given the force of Shaw's critical principles and the sanity of his approach to journalism, it was perhaps not absolutely necessary for him to know a lot about music to be a great "middle-class musical critic." We must be grateful for how much he did know, and for the few years he gave to that "most ridiculous of all human institutions."

# Acknowledgments

Chapter 1 was first published as "Romantic Originals," *New York Review of Books*, December 17, 1987; Chapter 2 was first published as "Isn't It Romantic?" *New York Review of Books*, June 14, 1973; Chapter 3 was first published as "Romantic Documents," *New York Review of Books*, May 15, 1975; Chapter 4 was first published as "And Thou Beside Me Boiling a Pig's Head," *New York Times Book Review*, July 14, 1985, copyright © 1985 by The New York Times Co., reprinted by permission; Chapter 5 was first published as "What Did the Romantics Mean?" *New York Review of Books*, November 1, 1973; Chapter 6 was first published as "The Mad Poets," *New York Review of Books*, October 22, 1992; Chapter 7 was first published as "The Ruins of Walter Benjamin," *New York Review of Books*, October 27, 1977 and "The Origins of Walter Benjamin," *New York Review of Books*, November 10, 1977; Chapter 8 was first published as "Art Has Its Reasons," *New York Review of Books*, June 17, 1971; Chapter 9 was first published as "The Miraculous Mandarin," *New York Review of Books*, October 21, 1993; and Chapter 10 was first published as "The Real Business of the Critic," *Times Literary Supplement*, December 25, 1981.

 Index

# Index

# Index